F. HOLLAND DAY

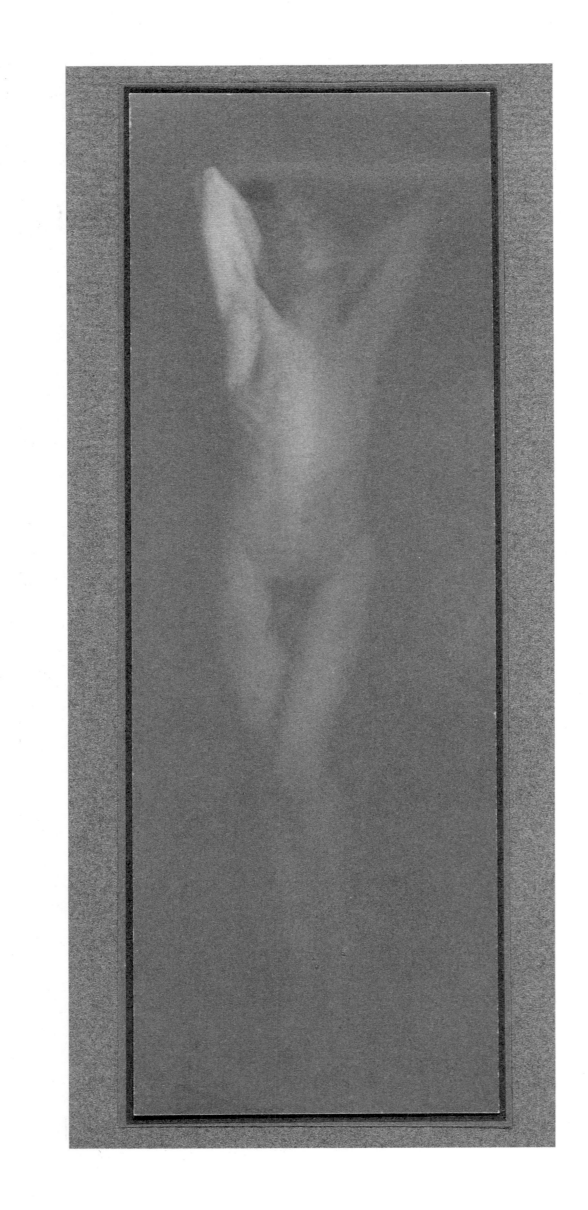

F. HOLLAND DAY
SUFFERING THE IDEAL

WITH AN ESSAY BY JAMES CRUMP

TWIN PALMS PUBLISHERS

CONTENTS

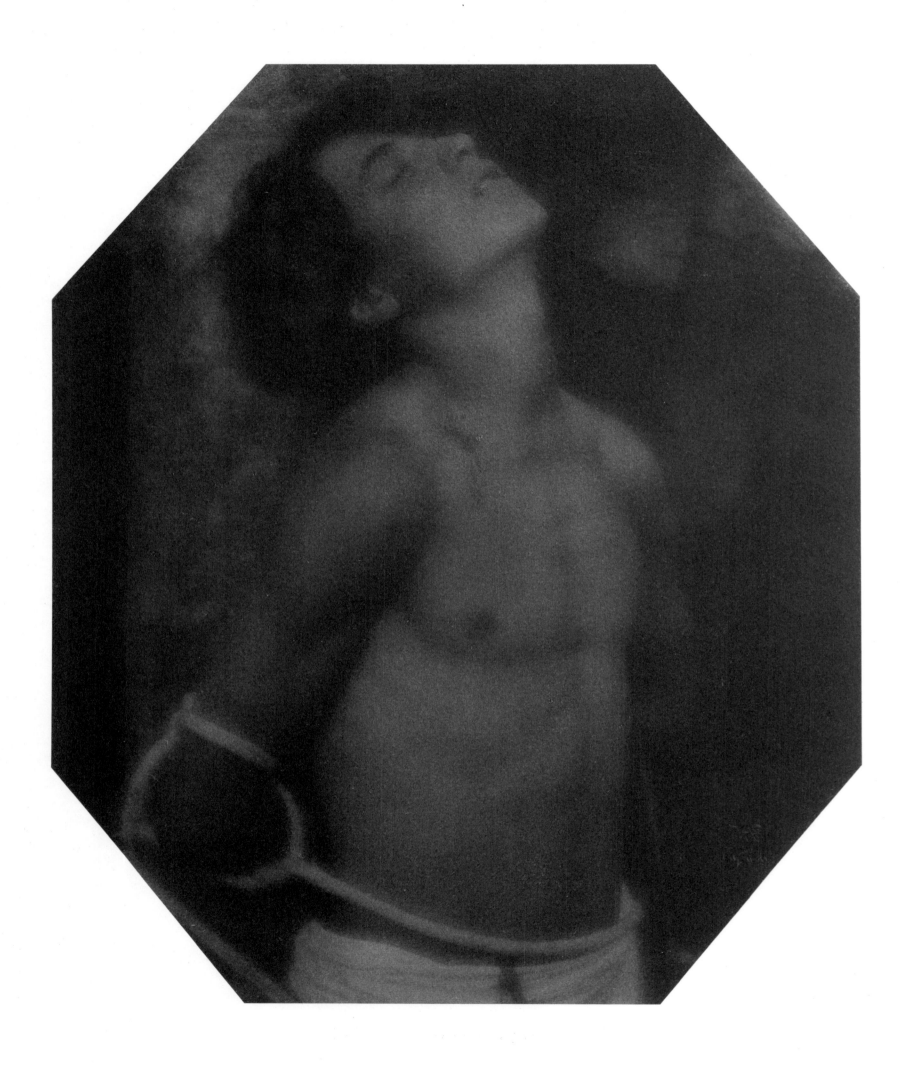

SUFFERING THE IDEAL

Bibliomania

IN THE SUMMER OF 1889, Fred Holland Day, twenty-five years of age, son of a wealthy leather merchant from Norwood, Massachusetts, was summoned home by his mother from his European holiday. Having convinced his parents that their rural Victorian house would look better as a Tudor-style mansion, Fred dashed to the Continent and left them to direct the work. Irritated by his mother's telegram, he learned that the renovation was about to fall on his shoulders, and his grandiose plan to hobnob with Europe's literary elite dissolved.[1] It wasn't the first time Fred had exhausted his parents' patience. Having given their only son everything he ever wanted, Anna and Lewis Day realized early on that young Fred had an inordinate ability to spend money. Their worry was not that he was squandering the family fortune. Rather, they wondered whether his obsession with literature and fine art, directed from a luxurious house he would someday inherit, would translate into a promising future. Day owned over 900 important volumes of poetry, fiction, and verse, many in rare first editions. With his childhood room overflowing with books, Day absorbed the renovated library, and eventually the whole mansion. To Anna and Lewis Day, the takeover was a reminder of their son's spirited individuality. To Fred, there simply was no other way to live.

It is easy to visualize Day, in a fit of excitement, moving about his library trying to shape its character. The imagery in the writings of John Keats, Walter Pater, Percy Bysshe Shelley, and Algernon Charles Swinburne, among others, had made such an impression on young Day that in 1884, when he graduated from Boston's Chauncey Hall preparatory school, Fred had earned a gold medal for "best scholarship in English literature."[2] Although after graduation he had tried to work as a salaried book clerk for the Boston publisher A. S. Barnes & Company, Day knew he could never suffer direction from anyone but himself. His dreams of publishing the most important texts by writers he admired would one day be realized on his own terms. Day demanded that books be works of art — objects worthy of regard apart from their literary worth. When Fred and his partner, Herbert Copeland, decided to fulfill this dream in

1884, it was no coincidence that they chose the motto "As a Lily among Thorns" for their publishing firm, Copeland & Day. The phrase fully suggests Day's singularity — a mind bent on preserving his idealism at any cost.[3] Designed by such like-minded artists of Day's circle as Ethel Read, Bertram Grovesnor Goodhue, and Maxfield Parrish, the ninety-eight beautiful books and periodicals published by Copeland & Day made a lasting impression on American bibliophiles. Like the English literature they showcased, the books of Copeland & Day established aesthetic standards that would fuel all of Day's subsequent endeavors in the arts, most importantly, photography.

Copeland & Day was, as *Book Buyer* reported when the firm closed, "practically a pioneer in the field which young publishers of well-made books have crowded so close in recent years."[4] Sustained by Day's personal funds, the firm never made money. It was an enterprise driven exclusively by passion and curiosity. Copeland & Day's impressive list covers the spectrum of late-nineteenth-century literature. With its first books, modeled on the hand-crafted tastes of William Morris's Kelmscott Press, Copeland & Day secured a place for itself in the history of book arts. With hand-tooled leather covers, individually stitched spines, letterpress typography, and innovative text layouts, these books are today most unusual treasures.

However, the firm's reputation, built solidly around Day's exquisite taste, eventually collapsed as a result of the young man's other associations and his affinities with eroticism and "Greek love," which scandalized Boston in the 1890s. Day published sexually provocative texts, such as Oscar Wilde's *Salomé* in 1894, *The Sphinx* in 1899, and the ten American issues of the *Yellow Book* with illustrations by Aubrey Beardsley from 1894 to 1896.[5] These publications later implicated Day as a "decadent" aesthete, a "queer sort" of man, with strange ideas about art and its relationship to society.[6] These books signaled Day's sympathy for Wilde, a convicted "sodomite," and Beardsley, a tubercular transvestite. Day's mind was at complete odds — intellectually, spiritually, and sexually — with Boston's conservative moral character, but his insistence on celebrating the notorious British Decadents was not calculated for sensationalism, though it entailed a certain level of risk taking difficult to comprehend today. Such works fitted securely into a publishing program that included Walter Pater's so-called

Imaginary Conversations in *Child in the House* (1895) and *Duke Carl of Rosenmold* (1897). It also included J. M. Dent's translation of Barbey d'Aurevilly's *Of Dandyism and George Brummell* (1898), and Dante Gabriel Rossetti's sonnet sequence *House of Life* (1894). Refined, elegant, and in small editions, Copeland & Day's books were a far cry from what was fashionable. They revealed Day as a privileged dandy, a *raffiné*, meditating in the lapidarian opulence of bohemian "decadence."[7]

Day was obsessed with creating a literary atmosphere befitting his self-styled milieu. His tastes wove the intricacies of modern Realism, the Pre-Raphaelites, Symbolism, and belles lettres into an aesthetic fabric often termed decadent. But his curiosities were too complex for such facile terms. With decadence Day tried to dramatize ordinary life with richness and complexity. The firm's list makes this clear. Copeland & Day published Bliss Carman and Richard Hovey's *Songs From Vagabondia* (1894), Philip Henry Savage's *First Poems and Fragments* (1895), Richard Le Gallienne's *Robert Louis Stevenson: An Elegy and Other Poems* (1895), Stephen Crane's *Black Riders* (1895), Alice Brown's *Road to Castaly* (1895), and *Nine Sonnets at Oxford* (1895) by Day's closest female friend and ally, Louise Imogen Guiney.[8] Although it is impossible to characterize the full range of Day's bibliomania as collector and publisher, one thing is certain. The poets and writers he favored formed a world of characters and an ideology indispensable to his photography. Bibliomania set the stage for a dream world of Day's own devising.

The publications of Copeland & Day tell us much about Day's philosophy, but they also reveal a personality bent on maintaining its individuality. This is best illustrated by the first publication of Copeland & Day, Ralph Adams Cram's *The Decadent: Being the Gospel of Inaction* (1894). Cram was one of Day's closest friends, and a fellow member of their mostly male occultist society, The Visionists. Cram later called his overwrought diatribe a "youthful indiscretion," describing the counterworld of bohemian Boston.[9] Day wrote a friend that Cram had tried to "do the Oscar [Wilde]."[10] The book was published anonymously in order to elude local apprehensions about the Visionists, and their late-night carousing, smoking, drinking, and carrying on. As Cram wrote much later, "In some way . . . word got abroad that [ours] was a queer sort of place; and in certain more conservative circles this did no good to our budding reputations — which was most unjust, for, if it was foolish, it was harmless; while it certainly meant most grateful companionship."[11] By Cram's account, the "grateful companionship" found at the club's headquarters was not to be confused with "Queer Street," an allusion to perversion found in Robert Louis Stevenson's *Strange Case of Dr. Jekyll and Mr. Hyde* (1886).[12] Both books shared the same atmosphere, nonetheless.

In a series of lofty exchanges describing the "decrepit and degenerate age" of 1890s Boston, Cram's protagonist, Aurelian, conceded to a life of futility and inaction. "You know as we all know here," Aurelian mused, "that the present condition of this happy world is very like the Puritan idea of Hell." Confronted with rapacious materialism and societal homogenization, Aurelian saw only melancholy and ruin in an age of ill will and acrimony. Any effort to alter this reality was "futile," an act complicitous with the very powers of culture that had fostered such a predicament. Aurelian believed

only in art which shall glorify that which we eat, that wherewith we clothe ourselves, those things whereby we are sheltered; art which shall be this and more, — the ultimate expression of all that is spiritual, religious, and divine in the soul of man. . . . I desire only absolute individuality.[13]

He seems to have been a fictitious counterpart of Day himself.[14] Not only did he live a privileged style of life, similar to Day's, he was also a troubled soul who prophetically announced the photographer's life to come. Aurelian's total commitment to art and his remorse-filled isolation eventually guided Day's retreat from society predicated on alienation, disillusionment, and professional rivalry. Like Aurelian, Day would be caught between his own material desires and the use of his privileged status to do earthly good in a world gone awry. Day was capable of grand gestures consonant with the hero of *The Decadent*, and any meaningful account of his life or career must acknowledge his concern with the well-being of many others outside his charmed circle. But like many of his colleagues and idols, Day was profoundly marked by contradiction. He was not simply a decadent, but an aristocrat, and his activities in publishing, writing, photography, and philanthropy have either been misinterpreted or ignored. It remains for this essay to put these roles in a new relationship that does justice to them all.[15]

Day and Aurelian shared remarkable affinities. But as a paradigm of conflict and dissent facing the overwhelming cultural changes in 1890s America, Day's reality was far more compelling. One hundred years ago, Day could not have confronted the end of Victorianism or defended a position for himself and the art of photography without profoundly encountering the changes that characterized late-nineteenth-century spirituality, his ambiguous sexuality,

and the politicized atmosphere of art and culture. The bitterly embattled position of photography vis à vis the traditional arts of painting and sculpture was matched by the difficult, and sometimes perilous, struggles Day faced in his professional and personal life.

Many have tried to fit F. Holland Day into a specific category of photography, but he doesn't conform. Constantly shifting between an aesthetic of symbolist decadence, the refined attributes of pictorialist splendor, and the burgeoning authority of photographic Modernism, Day's activities need new classifications to account for the peculiar web of interrelationships he formed between them. As an artist he was not merely a Symbolist, a Pictorialist, or a Protomodernist. As with his eclectic bibliomania, Day pulled his photographic imagery from a host of literary and artistic sources that he had absorbed completely by 1886, the year he took up the camera. Though Day's photographs might seem to some to embody the highly debated notion of photographic indeterminacy, more often they signal his attempt to question the Victorian atmosphere under which they were made and viewed. In his own time, Day's photographs were both lauded and damned with faint praise. If the pictures seem oblique today, it is because his imagery has not been properly assigned to its sources. Self-absorbed, and in perpetual state of self-discovery, Day made the subjects of his photographs extensions of an artist's life. The imagery assists us in distilling Day's own trials as a troubled American philhellene, and as a portraitist whose artful collaborations were experiments in retrieving the soul, the inner self of his models. Day's photographs are the best evidence we have of a singularly creative mind that interpreted the merits of photography not simply in abstract terms, but within a larger framework of self-discovery and critical engagement. These are the hallmarks that render his images so difficult to place into conventional categories of photography.

Day: What Kind of Pictorialist?

Prior to the first major retrospective exhibition of Day's work, in 1975, his photographs were veiled in obscurity. The artist was regarded as a marginal figure whose contribution to photography was, at best, clouded by myth and sensational pictorial rhetoric that seemed fey and self-conscious. Having effectively ended his career by 1917, Day lived out the remaining years of his life as a recluse. The chief histories of photography subsequently condemned him as an "invert" working with misguided aesthetic sentiment.[16]

As the chroniclers of the medium worked overtime to legitimize photography's history, and to construct for it a "valid" genealogy, they were never sure where Day's art fit into the grand narrative of Pictorialism, itself a beleaguered movement supplanted by photographic Modernism at the turn of the century. Scholars emphasized Day's most controversial series of images, wherein the photographer posed as Jesus Christ, and they tended to overlook, even to dismiss, his portraits and the protracted series of allegorical and mythological subjects featuring the male nude.

The problem scholars posed was not simply Pictorialism's viability, nor its significance to art history, but Day's role in the movement. In his *History of Photography from 1839 to the Present*, Beaumont Newhall tried to create a positivist ordering of the seminal periods of photographic history by employing the modernist precepts of dominant art criticism. Interpreting the history through a "straight" modernist aesthetic, Newhall effectively branded Pictorialism an aberrant, isolated, protomodernist manifestation that failed in its naïve attempt to emulate the traditional painterly arts. By Newhall's account, Pictorialism never matched the vigor of its modernist offspring. Photography's "straight" condition of faithfulness to materials and the mechanical apparatus were, to Newhall, what made the very act of image making possible. By contrast, Pictorialism, with its soft focus and hand-touched effects, seemed to undermine the medium's potential for lens faithfulness, as Newhall understood photographic Modernism. Newhall noted Day's role in introducing the most progressive American photographers to British audiences in the famed "New School of American Photography" exhibition of 1900. But discussing the *Crucifixion* series and *The Seven Last Words of Christ* (hereinafter *Seven Last Words*), Newhall gives the impression of Day as a one-dimensional artist obsessed with bizarre theatrical interests.[17] To this wobbly foundation other scholars added Day's problematic images of the male nude so that he emerged troubled, at odds with the photography movement he championed, and alienated from the circle of his primary rival, Alfred Stieglitz.[18]

As an eclectic in the truest sense, Day was as easily captivated by the work of James Abbott McNeill Whistler as he was by Holbein, Dürer, Michelangelo, and Titian. He was never content to focus on one period or movement alone. Day expressed an equivalent interest in the Pre-Raphaelites, and the sensuality and melancholy foreboding that permeates their painting, by publishing Rossetti's sonnet sequence *House of Life*. Having traveled to Europe several times by 1900, Day was aware of Symbolism in the painting

of Ferdinand Hodler, Gustave Moreau, and Alexander Séon.[19] But to frame Day within the main currents of European Symbolism fails to acknowledge his remarkable affinity with American art.[20] His tastes as an image maker, like his tastes in books, grew from a host of sources that bridged earlier theory with innovative representational strategies relatively new to photography. Composition and design were directed by subject matter. Day's own writings demonstrate that he helped establish a technical and poetic standard for art photographers to aspire to. In his photographs as well, Day sought to weave the overwrought emotionalism and movement of Caravaggio into the more placid moods of contemporaries such as Puvis de Chavannes and Hippolyte Flandrin. Many photographs by Day show compositions that wed the great Baroque and neoclassical painters to images from Asian art. He had developed this interest as a young boy, charmed by the decorative richness of pottery and sculpture, Japanese woodblock prints, and the textiles of China. All of these determined the composition, design, and overall feeling of Day's photographs, especially the portraits. The same can be said for Muslim art and the exotic allure of North African costume and architectural decoration. With the Museum of Fine Arts within walking distance from his father's office and the Boylston Street apartment the family occupied in Boston during the winter months, Day had access to perhaps the finest collection of nonwestern art in the United States.

Hand-touching his prints, focusing for blurred softness, and mounting his photographs in elaborate frames, Day tried to affect the look of traditional fine art. He challenged Alfred Stieglitz to become the leading spokesperson for American photography, and both men fought the prejudice that the medium's purpose was simply a recording technique unworthy of a higher status. But Day never possessed the domineering qualities that gave Stieglitz so much influence on photography's future. He never had Stieglitz's chameleon-like abilities to alter his course in the face of change. Although Day's capacity for giving each print a unique look was consonant with Pictorialism's stylistic bias — in seeming "painted" like any hand-wrought work — it would be incorrect to classify his photographs as merely painterly. In content and form, Day sought to establish a singular identity for photographic art that moved between the categorical subject matter and treatment of Pictorialism. His photographs of African Americans, "new" women aligned with the suffragette movement, occultist activities, and sexualized and eroticized young men, to say nothing of images of Christ with the photographer as principal actor, were

hardly the prescribed fare of American camera clubs, which imitated the artistic virtues of the pictorialist aesthetic. Day's use of costuming and his selection of bizarre objects, props, and artifacts underscore this point. But Day, unlike his cousin Alvin Langdon Coburn, wasn't a Protomodernist either. His photographs resist an exclusive formalism, seeking instead to mollify "straight" photography's hard edges and coldness with tonal blending and saturation. His compositions exploit the textural richness and tactility of objects and environments without conceding their total recognition.

Whether photography could assume a role in the fine arts was one of Day's fundamental preoccupations. This is clearly seen in the writings he contributed to *Camera Notes*, *The Photogram*, and *Amateur Photographer*.[21] Day was troubled by the lack of examples of art photography and the public's inability to distinguish camera art from ordinary snapshot or amateur photographs. He reiterated this position in many published articles. For example, in "Art and the Camera" (1897) he wrote,

When the man behind the camera learns in the first place to know good art when he sees it, and then to study it and find out why it is good art, before he tries to reproduce its like, then we shall have in the measure of capability that which is art.[22]

For Day, the insincere or incompetent photographer only hindered the growth of the medium and the public's ability to accept art's "new phases." This undoubtedly alluded to his own work, which, by 1897, had already begun to challenge issues of censorship and the staid subject matter associated with pictorialist photography. Day's published articles on fine art photography undoubtedly promoted Pictorialism as a whole by buttressing its high-minded pleas for acceptance and legitimacy in a medium that many felt justified itself only by recording "truth." But more importantly, these writings advise us of Day's singular approach to a medium that would defy the main currents of Pictorialism. His remarkable adherence to his own working principles is particularly evident in his defense of the nude as legitimate subject matter.

In mythological, religious, and allegorical photographs, Day emphatically defended the artist's right to treat the undraped body. Of its viable use in photography Day wrote that "merely a nude figure, showing beautiful lines and beautiful modeling, is not enough for the photographer . . . if raison d'être be not found in the subject or composition . . . its cause for existence is nil."[23] As we shall see, Day's use of the male nude was never arbitrary. The photo-

graphs of the male nude intervened in nineteenth-century debates on sensuality, "Greek love," as John Addington Symonds called it, and the neoclassical worship of male youth and beauty.[24] In close proximity to an eroticism associated with homosocial bonding and sexuality, these pictures were infused with desire and anxiety, repulsion and attraction. Alluding to erotic acts feared by Victorian society, especially in light of their virtual criminalization after Wilde's conviction in 1895, Day's male nudes possess the aesthetic trappings of refined art and high culture demanded by those questioning the nude's legitimacy. But these photographs also convey a problematic side to desire; they contain a frisson of impending sexual release and bodily pleasure, to say nothing of their sadoerotic inflection and pedophilic associations.

The male nudes and the "sacred" subjects, cast a panoply of conflicting signals. This is not to say that the photographs were, or still are, "unreadable," any more than their meaning is indeterminate or free floating. Most critics then knew what Day's photographs meant, and they recognized the troubling literary sources that informed them. Nevertheless, late-Victorian discourse, even by enlightened writers, discussed the images in a veiled critique that inevitably typed Day with euphemistic terms such as "decadent," "decorative," "eccentric," "purely Greek," "pagan," "Christian," and "sentimental." These terms signified something specific at the end of the nineteenth century.

Beginning in 1898, those reviewing Day's work, alongside the best-known members of Pictorialism, had no choice but to extol his mastery of lighting, posing, selective printing, and mounting. Yet these critics were less circumspect in responding to Day's subject matter, and in their appraisal of his character. Sadakichi Hartmann, the most influential and respected art critic of Day's time, suggested how pervasive this textual dilemma was. In his literary portrait of Day from 1900, Hartmann praised the photographer's artistic mastery and his premier artistic position among his peers.[25] The critic's enthusiasm in this article is matched by a statement he had made the preceding year, declaring that Day was "indisputably the most ambitious and most accomplished of our American portrait photographers."[26] But Hartmann's praise soon collapsed into ambivalence, compelled as he was to define Day's personality, or what Walter Pater and Edward Carpenter called "temperament." Alluding to the emerging stereotype of fin-de-siècle decadence, Hartmann characterized the photographer as an effete dilettante, the embodiment of privilege, status, and superior education. With the scandal of the Wilde trials

hardly dissipated, Hartmann suggested equally scandalous proclivities in Day he found troubling. "It is not the kind of work to please everybody," Hartmann wrote and then leveled:

It appeals rather to the intellectual and the refined; to those, in a word, who can understand and can feel. . . . Mr. Day is fond of strange and wayward fancies. He likes rich chords, but muffled, as it were, by the mist of his dreams. His peculiar tournure d'esprit, *recognizable in his whole behavior, is decidedly against him; he has always lived the life of an aesthete, who appears to all at the first glance as an extraordinary, extravagant personality, one that excites immediate curiosity. Strange tories, both astonishing and ridiculous, are told about him, and he in no way objects to them.*[27]

In Hartmann we find a critic grasping for the words to articulate the style and meaning of Day's imagery, but constrained by the popular norms of photography. The problem wasn't so much that Day's *tournure d'esprit* subscribed to a stereotype of decadence or aestheticism, but rather how his imagery challenged the prevailing, and acceptable, figuration of Pictorialism, forcing critics such as Hartmann to ask themselves what kind of Pictorialist Day could actually be.

Day and the Literature of British Decadence

Had Hartmann realized, or been willing to acknowledge, what sources fed Day's work, he might not have dwelled on the vagaries of aesthetic innuendo. As an Anglophile, Day had precocious passion for the book arts and a special regard for British poetry and literature. This passion was complicated by an eclectic intellectual development sparked by classical texts and turn-of-the-century utopian philosophical tracts concerning spirituality and sexuality. The cauldron of ideas that inspired Day's imagery was no mean object to master. It obviously challenged the most intuitive critical thinkers such as Hartmann. The literature of British Decadence, seen by many as an aspect of Day's taste as a publisher, and not sufficiently recognized for its influence on his subject choices as an artist, in no small way informs Day's photographic imagery. British Decadence in literature and the arts links Day to a world insufficiently understood in late-nineteenth-century Boston. This literature forms the core of Day's marginal status in photography. Alternately termed the Aesthetic Movement, Decadence is a foil to the vagueness of Hartmann's opinion, for it shows Day's simultaneous interest in the occult, exoticism, eroticism, and desire. As Cram's protagonist, Aurelian, said to his youthful protégés, Decadence "is only a dream after all, even a dream

of the land of endless afternoon."[28] Day's world of dream imagery extended the literature of British Decadence to a pictorial vision of beauty and sensuality that Hartmann ignored. Yet Walter Pater, the single most influential figure of British Aestheticism, has never figured into the interpretations of Day's photographs. Pater is the departure point for the more notorious publications associated with Decadence, which Day's firm courageously published in the late 1890s.

WALTER PATER

After his graduation from Chauncey Hall, Day did not go on to Harvard. Nevertheless, this university was Day's intellectual stomping ground. It was the site where Walter Pater's writings had been immensely popular throughout the 1880s. Day's interest in Pater was further strengthened by the relationship the photographer maintained with Bernard Berenson, a Harvard student, and later a noted art historian of the Italian Renaissance. Called Pater's most devoted American disciple, Berenson had left Harvard in 1887 to attend the master's lectures at Oxford.[29] As a confidante and trusted literary friend, Berenson probably introduced Day to Pater in the mid-1880s.

The neopaganist spirit we find so often in Day's mythological and sacred photographs was made an intellectual quest by Pater. Signaling a break with the dominant materialism of Victorian culture and its dearth of values, Pater's two popular books, *Studies in the History of the Renaissance* (1873) and *Marius the Epicurean* (1885), helped Day define an ideology he would subscribe to throughout his life. As witnessed by Pater's two "Imaginary Conversations" published by Copeland & Day, the British writer, for Day, was no wayward fancy. Pater had taught Wilde at Oxford. Thus, he became the source of a continuum of British Decadence that Day found himself inextricably part of.

Obviously more problematic was Pater's veiled advocacy of an aesthetic ideal founded in ancient civilization which celebrated the beauty of young men.[30] Intellectually rigorous, Pater's *Renaissance* and *Marius* revitalized interest in the classical past, and in what the author perceived as a society more civilized than that of the present day. *Renaissance* and *Marius* integrated spirituality and aestheticism in a critique of organized religion that subtly addressed the perceived crisis in masculinity. Perhaps anticipating the fallout of scandalous association, both books presented a high-minded justification for what, according to Pater himself, "might possibly mislead some of those young men" exposed to them.[31]

Pater was referring to the late-Victorian conception of same-sex relations, Greek love, and homosocial bonding — the emerging legal, psychological, and sexological categories used to type difference and pathology.[32] Located within a framework that advocated moral integrity, responsibility, and the way these qualities formed one's individual character, Pater's aesthetic was immensely appealing to Day and his circle. As William Sharp observed in 1894, Pater wished to be known as a critical thinker in an age dominated by materialism.[33] Day's quest for alternatives to the materialism of his own life led him to this forefather of British Decadence.

In "Is Photography an Art?" Day wrote that the modern photographer "no longer speaks the language of chemistry, but that of poetry. He quotes less Herschel than Pater."[34] As a conduit through which the photographer and his circle gained access to the Victorian cult of classical Greece, Hellenism, and Platonic spirituality, Pater's writings help us link Day to an ongoing construction of idealized male beauty begun in the late eighteenth century. This paradigm of bodily desire is present in the *Crucifixion, Seven Last Words*, and Day's other images featuring the male nude. At the nexus of art-historical expressions favoring classical male beauty, as in the ecstatic characterizations by Johann Winckelmann, and later the gender theories espoused in the writings of John Addington Symonds and Edward Carpenter, Pater's aesthetic traces a lineage of pain and suffering commingled with bodily pleasure and sexual abandon. The manifestation in photography was fulfilled in the twentieth century by George Platt Lynes (1907–55) and Robert Mapplethorpe (1946–89). In Day's lifetime Pater wedded artistic appraisal with sensuality. By affirming the morality of spiritual and material alternatives, and open sensuality and eroticism, he offered Day and his milieu a standard to live by: "To burn always with this hard, gemlike flame, to maintain this ecstasy, is success in life."[35]

For Day and his friends, the attraction to Pater's writing came in the form of sensuous description and illusionistic referencing. Pater's summons would lure Day to affirm his own art-historical mining, and his increasing fascination with Greek antiquity. The worlds of Michelangelo and Leonardo would connect with those of Winckelmann and John Addington Symonds. The brew was intoxicating. Pater's undeniable homoeroticism hailed the beauty of male-bonding and intimacy in a flurry of veiled phrases. His writing instigated fantasy, and immersion in a counterworld. In his discussion of Leonardo, for instance, Pater wrote of the artist's "solitary culture of beauty," alluding to the importance of male intimacy to his art:

Among the youthful heads there is one at Florence which Love chooses for its own — the head of a young man, which may well be the likeness of Andrea Salaino, beloved of Leonardo for his curled and waving hair . . . and afterwards his favourite pupil and servant. Of the interests in living men and women which may have filled his life at Milan, this attachment alone is recorded.[36]

Pater's descriptions are as eclectic as any photograph by Day would be. They prefigured Day's medieval costuming, the sensuousness of his series *Orpheus* and *Pan*, and the ennui that permeates several of the photographer's best portraits of young males and females. For Pater, Leonardo's painting combined the "animalism of Greece, the lust of Rome, the reverie of the middle ages with its spiritual ambition and imaginative lovers, the return of the Pagan world, the songs of the Borgias."[37]

A work that Day returned to for inspiration was Michelangelo's marble *Dying Slave*, which emitted phenomenal sensuality and homoeroticism. Day converted it into his *Study for Crucifixion* (c. 1896), *Nude Youth in Dappled Woods* (1907), and *Nude Youth in Shadow* (1909), among others. *Dying Slave* summarized Day's spiritual and aesthetic ideal of male beauty. Pater saw that "beneath the Platonic calm . . . there is latent a deep delight in carnal form and colour," adding that Michelangelo "had not been always a Platonic lover."[38] This coded indulgence of homoeroticism appears analogously in Day's images of the male nude. *Orpheus* and *Pan*; the young men posed at Day's retreat, Little Good Harbor, in Five Islands, Maine; and even *Study for Crucifixion* and *Seven Last Words* exploit this reverie. They have oneness with an evolving literature of Decadence that late-Victorian culture found increasingly problematic.

The most important essay for Day in Pater's *Renaissance* was "Winckelmann," in which the writer reinvigorated the beauty and eroticism that the eighteenth-century German archaeologist had found in Greek art. "Winckelmann" further affirmed the dream of Decadence, and the ideal suffered for an utopian age of open sensuality and masculine intimacy. In this essay Pater wrote of the shortfalls of "mystic passion" and "monastic reverie" characterizing nineteenth-century spirituality, and how this modern Christian position "deflowered the flesh; how little [it] emancipated us."[39] According to Pater:

The modern student most often meets Plato on that side which seems to pass beyond Plato into a world no longer pagan, based upon the conception of a spiritual life. But the element of affinity which he presents to Winckelmann is that which is wholly Greek, and alien from the Christian world, . . . uninfected by spiritual sickness, finding the end of all endeavor in the aspects of the human form, the continual stir and motion of a comely human life.[40]

In Winckelmann's assessment of the classical world and its beauty, Pater found the liberation of mind and spirit. This critique of Christianity, predicated on neopaganism, gave priority to the senses and human form. Pater wrote of the archaeologist's "temperament," and the failure of a culture unable, or unwilling, to accept it. In this lineage of Winckelmann and Pater, Day sought the "more liberal mode of life," and the hedonism associated with ancient Greece. Although, according to Pater, it had been "near us all the while," the Greek mode of living was suppressed by Christianity and its virulent denial of bodily sensuality. For Pater, "Hellenism, which is the principle pre-eminently of intellectual light, has always been most effectively conceived by those who have crept into it out of an intellectual world."[41] Pater found a paradigm that underscored the superiority of male beauty. He quoted Winckelmann:

As it is confessedly the beauty of man which is to be conceived under one general idea, so I have noticed that those who are observant of beauty only in women, and are moved little or not at all by the beauty of men, seldom have an impartial, vital, inborn instinct for beauty in art. To such persons the beauty of Greek art will ever seem wanting, because its supreme beauty is rather male than female.[42]

Within Pater's "Winckelmann," the singular achievements of Leonardo and Michelangelo resonate as Day's compositional guide.

There is no question what position Day took as an image maker in the 1890s. Day's photographs established a visual critique of modernity consonant with Pater's prescriptions. In *Study for Crucifixion*, perhaps the first frontal male nude ever exhibited in Boston, Day conveyed rapturous sensuality and bodily freedom.[43] This tightly composed photograph has little to do with the Christian theme from which its title was derived. Adapting the pose of Michelangelo's *Dying Slave* and titling the work with the penultimate scene of Christ's suffering, Day resisted ascetic behavior. The figure writhes in pleasure, not pain. With the model's hands hidden behind his head, the slight *contrapposto* of his legs, and his ecstatic gaze, *Study for Crucifixion* exudes pagan hedonism while questioning Christian authority. This work is a prelude to the ideological complexity that pervades his later photographs of the male nude. Like *Nude with Trumpet* (c. 1897) and *Nude Youth in Studio with Shepherd's Crook* (c. 1896), *Study for Crucifixion* shows Day's engagement with the spiritual

conflicts of his time. Such construction of meaning reaches its pinnacle of complexity in photographs such as *Beauty Is Truth, Truth Beauty* (c. 1896), and in Day's sacred subjects.

To a lesser extent Pater's *Marius the Epicurean* was also important to Day. The hero of Pater's later book was a "neo-pagan . . . [who] leave[s] upon the mind of his reader . . . [a] much more winning and persuasive impression than does the Neo-Christian of the balm, the brightness . . . brought into the diseased and moribund *société* by the coming of Christ."[44] Moral authoritarians found such comments contemptuous. For the censors of *Marius*, Decadence or Aestheticism was anti-Christian, wholly immoral, and indecent. The position would challenge Day's commitment to art and altruism, and his resistance to misguided puritanism, which he felt prevented society from realizing its potential. As the Christian Socialist Reverend Washington Gladden warned, there existed a new "aesthetic paganism" that was affecting the "cultivated and luxurious congregations" of America's great cities. According to Gladden, "it is evident that the two kingdoms of Christianity and aestheticism are now in many quarters contending for the mastery. . . . The modern Paganism lays down its law. . . . Love art for art's sake, and all things that you need will be added unto you."[45] Invoking the creed of Decadence, Gladden intended to implicate those committed to its ideals and the sensualism advocated by Pater. The accusations made by defensive traditionalists such as Gladden, if not dismissed entirely would have been found venal by cultivated minds such as Day's. The *Orpheus* series, the *Pan* series, and the male nudes he executed at Little Good Harbor, underscore a pervasive, nonascetic liberality with which Day infused his later photographs.

Perhaps the most compelling of Day's photographs is *Beauty Is Truth, Truth Beauty.* It was not an "ideological statement" derived "straight out of Keats," but a bridge to the philhellenic conception of male beauty that Day and his peers sought in the literature of their age.[46] Originally entitled *The Genius of Greek Art, Beauty Is Truth, Truth Beauty* references Pater, and therefore Winckelmann, as a visual response to the neopagan ideologies that the photographer shared with both writers. In this image Day diagrammatically collapsed the ancient, pagan past, onto the topos of Christendom. Here, the Roman lover of luxury, Petronius – sitting erect, with his right hand holding an orb and his left, a potted bouquet of artificial orchids, an *arbiter elegantiae* of Nero's court – reigns high above the entombed figure of Christ. The sacrificial martyrdom signaled by the lower figure cedes to the pagan symbol of languor in death – death celebrated in beauty and physical acquiescence. Petronius

stares at the fate before him – his wrists slashed for his peer's amusement. Inscribed are the words "BEAUTY · IS · TRUTH: TRUTH BEAUTY: THAT IS ALL · YE · KNOW · ON · EARTH · AND · ALL · YE · NEED · TO · KNOW." There can be little question regarding Day's strategy to intermingle pagan and Christian signs, and at the same time call attention to the photographer's aesthetic ideal of life lived as art in the embrace of masculine sensuality. The juxtaposition was controversial, and like that of *Hypnos* (c. 1896) provoked the critics. For Joseph T. Keiley, Alfred Stieglitz's closest friend and ally, Day's "purely pagan idea" signaled the photographer's conviction "that the enjoyment of refined, elegant, sensuous beauty alone was the highest purpose and motive of existence."[47] As Walter Pater was fond of noting, there was a significant distinction to be made between the spectator who, like the spiritualist Keats, loses himself in the sensual experience of art, and the creator of the work who was already immersed in that sensuality. Day's complex image summons a return to the pagan past, an age when writers such as Pater claimed that the artist lived through his sensuality.

JOHN ADDINGTON SYMONDS

Although there is evidence to suggest that the ideology in Pater's writings appealed to Day, the most thorough interpretations of Day's photographs have failed to account for this influence. But Pater's veiled prose was not the only voice promoting the neopagan spirit emerging in the 1880s and 1890s. During the period of Day's most prolific photographic activity, a more overtly sensual literature circulated in texts that gave credence to the neopagan spirit emanating from writers and thinkers such as Pater. More importantly, these writings opened the discourse on Greek love which writers such as Pater, and Winckelmann before him, had discussed in coded terms. As Michel Foucault noted more recently, the discourse on homosexuality fostered significant advances in the observation and control of "deviancy." But it also created a reverse discourse in which "homosexuality began to speak on its own behalf," demanding that its legitimacy, or naturalness, be accepted.[48] In the wake of the Wilde trial of 1895, perhaps no writer better epitomized this trend than John Addington Symonds.[49] Symonds was writing in response to the increasing academic treatment of sexuality. If Day had a perspective on same-sex love, eroticism, and desire, it would have derived from an Anglo-European intellectual position on the subject of Greek love – a prominent visualization in Day's mythological and sacred photographs which drew substance from Symonds's intellectuality.[50]

In his surreptitiously published "A Problem in Greek Ethics" (1883), Symonds stressed the normal social behavior of same-sex love among the ancient Greeks, arguing against contemporary claims for its "degeneracy." By de-emphasizing the bodily corruption associated with male-to-male sensuality, Symonds attempted to establish a philosophical theory for "sexual inversion" derived from antiquity. For students of sexual inversion, Symonds wrote:

Ancient Greece offers a wide field for observation and reflection. Its importance has hitherto been underrated by medical and legal writers on the subject, who do not seem to be aware that here alone in history have we the example of a great and highly-developed race not only tolerating homosexual passions, but deeming them for the benefit of society.[51]

Although Symonds's eloquent, and historically based, apologia circulated widely at the time, Day probably didn't come upon it until 1901, when the essay was reprinted in a larger edition.

As a founding member of several literary societies in Boston, including Athenes Therapes, established in 1894, Day may have already known Symonds's *Studies of the Greek Poets* (1873), which extolled the sensual beauty of pagan culture. Among works read and studied by the members of Athenes Therapes were translations of classical Greek dramas, poetry, and verse. As we shall see, Day's eloquent writings on the beauty and artistic use of the male nude share affinities with Symonds's earlier tract. Like Pater, his more celebrated compatriot, Symonds also evoked the romanticism of Winckelmann, describing the virtues of Greek civilization with a strong subtext of homoeroticism. In his metaphor of the "Genius of Greece," Symonds utilized the lithe, youthful, athletic body, the description of which might easily apply to Day's *Beauty Is Truth, Truth Beauty*, whose provisional title had conjured Symonds's essay. "Like a young man newly come from the wrestling-ground," Symonds wrote:

the Genius of Greece appears before us. . . . The pride and strength of adolescence are his — audacity and endurance, swift passions and exquisite sensibilities, the alternations of sublime repose and boyish noise, grace, pliancy, and stubbornness and power, love of all fair things and splendors of the world, the frank enjoyment of the open air, free merriment, and melancholy well beloved.[52]

In such effusions Symonds described Day's arcadia, the recreation of a mythic site of nature and male beauty, where sensuality and the "delicious uncertainty of the soul" reign in splendor.[53] Day's *Nude Youth with Laurel Wreath Standing Against Rocks* (c. 1907) shows a boy arching his back,

dreamily staring into the lens. The young model evokes "sublime repose" while resisting explicitness. With the laurel wreath framing his dark shock of hair, the model is a symbol of youthful splendor, and of uninhibited luxury and pleasure, a perfect illustration for Symonds.

Day first began photographing the undraped male body in the mid-1890s, a period in which the topic was a lively subject for debate by writers on photography.[54] Consistently returning to precedents in art history, notably ancient Greek paradigms of civilization, Day's writing is a template for working in nature, the primary context for his series of mythological images, and sacred subjects. In "Is Photography an Art?" Day, like Winckelmann, Pater, and Symonds, cried for a return to "antique life," when nature inspired the artist and Christian asceticism was unknown. The contemporary photographer could do no better than follow the lessons of classical history, take

figures out doors. . . . For the landscape has preserved for us the places where moved the contemporaries of Anacreon. . . . We are no longer astonished to behold beneath the pine tree a revival of the games and festivals of sculpture. . . . Since there are still pines, we have thyrsus; since there are still turtles, we have lyres; since there are still reeds, we have pipes.[55]

Re-creating the male body epitomized in ancient sculpture and Renaissance painting was a logical extension to Day's own plea for a mythical world populated by Orpheus and Pan, "dying slaves" and reposeful ephebes. Day's rustic arcadia with beautiful youths is not unlike the atmosphere evoked by Symonds, the lyrical ambiance of Anacreon, where the joys of life flow freely, driven by passion, desire, and the spiritual quest for beauty. But the "acceptable" or "legitimate" portrayal of the male body, for Day, rested on its aesthetic merits. He was unyieldingly against the censorship and prudery that dominated the critical discourse of photography. As he wrote, "We must then admit no question regarding the righteousness or legitimacy of the undraped figure in Art in this year of grace any more than it was admitted by Praxiteles and Titian in earlier times."[56] Day called "for a well planned, well thought out, well executed *motif*, which alone, with the proper figures, can be considered worthy to be called Art."[57] In his *Study for Crucifixion*, in which he appropriated a motif from Michelangelo, and in *Ebony & Ivory* (1897), in which the photographer invoked a composition by Hippolyte Flandrin, the proper figures and props justified Day's interest in the beautiful male body. With special lenses, blurring techniques, and innovative control in the use of lighting, Day produced so-called acceptable images of the male

nude. Yet even his most cautious nudes retain a potent eroticism, with impending sexual energy and passion. They manifest the subconscious hidden world of desire, homoerotic sensuality, and voluptuousness.

Day's own sexual orientation remains concealed in his veiled representation of the male nude, his self-imaging of Christ, and his portraits of young men and boys. But these images confronted the norms of late-Victorian culture, and its rejection of allusions to homoerotic and homosocial desire. The backlash against Greek love effected after 1895 by Wilde's trial, and the scientific, legal, and psychological ordering of difference and pathology, fostered remarkable fear and anxiety. Day internalized and refigured homophobia in his tension-filled images of desire and self-martyrdom. Many of these images respond to a homoerotic impulse that both affirms its own legitimacy and negates its own troubling potential. The *Crucifixion* series and *Seven Last Words*, and even Day's portraiture, underscore his tendency to affirm and negate, comply with and reject, a complexity never resolved in the works' meaning.

OSCAR WILDE

Had scholars realized the extent to which Day's sacred subjects were not mere novelties but integral to the rest of his work as a photographer, perhaps his reputation would have suffered less in the histories of the medium. There are several additional factors to be considered. One is Day's friendship with Oscar Wilde, and their shared response to the Christian world of the 1890s. This response, doubtless precipitated by Wilde's infamous trial for homosexuality, indicates the antagonism both men would have experienced for having aesthetic points of view that celebrated male beauty. Wilde had called Pater's *Renaissance* "that book which has had such a strange influence over my life . . . the golden book of spirit and sense, the holy writ of beauty." Day's idolization of Wilde reinforced Pater's aesthetic.

Having met Wilde in 1882, the year the playwright toured the United States, Day, at eighteen, began a friendly association that eventually ended in conflict, but not before his firm, Copeland & Day, had published Wilde's *Salomé*, and the notorious quarterly *Yellow Book*. These publications, and Wilde's *Sphinx*, which Copeland & Day published in 1899, implicated Day in the divisive scandals of "decadence" that revolved around the veiled literary phenomenon of homosocial interaction and desire. Particularly fond of Boston, Wilde had told his audience there in 1882 that theirs was the "only city that influenced thought in Europe." In the decade preceding his trial, Wilde maintained contact

with Day by frequent correspondence. Their interaction would eventually trouble the photographer, especially as Wilde's scandalized life unfolded in the popular press. The trial, in which Wilde paraded his exploits with "sodomy," created a major scandal that shocked the emerging homosexual communities in England and the United States. It is certain that Day's privileged position among the population of Boston's well-educated and affluent bachelors placed him within the ranks of those under close scrutiny by moral authorities and church leaders, as well as the intellectual circles critical of the Aesthetic, or Decadent, movement. Wilde's eventual conviction was equated with a presumed crisis in morality, in which, as the *London Times* reported, "scores of rival stories are afloat about other men incriminated, including some names throughout the English speaking World."[58] As Wilde's friend and Boston publisher, Day did not escape this association.

Day's relationship with Wilde also introduced the problem of Christhood, or alternative spirituality as it informed late-nineteenth-century figurations of ideal male beauty. Key to this was Christ's new identification with the pagan past, and the new perceptions of Christ found in nineteenth-century literature, such as Ernest Renan's *Historie des origines du christianisme* (eight volumes, 1863–83), of which the first volume, *Vie de Jésus*, was a bestseller in the 1860s. Most significantly, the figure of Plato, seen as a precursor to Christ, further blurred the distinctions between Christian teaching and the pagan past. This gradual transition, which began in the first quarter of the nineteenth century, had ramifications that reached their ultimate severity in the 1890s. Day's mythological images, created primarily after 1904, are located in time between the intensive sacred subjects (1898), and the photographer's return to Christian typologies with, for example, his series depicting Saint Sebastian (1906–7). This meandering course of representation suggests the conflicts of ideal male beauty fostered by the new identification of Christ with the pagan past. That Day was aware of this problematic identification is evidenced in photographs such as *Beauty Is Truth, Truth Beauty*. This image illustrates Day's willingness to engage in this most controversial issue which affected him as an artist and individual.

The (mis)identification of Christ associated with decadence issued from the ambiguous literary and parareligious texts of the period. They called into play the hotly debated issues of asceticism, moral decay, and cultural decline. By asserting the relativity of spiritual thought, or how the moral teachings of Plato and Christ are analogous to one another, nineteenth-century spiritual leaders, such as B. F.

Westcott, Bishop of Durham, unwittingly fueled the perception of pagan and Christian continuity. They stressed the role that ancient Greek spirituality had in the formation of Christian belief, never more so than when invoking Plato's great influence. As Westcott wrote in his *Essays on the History of Religious Thought in the West* (1891), "the work of Greece lives for the simplest Christian in the New Testament."[59] For Westcott, Plato and Christ occupied the same plane; both were heirs to the pagan root of deep spirituality. Further complicating Christ's identification were nineteenth-century literary interpretations that presented Plato either as the supreme advocate of homoerotic love and male beauty, or the outstanding predecessor of Christian morality. The key focus of Winckelmann and Symonds had been to rid the socialized male body of prohibitions placed upon it, to escape the shame that puritan Christian minds associated with bodily pleasure and homosocial interaction. In his association with several literary societies, Day encountered the conflicts and ambiguities of contemporary discourse, and recognized the classical origins of male beauty worship, and the emotional and spiritual qualities that characterized same-sex desire.

Day's mother, Anna, had raised him with the principles of New England Unitarianism, a tolerant Christian sect that, oddly enough, suited his increasing ambivalence toward organized religion. Unitarianism's benevolent position toward other faiths, its belief in the innate goodness of man, and the primacy of reason and conscience for religious truth would inform Day's eventual critique of Christianity as a whole and his willingness to search for, and accept, spiritual alternatives. This liberal religious belief system certainly would have clashed with the Boston-Irish Catholicism of Louise Imogen Guiney, Day's closest female friend. Guiney held a position of influence throughout Day's life, but her devout Catholic spirituality eventually antagonized Day who, obsessed with individuality, wanted to avoid Catholic absolutes of moral and spiritual order.

Wilde amplified the conflicts of Greek love and Christianity by referring to Plato and Christ. Following Percy Bysshe Shelley, the romantic poet John Keats became the glorious metaphor of the Crucified Christ in Wilde's essay "On the Sale by Auction of Keats' Love Letters" (1886).[60] Possessing one of the largest collections of material by this poet, Day was hardly a passive Keats enthusiast. Wilde became Day's bridge to the poet. Using Keats's life and his romanticized death as a metaphor for the suffering artist alienated from society, Wilde rendered the suffering and humility of the young martyr into a Christlike, spiritu-

al prototype not only for himself, but for Day in his decline in the last years of the 1890s.

In *Ballad of Reading Gaol* (1898) Wilde evoked the Crucifixion again, as a metaphor for the incarcerated victim of societal pressure sentenced to die by hanging. As the prisoner is led to the gallows his fellow inmates chant a hymn alluding to the Roman soldiers throwing dice. Wilde eerily described the executioner as the mounted centurion lancing Christ at Golgotha:

> He did not pass in purple pomp,
> Nor ride a moon-white steed.
> Three yards of a cord and sliding board
> Are all the gallows' need:
> So with rope of shame the Herald came
> To do the secret deed.

Described as Wilde's attempt to "frame his own image between, or even as, those of a woman-murdering man and the Crucified," the scene suggests the significance of Christ's personage in the rhetoric of decadence.[61] Christ's sacrifice epitomized individuality and a ceaseless belief in ideals. In *The Soul of Man Under Socialism* (1891) Wilde advocated individualism through Christ, whom he had say, "you have a wonderful personality. Develop it. Be yourself."[62]

Individualism had many connotations for Wilde's readers. For Day and his milieu it signaled resistance to those imposing oppressive morality at odds with spiritual autonomy. Wilde's typological construction of Christ was meant to subvert traditional beliefs and the institution of formalized religion. In Wilde's writing, Christ became a secular model, a humanistic personality whose individuality, rejection of personal property, and acceptance of social dissent was not a link to resurrection, but to the classical past and the ideal of self-perfection.[63] For both Wilde and Day, the order was one of embracing total individuality, at the cost of martyrdom. Through allusions to ancient Greece and traditional Christian spirituality, both Wilde and Day constructed an antithetical Christ born of ideals of Platonic beauty and form. Wilde's protracted letter, *De Profundis*, written around 1897 and published in 1905, summarized this ideology of Christhood and individuality. Although Day could not have seen this text before making his *Crucifixion* series and *Seven Last Words*, the ideas in *De Profundis* pervade his images. "Indeed, that is the charm about Christ," Wilde wrote, "when all is said; he is just like a piece of art . . . the beautiful white Christ."

Wilde's and Day's uses of Christian typology are linked with autobiography. Both men became spectators of their

own personal tragedies by creating a myth of themselves in the form of a typological model – Jesus Christ.[64] The "beautiful white Christ" would pervade Day's image of himself. The issue here is how Day's narcissistic self-image played into the realms of masculinity and male sensuality as defined by late-Victorian culture. As eroticized images of Christ, partially draped and revealing physical suffering, Day's photographic self-portrayals as martyr were a threat on many levels. They were considered blasphemous, indecent, and an affront to the accepted style and subject matter of Pictorialism. As this text will show, Day's *Crucifixion* and *Seven Last Words* were not mere flights of narcissism. They combined the issues of asceticism, increased awareness of suffering as spiritual expression, the figuration of classical male beauty and sexuality, and the problems of same-sex relations. Day was not simply a witness to this period of radical change, but cast himself eternally as a participant in a long struggle to confront the material world and its advocacy of prescribed spiritual and moral behavior. In circumscribing the complexities of Greek spirituality and its antagonism with traditional Christian beliefs, actions such as Day's made a plea for tolerance by giving suffering mythological dimensions.

EDWARD CARPENTER

With their parallel convictions about art, society, and spirituality, the writings of the utopian socialist and critic Edward Carpenter were also part of Day's library. Day's portraits of young men and boys, no less than his male nudes and sacred subjects, reflect the philosophical tenets of Carpenter's work. As a committed social critic, a strong advocate of both the homosexual and women's rights movements, and a voice against prohibitions that shamed bodily pleasure, Carpenter extended the arguments of Pater and Symonds. Day met Carpenter in England in 1900. His library contained nineteen of Carpenter's books, four of which the writer personally inscribed to him.[65] Carpenter's defense of individuality, and the artist's role in preserving it, would have been particularly compelling. In "The Individual Expression" (1898) Carpenter wrote,

To be absolutely oneself — and to be oneself through the profoundest sympathy with one's subject . . . following the lead of some divine unapprehended instinct — the sheer need for expression of something which lies at the root of themselves — neither good nor wicked, moral nor immoral — they produce effects which no calculation could provide.[66]

Day saw Carpenter as an eloquent partisan in his artistic and spiritual quest for tolerance. Day also subscribed to

the mentoring relationships between men and boys that Carpenter advocated.

The bond Day maintained with many young male models was not based simply on the photographer's attraction to their physical features. These relationships resembled what Carpenter called "Uranian Love," a classical model whereby an adult acts as a spiritual and intellectual guide, ushering his charge into the rites of manhood, and the particularly Victorian notion of philanthropy in economic betterment and social ascension. Coined by the German activist and theorist, Karl Heinrich Ulrich, the term *Uranian* was a reference to Plato's *Symposium*, and symbolized a higher, more heavenly form of love.[67] Carpenter believed older and more experienced men could benefit their youthful protégés as role models and agents for success. But as he stressed in "The Intermediate Sex," the benefit that Uranianism brought to society went unacknowledged, overshadowed by prejudice toward nonheterosexual intimacy:

It is their great genius for attachment which gives the best Uranian types their penetrating influence and activity, and which often makes them beloved and accepted far and wide even by those who know nothing of their inner mind. How many so-called philanthropists of the best kind . . . have been inspired by the Uranian temperament, the world will probably never know. And in all walks of life the great number and influence of folk of this disposition, and the distinguished place they already occupy, is only realized by those who are more or less behind the scenes.[68]

Wilde's London contemporary and Aubrey Beardsley's last lover, Marc-André Raffalovich (1865–1934), author of *Uranisme et Unisexualité* (1896), may have introduced Day to Uranianism.[69] But it is certain that Wilde's and Carpenter's writings were definitive in shaping the utility of the term for Day. Uranian love accounts for Day's philanthropy, and his desire for reform. Between 1905 and 1915, at his retreat in Little Good Harbor, Maine, Day created a community of men and boys, a "summer camp" based upon the altruism described in "The Intermediate Sex." The site of the camp provided Day with an arcadian dream world, in which he executed a number of his latest photographs using themes from Greek mythology and Christian allegory. Little Good Harbor was a seclusionary outback where photographers could "loiter in the open, amid the woods and plains, or stroll along the beach."

In his portraits of young men and boys we find the end result of Carpenter's poetic divinations. The models are the focus of Day's passion, his deep regard for the marginal classes, and his profound interest in raising his models'

prospects. Simultaneously, the pictures operate on a moral plane that challenges any reductivist reading of homosexuality. They help retrieve the complexity and historical context of homosocial interaction, while defining the submerged or hidden element of desire that structures much of Day's other photographs. Realizing that most of the young men invited to Little Good Harbor had little opportunity for exposure to art and literature, he saw that photography was a natural means of introducing them to creative expression, first as models, and later as image makers, when he gave them cameras. The dynamic that evolved at Little Good Harbor empowered Day's models and reveals not merely Day's physical attraction to his summer guests, but the influence of Carpenter's philosophical texts, which advocated mutual tolerance and respect. As Patricia G. Berman has written, "By providing the youths with cameras . . . Day demystified the process of creating images and encouraged them to collaborate in his photographic practice."[70]

The boys who came to Little Good Harbor were not demoralized as passive objects of Day's gaze, nor victims of sexual mastery and control. Rather these protégés assumed a collaborative role in image making. The summer camp album pages published here, and the more fully develpoed portraits of young men, to be discussed later, show an interest in youthful beauty and masculine sensuality that expresses Carpenter's philosophy. Little Good Harbor housed a rare exchange that ultimately benefited Day and his models. While it provided the visitors a chance to develop social, intellectual, and artistic skills, it also gave Day the atmosphere for his most ambitious photographs of the male nude.

These images along with his sacred subjects, and his portraits, reflect an aesthetic ideology that derived from the utopian and philosophical texts that British Decadence intellectually relied on and championed. We shall see that Day not only grasped the views advanced by Pater, Symonds, Wilde, and Carpenter, but let them inspire his art and life with abandon. Although their texts have been largely overlooked in relation to Day, these four writers may be seen to have formed the intellectual framework of the photographer, who was driven to excel in a society that would have completely misunderstood him. The overwhelming spiritual and social questions that Day faced in the late nineteenth century became guideposts to photographic representation. They allow us to piece together his disparate images in portraiture (*The Question*, *The Novice*), allegorical and mythological images of the nude (the *Orpheus* series; *St. Sebastian*; *Beauty Is Truth, Truth Beauty*), the sacred

subjects, and the nearly forgotten meditative and occultist photographs (*The Lacquer Box*, *The Vigil*). Day was an aesthetic juggler, constantly borrowing. As this text will show, in Day's art a sophisticated vocabulary of art-historical quotation and literary analogue converge in a visual response to culture which is impressive in its complexity. Willing to stake his individuality by expanding the notion of photographic artistry, Day must be given credit for the range of his vision, and not criticized for its marginal narrowness.

The Truth of Masks: Self and Other in Day's Portraiture

In his essay "Truth of Masks" (1878), Oscar Wilde wrote of the contradictory nature of art and the falsity of universal truths. To explore the "truths of masks," Wilde argued, is to acknowledge their opposite, the invisible and hidden world beneath the surface of all things. As the German philosopher Arthur Schopenhauer had theorized in his *World as Will and Representation* (1819), "reality" is simply a succession of illusions and masked appearances that link the exterior world to our erotic impulses. What we choose to reveal, Schopenhauer believed, is only a veil for the transitory nature of self-will and desire.

Day's portraiture rests upon similar notions of the mask and the flux between artifice and reality. He argued in "Portraiture and the Camera" (1899) that "a likeness and a portrait are far from being one and the same."[71] Between sitter and photographer was a space for collaboration that challenged the notion that the camera was exclusively for recording, a technique unsuitable for art. Day's portraits suggest a ceaseless desire to beautify, but in them he sought to penetrate the mask, to uncover the eroticism suggested by Schopenhauer. Day's portraits communicate something beyond modernity; for him, faithfulness to detail was reserved for science: "The truth of art is a truth of ensemble," a search for the proper visual synthesis. "And if it chance that [the] picture is beautiful, by what name shall we call it? Shall we say that it is not a work of art, because our vocabulary calls it a photograph?"[72] This argument applied to portraits that surpassed resemblance but were daring constructions expressing a higher order of awareness.

The inward, reposeful gaze and, alternately, the piercing eye contact Day made with his portrait sitters allude to the fin-de-siècle search for the soul, and how it molded the face, its contours and lines. But these features, the glazed, sometimes hallucinatory look that we find in Day's por-

traits, such as *Pepinta* (c. 1899), *Zaïda Ben-Yusuf* (1899), and *Alvin Langdon Coburn* (1901), and the sidelong glance that avoids the viewer in many of his portraits of young men, also bring to mind suffering and the potential loss of spirit. The collision of individual interests with the disruptive and intrusive character of science and technology in Day's era created profound uncertainty and anxiety. The emotional and psychological intensity in many of his portraits is underscored by a clear sense of alienation that lurks behind contemplation and reclusiveness. In *Mrs. Cora Brown Potter* (1897), the model's downward glance, accentuated by the darkened chamber in which Day has placed her, does not fully suggest wariness; neither does it display any sense of promise. Bathed in crisp white light, Cora's face and eyes trace a line to her clenched hand, tightly gloved in suede. The portrait shows inner discovery almost as a means to ward off the shock of modernity.

As for Julia Margaret Cameron, the British Pictorialist photographer of the 1860s and 1870s whom Day greatly admired and even identified with, calling her the "fore-runner [of] artist photographers," for Day physical beauty was the testimony of transcendent spirit.[73] Day and Cameron approached the portrait similarly, first by subverting its aim of mere bourgeois resemblance, and then by discovering new kinds of beauty in imaginative categories and character types. Simultaneously earthbound and heavenly, their subjects share masculinity and femininity as well as natural and supernatural worlds. In Day's portraits such as *Youth With Winged Hat* (c. 1907), and *Young Asian Woman* (c. 1895) gender became blurred as the photographer refined a more universal comeliness. The line of the brow, the bridge of the nose, and the curves of shoulder blades, cast beauty in terms that abstracted gender, but never relinquished an erotic allure. What ultimately links these portraits with Cameron's is Day's use of the beautiful face as a kind of specter of soul, where the face seems to be an involuntary vision emanating from an immaterial world.

For Day, as for Wilde, the "truth of masks" is a paradox. The photograph exemplified this by arresting the specter, the fleeting apparition or spirit. The conventional face of modernity was simply a mask that individuals were forced to wear in everyday life. The mask of modernity repressed emotion and the internal drama found in every person. These subtle characteristics were not always appreciated. More often they were misunderstood. As Sadakichi Hartmann ambivalently noted in his article "Portrait Painting and Portrait Photography" (1899):

There are passages in [Day's] portraits which are exquisite, but all his representations lack simplicity and naturalness. He has set himself to get painter's results, and that is from my view-point not legitimate. He has pushed lyricism in portraiture as far as it can be without deteriorating into mannerism; even his backgrounds speak a language of their own, vibrant with rhythm and melody; they are aglow in the darkest vistas.[74]

In representing "reality" and quasireality, material and spirit, the portrait photograph, for Day, was no mere playing with truth or falsehood, but an elaborate staging wherein metaphor was directed to emphasize individuality and difference. The "darkest vistas" found in Day's portraits reflect his own self-projection, even as he utilized the ideal beauty of his sitters to pass through "reality." If these representations troubled discerning critics, such as Hartmann, it was because they resisted the simplicity of "accuracy," and the "truth" of detail. Day's portraits were counterrepresentations to the Victorian stereotype of replication of externals that still dominated in the 1890s. Day's figuration of beauty was suspected of capriciousness; it came too close to the opulence and voluptuousness of European *l'art pour l'art* and the depraved aura of British Decadence. Beauty threatened when it betrayed the trace of Eros.

OF MEN AND BOYS:
DAY DREAMS OF ETERNAL YOUTH

Day's portraits of young men and boys dating from the mid-1890s show attractive and magnetic subjects. They help to establish a definitive approach to beauty born of personal aesthetic concerns and masculine sensuality. The sitters garbed in uniforms, hats, and playful attire, a fair number of the portraits speak to an classical ideal of youthful masculinity foretold by Pater, Symonds, and Carpenter, but they also underscore Day's interest in the working class and in diverse ethnic communities. Subtly, these portraits affirm the aesthetic continuity of Day's photography, but often suggest an unconscious attempt to satisfy something more profound by recapturing and celebrating youth, and indulging in its inherent sensuality. Day looked to Winckelmann, for whom "Ideal beauty, for the Gods, derived from the natural beauty of perfectly built boys." As many of these portraits show, Day's response to youthful male beauty and its photographic preservation resembles Wilde's *Picture of Dorian Gray* (1890), a novel in which the main character seeks a new hedonism by hopelessly attempting to retain his handsome face. Like Dorian, Day's young models exemplify what Wilde called the "glamour of boyhood." The late-nineteenth-century taste for suffering in the realm of

artistic sacrifice, as Wilde's life attested, is here commingled with eroticism and, at times, fatal beauty. The boys' fair and effeminate features often read today as androgynous. These subjects are at once immaculate and pretty, vulnerable and manly. Their smooth, angelic features evoke melancholy and loss, ennui and death. At the same time they display the classical ideal of passive beauty and strength in equipoise. Day's young heroes are valorous, sensitive, and sensual. Their uplifting spiritual character suggests inner resolve and youthful optimism. Projected desire layered with male subjectivity results in a fantasy of eternal companionship and brotherhood between men. These works show Day as director and collaborator, identifying with his impressionable young fold, while his money and privilege restored to the young men a sense of stability.

In photographs of around 1900 showing the model tentatively identified as Nicola Gioncola, the effeminized features of boyhood combine with the promise of mature masculine beauty. Nicola is neither a little boy nor a man ready for the rigors of adulthood. With an interior, peaceful gaze that recalls the portrait of *Mrs. Cora Brown Potter*, Nicola's visage is more languid, beaten back, as it were, by the reality of his humble urban origins. As a fallen angel "worth saving," Nicola emits a casualness and a serenity that do not appear in the portrait of Mrs. Potter. Day had "adopted" Nicola as a protégé, and Nicola became a commercial artist. For over twenty years the two corresponded; Nicola continually thanked Day for his generosity. "I will always remember you for all of the good you did for me and my people," he wrote. "For I know now you have been a man without equal for goodness when you first started me in my enterprising decorative dreams."[75] Day's portraits give an optimistic glow to Nicola's roguish veneer. Day removed the stigma of urban depravity and recalled in Nicola the full potential of youth, which, in fact, was realized through Day's transformative philanthropy.

Wilde's "Truth of Masks" offered a theater of emotion to Day as a portraitist. As the dramatist wrote: "One of the facts of physiology is the desire of any very intensified emotion to be relieved by some emotion that is opposite. Nature's example of dramatic effect is the laughter of hysteria or the tears of joy."[76] Emotional tension, derived from the to and fro of artist-model interaction, became an emblem of Day's portrait style. As Petr Wittlich observed of the visual culture of the fin-de-siècle, "Emotions were not just experienced, but deliberately worked up, and on occasion, even artificially stimulated."[77] It is easy to imagine Day urging his models to explore the potency of emotion,

to enliven the internal spirit subsumed by the banality of ordinary existence.

Day expanded the many-faceted relationships that developed between him and his young models in his portraits of Kahlil Gibran, who was to become a noted poet and author. In the earliest of Day's portraits of the young Gibran, the sitter wears an Assyrian costume that hardly conceals his waiflike appearance. His delicate hands clutching a staff, he is sullen and forlorn. This expression would change as mutual trust and admiration developed between photographer and model. In Day's later portraits of Gibran, there is a more forceful aura of confidence, self-awareness, and intellectual intensity. In two portraits of 1897 published here, Gibran wears a formal corduroy suit. One image shows the young boy peering passionately into the camera lens, his index finger buried within his thick black hair, and his hand sensuously touching his temple. Compared with the earlier portrait, this one suggests a maturing friendship and increasing trust. Day provided similar settings for other young men and boys, conspiring in portrayals that shed the "mask" of social "reality" and convention. By offering his sitters a collaborative role in his photographic dramas, he made the portraits transformative, a way to transport his young models' visage to a higher level of honor and nobility. Beautified and refined by his soft-focus effects and fine printing techniques, these young men and boys were not simply physical models for the camera; they became social models, prototypes for Day's utopian world of dreams.

Gibran first came to the photographer's attention in 1896 as an exotic immigrant boy with talent who was threatened by depravity in Boston's slums.[78] Day agreed that Gibran needed an "an artistic education" and became his mentor, introducing the boy to art and literature, assisting him financially, and inviting him to join others during summers at Little Good Harbor. For Gibran, the portrait sitting was an inspirational moment, and an opportunity to bathe in Day's attention. According to Gibran's daughter-in-law, Jean, "Kahlil in particular fortified his self-image and sought to overcome the reality of a poverty-stricken childhood."[79] Collaborating with Day, he sought "nobility and lineage."

At the same moment, Thomas Mann was expressing the effect of losing oneself in the sight of youthful male beauty. Like Day's, the German novelist's desire revolved around Platonic notions that dismissed racial and class barriers. Recalling an encounter he had had in 1911, Mann wrote:

Passing the plant nursery I was pleasurably smitten by the sight of a young fellow working there, a brown haired type with a small cap on his

head, very handsome, and bare to the waist. The rapture I felt at the sight of such common, everyday, and natural "beauty," the contours of his chest, the swell of his biceps, made me reflect afterward on the unreal, illusionary, and aesthetic nature of such an inclination, the goal of which, it would appear, is realized in gazing and "admiring." Although erotic, it requires no fulfillment at all, neither intellectually nor physically. This is likely thanks to the influence of the reality principle on the imagination; it allows the rapture, but limits it to just looking. [80]

The dream of eternal youth preoccupied Day as it had Mann. Made in the "rapture" of his imagination, these portraits underscore Day's own fascination with "gazing and admiring." As the narrator of *Dorian Gray* remarks: "There was something in [the] face that made one trust . . . at once. All the candor of youth was there, as well as all youth's passionate purity."[81] Day refined the act of looking with the imagination, with a goal of uncovering the inner soul of his young male sitters.

OTHER VICTORIANS: WOMEN

It seems that Day had always been surrounded by intelligent, challenging women as social counterparts. His own mother, overly domineering, was nevertheless one of these. Beginning chiefly with the literary clubs he joined in his teens, and at the Chauncey Hall School, these relationships seem to have shaped his response to feminism and gender equality. It is difficult to imagine that Day was ever an anti-feminist threatened by the "new woman" of the 1890s and her freedoms. Counted among Day's closest confidantes and intellectual sparring partners were the Boston poets Louise Imogen Guiney and Alice Brown; the artists Ethel Reed, Gertrude Käsebier, and Zaïda Ben-Yusuf; and a frequent guest at Little Good Harbor, Beatrice Baxter Ruyl. In his twenties Day had been a favorite of Louise Chandler Moulton, a grand dame of Boston society with numerous literary contacts in England. The close relationships Day maintained with these women suggests his undying respect and admiration for them. He was intellectually drawn to the high drama and flair of his female models. Day strove to reveal their spiritual qualities, and at times their sensuous and erotic appeal. Each female portrait, like those of the males, challenged the falsity of stereotypes and masks.

In his construction of femininity, Day was interested, like all portraitists, in his sitter's relationship with society. But he was also fascinated in her resistance to it. The works depicting the model referred to as "Papinta" suggest Day's synthesizing process, which infused psychological intensity with dramatic artifice. Papinta, a stage dancer who per-

formed at Boston's Keith Theater in 1896, posed in several of Day's theatrical portraits, at times as a draped muse or chiton-clad pagan goddess. Her exotic features could evoke Greece or North Africa, ancient Palestine or Turkey. Her dark skin and hair and wide, peering eyes convey a powerful exotic presence. In the most straightforward of Day's portrait studies of her (c. 1900), the photographer's source of light beams from Papinta's eyes as she stares into the camera lens. Wrapped in a dark and heavy mantle, with her hair in a wild state, Papinta exudes a marked ambivalence between a late-Victorian spinster, a model of chastity, and a repentant Magdalen. Papinta represents not the prudish "ideal type" that Rupert Hughes admired in Day's celebrated portrait image, *Hannah* (1895), but a free spirit at odds with propriety.[82] Like Cram's character Aurelian, Papinta signaled a new, liberal age, oblivious to the increasing loss of individuality.

In *The Question*, which appeared in an 1898 issue of *Godey's Magazine*, Papinta offers white and red roses to a plaster bust of a maiden, as if to some oracle. The roses signify many qualities — virginity, chastity, and the triumphant fulfillment of love. They belong to Venus and to Mary, mother of Christ. Beauty is timeless and ethereal. An eroticizing tension is built up, with Papinta gazing at the statue as if it possessed a secret. Day seems to want the aura of her hair, wispily shrouding her face, to suggest an unanswered question. Papinta has the elusive nature of the mask. Her figure asks what lies beneath the surface of appearance. As she peers deep into the eyes of the statue, Papinta's concentration is like that of meditation or prayer. It calls up something from the past, a moment lost and forgotten.

Womanhood in Day's portraits appears unhampered by contemporary discourse, which divided the sexes, and redemptive of Victorian social repression and convention. The debates concerning the intellectual differences between men and women in the 1890s seem never to have come between Day and his female collaborators. But neither were these models the "private and passive" women desired by Henry James's male protagonists in the novel *The Bostonians* (1886). If these women were in fact the "angels" of any bourgeois Victorian household, Day rarely shows it.[83]

For Day, motherhood could also be beautiful, but it was a role few of his models wished to play exclusively. In a few instances he utilized the motif of the nursing mother, but he always gave it a contemporary feeling. Gertrude Käsebier had stated that a "woman never reaches her fullest development until she is a mother."[84] Day's photographs picturing maternity evade this declaration, and any allusion to the

"new" Mary archetype of maternal love and sexuality found in Käsebier's *Manger* (c. 1898) and *Blessed Art Thou Among Women* (1899). For Day, such images of motherhood, however moving, only confirmed women's conventional social roles. They affirmed, by comparison, the greater freedoms men enjoyed, which the women of his circle aspired to.

Day's brand of feminism in many of these portraits was not based on a woman's triumph over oppression and suffering. He portrayed a type of womankind without borders or restraints. The women Day chose to photograph emitted strong will and inner confidence. His portraits of them show an interest in the soul of the opposite sex, no less a fascination with physical glamour. But these portraits never display the raw or fleshy sensuality evident in his portraits of young men. With female nudity not even a consideration, a woman's nature, her bodily features and physical attributes, were of less concern, unlike with Day's colleagues, Clarence White, Frank Eugene, and Alfred Stieglitz, who confronted all females as they might a lover. Day's portraits of women underscore the photographer's interest in deeper, otherworldly concerns, using surface beauty to convey internal drama.[85]

ORIENTALISM AND DAY'S PORTRAITS OF BLACKS

Day began photographing people of color in Boston in the mid-1890s, a period marked by increasing racial tension and polarization. His own mythological conception of the black race leads us to explore Day's orientalism, and how popular stereotypes of Africa were informing his imagery. In *Ebony & Ivory* (1897), his most important photograph depicting race, Day's black-skinned model sits in profile, his head cocked slightly away from the viewer. As he perches gracefully upon a leopard skin, his defined musculature and the luster of his body contrast with the bright white marble replica of a dancing satyr the man holds in his right hand. The photograph signals the nexus of the Christian and Greek worlds with the world of ancient Africa. By juxtaposing the seminude body with a classical symbol, Day established the dualities of nature and culture, and black and white. *Ebony & Ivory* underscores his sophisticated process of conceptualization, and his conscious appropriations from the history of art. Although in one of the variants of *Ebony & Ivory* Day directly quoted Hippolyte Flandrin's well-known composition *Jeune homme nu assis au bord de la mer* (1835–36), in which a bronzed young man sits on a seaside rock, the published version of the variant image had the black man's back turned slightly away from the viewer. Utilizing animal skin, Day made an allusion to

Saint John the Baptist, the forerunner of Christ. But the leopard skin also alludes to the indigenous wildlife of eastern Africa, and the colonial white man's recreational safari. Day's use of this motif seems not only exotic, it creates pictorial and ideological tension. It has been suggested that he was responding to the colonial events in Ethiopia by depicting the sitter's Africanness and his loss of identity.[86] But *Ebony & Ivory* also signals aesthetic immersion; it is an exercise in technical mastery for artistic effect. In the context of pictorial photography at the century's end, this powerful, yet highly problematic, image seems deliberately ambiguous.

That Day was aware of the colonial conflicts in both Ethiopia and Algeria has been reasonably well established.[87] Based on the evidence we can mount a defense for Day's visual response to these conflicts. Nevertheless, the nature of colonialist representation and new awareness of colonial hegemony in Africa and the Middle East suggest that the problem of interpreting photographs such as *Ebony & Ivory* is extremely complicated. Although the historical record details Day's altruism and philanthropy, his social work, and a true interest in the life history of his models, photographs such as *Ebony & Ivory*, *An Ethiopian Chief* (c. 1897), and *Youth in North African Costume* (c. 1907) are intermediated with profound contradictions. They show Day's complexity by neither implicating him in gratuitous stereotyping nor extricating him from the discourse of colonialism. With a long history of colonialist domination and control, the United States and Europe constructed their own, eroticized view of the nonwestern world. These remote regions were seen as exotic, savage, feminine, or submissive. Exemplified by paintings such as Jean-Léon Gérôme's *Slave Market*, a whole genre of representation existed that Day would have known. But now it became interesting within homosocial contexts. As Todd D. Smith has pointed out, the collective perception of the Orient, Arabia, and Africa as sites of promiscuity, pederasty, and sodomy was predicated on a succession of literary fabrications that began to appear in the mid-1880s.[88]

Ethnocentrism and cultural arrogance often served as the underlying motif in this literature. In books such as Sir Richard Burton's *Sotadic Zone* (1885), a stereotype evolved which suggested that sodomy, or "the Vice," was a prevalent and "endemic" feature of the Orient. According to Burton, homophilia was a regionally specific phenomenon of the Sotadic Zone, and offered proof of the "blending of the masculine and feminine temperaments."[89] This titillating hearsay rendered Algeria and Morocco, much like Venice and the Mediterranean, particularly popular as cruising

grounds for American and European men seeking sexual intrigue.

In 1901 Day and Alvin Langdon Coburn "toured" Algeria on a so-called wild spree.[90] Possibly attempting to meet André Gide on this trip, Day, like the young French writer, had long been captivated by the region and its erotic allure. Gide had first ventured to Tunisia in 1893, returning to Paris changed, willing to explore his sexual attraction to the same sex. It was on his second sojourn to North Africa that Gide encountered Oscar Wilde, who thereafter became the mutual point of contact between Day and the young Frenchman. Wilde once expressed to Gide that "while metaphysics had but little real interest for [him], and morality absolutely none, there was nothing that either Plato or Christ had said that could not be transferred immediately into the sphere of Art."[91] Although it remains speculative whether Day actually met the writer, the imagery in Gide's *Immoralist* enraptured the American, and became a prominent focus in his photographs exploring North African themes. Published in an edition of 300 copies in June 1902, *The Immoralist* concerns the homoerotic awakening of its main character, Michel, who realizes he is particularly aroused by Arab boys. Slow to recognize his "unsuspected faculties," Michel, unbeknownst to his wife, leads a double life that advanced "every day into a richer . . . more delicious happiness."[92] Michel's "preferences" suggest a level of sexual ambiguity that paralleled Gide's. In Michel, Day saw an aspect of himself, a passive voyeur cataloging the sensual features of boyish Arab beauty. "Can I really be interested in such things?" Michel asks his conscience. "His feet are bare, his ankles lovely, as are his wrists. His hair is shaved in Arab fashion. . . . The *gandoura*, sliding down, reveals his delicate shoulder. I must touch it."[93] The narrative that unfolds in Gide's sensuous text was for Day another dream of utopia. It reflected a sense of sexual ambiguity and erotic complexity that the photographer could identify with; he would explore it in his photographs of blacks and Arab "types."

Ebony & Ivory and *Youth in North African Costume* operate in a pictorial traffic of homoerotic desire, but one in which Day's subjectivity was ever shifting and unfixed. Alternating between mastery and submission, Day, as a photographer, was acting out a fantastic scenario. As a model himself, garbed in exotic attire, he also engaged in a form of colonial discourse that drew from stereotypes of race and ethnicity. Until 1905, when the Hampton Institute portraits were created, Day's ambivalence, his fractured and destabilized identity alternated between colonial oppressor and liberator, cultural elitist and ethnic enthusiast.

Day's philanthropy, as suggested, was an effort to enrich the material lives and well-being of those he met. Day's benefaction of Alfred Tanneyhill, his black chauffeur and servant, and Tanneyhill's family, illustrate that his deep respect for all races was universal. Indeed, Tanneyhill's story informed Day of the tenuous economic and racial struggles faced by African Americans after the Civil War. Day's sensitive, yet penetrating portraits of young black men, women, and children exemplify his desire to render the peculiar anguish of his sitters. Day was equally interested in the noble qualities and innate goodness that gave these blacks the strength to overcome oppression. The portraits Day executed at the Hampton Institute mark a departure from the stylized work of Frances Benjamin Johnston, who, five years earlier, had created *The Hampton Album*.[94] Conceived to show the progress that ex-slaves and Native Americans could make with access to education, Johnston's fabricated tableaux lack the sense of pride, strength and individuality that many of Day's portraits convey. The latter show Day in a more direct confrontation with popular perceptions of race and color. These photographs are neither stylistically constructed in the manner of Johnston, nor are they the clichéd representations of the ex-slave that still circulated in the print media. They suggest Day's move away from a mythological construction of race found earlier in his Nubian series, *Ebony & Ivory*, *An Ethiopian Chief*, and *The Smoker* (1897).

The shift in Day's image of blacks is readily apparent in photographs such as *The Young Woman and Girl in White Dress* (c. 1905) and the luscious portrait image *Girl with White Collar* (1905). In the former, which Day executed while visiting the elementary school affiliated with Hampton, a young girl stands before a draped window, her white dress bathed in intense sunlight. She stares at the photographer without intimidation. Before her, and partially obscured by shadow, is an older black woman, perhaps the girl's teacher, whose crossed hands and relaxed posture give a sense of compassion and warm interaction. Like *Ebony & Ivory*, this photograph manifests the full range of tonalities, contrast, and subtle lighting effects that distinguish Day's work. *Girl with White Collar* is a remarkable image capturing all the beauty of race and color, youth, and its potential future. Day emphasized the young girl's soft African features. She sits humbly, but her round eyes and semipursed lips reflect the ambient light, giving her confidence. An undeniable rapport of sitter and photographer issues from the photograph, as we sense Day's fatherly interaction with the child. Compared with the robotic paragons in Johnston's *Hampton Album*, Day's little girl transcends the message of educational promise

and familial order. But like Johnston's photographs, Day's underscore his belief in the marginal classes, and his utopian commitment to a world of racial equality and harmony.

PICTURING THE OCCULT:
DAY'S PSYCHIC PORTRAITS

Day's youthful fascination with the occult and the magical practices of psychic research further emphasize his interest in revealing the soul of his portrait sitter. These photographs give visual expression to the hidden aspects of an individual masked by modernity. This fascination also helps explain Day's questioning of traditional spirituality and belief systems. The photographer's use of symbolist imagery in the last half of the 1890s was fostered, in part, by the symbolist fascination with death and the afterworld. But mysticism held other curiosities. Narcotics, most notably hashish and opium, were a prominent feature of late-nineteenth-century occultist activities. From the atmosphere evoked in Cram's *Decadent*, as well as his autobiography, we learn that Day and his friends moved in circles that were hardly removed from the excesses of such "artificial," drug-induced dream realities. "Opium and Burgundy are not faultless substitutes," *The Decadent*'s protagonist, Aurelian, states, "but – they do very well – for the time."[95] Aurelian, Cram's literary allusion to Day, was an opium addict, who stood accused of "debauching" his young protégés with the drug. Cram denied drug taking by the occultist societies in which Day was a prominent participant. He stated, rather defensively, that "the smoke, which was indeed dense, was innocent of any aroma other than that of pipes and cigarettes, or, on occasion, the lingering perfume of incense."[96] Whether Day, his friends, or his portrait sitters actually used drugs remains speculation. But certain portraits of Day himself, discussed later, suggest the photographer did little to discourage this perception, or rumors circulating about the "queer sort" of practices in which The Pewter Mugs or The Visionists were engaged. In *Paradis artificiels*, a work that significantly influenced Symbolist thought, Charles Baudelaire, a self-declared opium user, wrote that "natural things exist to only a limited degree; reality lies only in dreams."[97] For Day, who was more than a curious enthusiast of the occult, drugs, the hypnotic gaze of self-discovery, and dream worlds constructed through photographic representation were legitimate means to extricate the soul from "natural" reality as Baudelaire knew it. As Charles Morice was to write in *La Littérature de tout à l'heure*, occult practices formed "one of the principle cornerstones of Art. Every true poet is instinctively an initiate."

It is certain that Day had been exposed to theosophist teachings and ideologies in Boston, and that in the early 1890s William Butler Yeats had introduced him to the Order of the Hermetic Students of the Golden Dawn, a cabalistic society.[98] However, as early as 1884, when Day was twenty, he began correspondence with the Boston-based American Society for Psychical Research (ASPR). The ASPR had already attracted attention for its work hailing the significance of dreams, hallucinations, telepathy, ESP, transference, and other paranormal phenomena. Day was intrigued by the ASPR's findings, hardly extraordinary given the immense numbers of people who followed spiritism at the end of the nineteenth century.

What was unusual, and indicative of his deep interest in spiritism and the occult, is the correspondence Day maintained with Mrs. Leonora E. Piper, an "extraordinary sensitive," who, like Day, was "a quiet seeker after the meaning of the new spiritualism."[99] Day became a friend of Mrs. Piper, and often invoked her powers as a medium and spirit voice. The friendship lasted for several years, as Day's visit to the London-based Society for Psychical Research coincided with Mrs. Piper's residency there in 1889.[100]

The Lacquer Box (c. 1899) and *The Vigil* (c. 1899) suggest that Day's interest in psychic forms of spirituality were not passing fancies. Ideologically speaking, there is little separating these two images from Day's *Crucifixion*, *Seven Last Words*, and mythological and allegorical photographs of the male nude. All are instructive in interpreting Day's collaborative portraits that reveal the invisible side of the sitter, the subterranean "truth" masked by the mores of modernity and its spiritualless materiality.

In *The Lacquer Box*, Day's model stares into the camera with an intensity that borders on madness or hysteria. A young man, dressed in a dark, flowing robe, perhaps the same robe that Day would wear for Alvin Langdon Coburn, reveals with a mannered gesture a Japanese lacquered box. It was believed that when such a box was rubbed vigorously a spirit voice of the dead would issue from within. Day's photograph conveys the magic surrounding fetishes that gives simple objects a votive quality not far removed from the power invested in images of saints or martyrs. The young man's hallucinatory gaze evokes the power of a higher agent, a force entering his body. Like the portraits of Mrs. Cameron thirty years before him, Day's portrait becomes a conduit allowing mystery into our sight. A testament to the allure of the hidden realm of the unconscious mind, it reveals Day's striking desire to "picture" the occult, and extends Pictorialism to realms of religious ecstasy.

The Vigil, like *The Lacquer Box*, also explores the invisible. The same young man who posed for *The Lacquer Box* sits facing the photographer, symmetrically framed as if to suggest God the Father. He is shrouded with a robe and presents a battle sword of fatal proportions. Perched upon his dais, the young man might be a soldier of the Apocalypse or a mystic leader admitting us to a secret ritual site. Behind the young man appears the lower portion of a crucifix, with the head of Jesus cropped from the frame. Tension is created between the crucifix's position, a large candle that emits a rather blatant phallicism, and the possessed eyes of this young man. Like *The Lacquer Box*, the image is hypnotic. *The Lacquer Box* and *The Vigil* work together to reduce the perceived disparities of Day's work. Like his sacred subjects, they signal the destabilization of identity fostered by the profound spiritual search for the self. With Day's other portrait images, they link the conscious and unconscious, the hidden features of the soul, and forecast Day's eventual retreat from society and reality, and his immersion in a counterworld that celebrated the unknown. Day turned the "mask" inward, onto himself, in a mystical quest for a higher, more tolerant, spirituality.

DAY AS OTHER

Day's self-portraits (and even portraits of him by others) are partially explicated by how artists were psychologically and aesthetically identified in late-nineteenth-century visual representation.[101] Day invested his self-image with the heroic purpose he had found in the literary representations of Keats, Christ, and Plato.[102] But certain portraits of Day suggest that heroicizing his visage was not a singular goal. Audacious, narcissistic, and often pretentious in the best sense of that term, most portraits of Day, by himself or others, show an ideal projection of desired character, an erotic fantasy of otherness. According to Dario Gamboni, "the notion of art and the artist underlying this image lays primary emphasis on originality and individuality: the artist is fundamentally different from other people, and it is by working out this individual difference that he discovers his identity."[103] Often assuming a role or persona, Day had strong preconceptions regarding how he would present himself. Situated within a trend in representation in which the artist used metaphor to depict and emphasize how different his style of life was from the rest of society, Day revealed himself in ways that confused or even threatened critics and observers. Sadakichi Hartmann noted that the photographer's appearance was "extraordinary," and conveyed his "extravagant personality, one that excites immedi-

ate curiosity." Presenting himself as a sailor, a North African sheik, or a black magician, to say nothing of his self-representations as Christ, discussed later, Day suggested desire and autoeroticism. By casting himself in roles mirroring those of his young male models, his was also a fantasy of erotic self-actualization. Presenting himself as a working-class type or character or with nonwhite ethnicity, Day contrived an "otherness" that cannot be explained by his philanthropy alone.

In Alvin Langdon Coburn's famous portrait of Day peering from behind the darkroom curtain (1900), the photographer motions us to enter his incense laden chamber. As if standing guard over some quasireligious sanctuary, Coburn's portrait of Day articulates the inherent contradictions of photographic portraiture and the private/public schism in self-presentation. It suggests Day's rebellion against the ordered, rational mediocrity of modernity. Coburn's portrait gives the impression of Day as a pictorial alchemist, a magician who turns matter into spirit. The darkroom is simultaneously a *chambre noire*, a place where black magic is performed, and the sorcerer's room for transforming light-sensitive paper. Day's visage is a looming specter of death, Coburn's portrait a supernatural evocation of spiritually transformative darkness.

The recently discovered photograph by Clarence White (c. 1897), in which Day stands affectedly before the semi-nude body of one of his black models, shows another obscure side of the photographer.[104] With Day elegantly dressed in black robe and starched cravat, and holding a lighted cigarette, this curious portrait explores notions of self-presentation, exhibitionism, and unrestrained moods he was willing to share with trusted confidantes. It is an image of Day that belies his later photographs of blacks, and his philanthropic work with the Hampton Institute.

In his influential writing on difference and pathology, Sander L. Gilman noted that the "nineteenth century knew that blacks, like Jews, had no aesthetic sensibility. They could never be 'beautiful' objects upon which the sexual gaze was thrown nor could they be the creators of beauty."[105] Although it was already evident that the black body could be beautiful in Day's photographs, White's portrait suggests Day's ambivalence, the artist-creator detached from his model, who hasn't the requisite skills of authorship. The portrait suggests Day's fantasies and his desire to retreat into dreamscape, where endless erotic possibilities exist outside convention. Executed about the same time as *Ebony & Ivory*, White's portrait is consonant with Day's mythological conception of blackness. It speaks to late-

nineteenth-century stereotypes of pathology and disease that rendered the black body dangerous – and desirable. The black body, both male and female, became a paradigm of difference, as Gilman noted, defining "a line between the Self and other." As the antithesis to self – the alter ego of the artist – Day's model becomes a sexual object, distanced, quite literally, in the frame of the image, but also through the proliferating discourse of racism.[106] Day and his model compositionally oppose each other. In doing so, they "mark the absolute boundary between the acceptable and the corrupt," between culture and nature, intelligence and racist perceptions of ignorance.

With his muscular torso exposed, the black model imitates Day's mannered posturing. Extending his wrist to his cheek, the black man is but a phantom in the shadows, standing behind Day's facade of elegance. But he is also a ruse, an object for Day's amusement. By allowing himself to be "pictured" with the eroticized body of a black man, Day locates himself in a position of mastery. Unclothed and seemingly vulnerable, the clowning black man is submissive. Thus, the image lends a twist to servitude in Day's Norwood mansion, underscoring its own profound contradictions.

Coburn's and White's images stand apart from the inward character embodied in Edward Steichen's likeness of Day entitled *Solitude* (1901), wherein the sitter's affected pose of the hand and the glimmering opal ring become defining features of character. With Day's face obscured by the shadow cast by his beret, *Solitude* implies isolation and his increasing withdrawal from photography. The photograph bespeaks a personality alone in a world he would not, or could not subscribe to. Perhaps knowing the fate of Decadence, and following the death of Beardsley and Wilde, and the dissolution of Copeland & Day, Day, in *Solitude*, conveyed to viewers all the tragic consequences of his life and friendships. Cropped tightly to stylize the mass of the sitter's black robe, *Solitude* is a metaphor of asylum and of sacrosanct individuality. It distills the hardened martyrdom evoked by Day's own *Crucifixion* and *Seven Last Words*. In a revelatory display of irreverence, spirituality, and self-deprecation, *Crucifixion* and *Seven Last Words* epitomize a will to suffer that later gave way to solitude. In an age flawed by gross materialism and rampant urbanization, traditional Christianity failed the test of true spirituality and self-discovery. As we shall see in Day's self-portraits as Jesus, Christianity's ascetic, moralizing character would have even less utility for the photographer.

The Sacred Subjects: A Crisis in Representation

With his emaciated body writhing under the sweltering summer sun of New England, Day chose to "crucify" himself for the camera sometime in July 1898.[107] Starving himself for weeks on end and going to extreme lengths to acquire the wooden cross, the elaborate crown of thorns, historically accurate costumes imported from abroad, and the other objects necessary for his martyrdom, Day wasn't attempting to achieve verisimilitude with this historic episode. "Reality" was never a priority in his photography. As the protagonist of *The Decadent*, Aurelian proclaimed, "Realism is the antithesis of art."[108] Day's *Crucifixion* and *Seven Last Words* were symbolic gestures that touched on something far more shocking to the public. A privileged man of the arts known for his relationships with sordid literary personalities such as Wilde and Beardsley could never justify dramatizing this event. Described in 1889 as "five feet nine inches, with a medium forehead, grey eyes, and prominent nose," Day had a slight build, and his carefully trimmed goatee and the pince-nez for which he had come to be recognized, severely compromised his plan to "act" Christ. Associated with British Decadence, Day's public visage possessed all the features of an overrefined and over-mannered effete. More troublesome was his depiction of Christ eroticized, which stressed an expression of ecstatic suffering and rapturous pain. According to one observer, "Norwood . . . sneered or openly talked of having Day arrested for sacrilege" or "immorality."[109] Day would be damned for mocking the historical Jesus.

The prints made from the roughly 250 *Crucifixion* negatives exposed in July 1898 elicited a response from close friends which Day might have anticipated. Louise Imogen Guiney told Day it would be "too hazardous" to exhibit the *Crucifixion* and *Seven Last Words* in Boston.[110] She believed the photographs would prove shocking to the general public. How friends, colleagues, and the public responded to the images when Day exhibited them in Boston in November 1898 is unrecorded. The photographer had requested that those viewing the work render "opinion[s] for or against exhibition," so we may infer that Day felt some anxiety.[111] He must have realized that photographic depictions of Christ, especially of himself as the Savior, might be seen as transgressions, willful acts hostile to Christ's divinity.

In Day's *Crucifixion* we are confronted with an image of the emaciated and attenuated body of the photographer.

With crown of thorns, beard, and loincloth, Day positioned his body to impart to the viewer the writhing pain and suffering of the dying Christ. Doubtless the images are theatrical, but they also possess a sadoerotic quality conveyed by Day's gaunt and seemingly tortured body. In his *Seven Last Words,* Day emphasized the agony seen in the face of Christ with a series of close-up studies that suggest his humiliation. Day's graduated poses intensified the articulation of pain. Exhibited horizontally and in succession, they evoked the motion picture. Image and text, the cinematic effect, and Day's poses rendered the *Seven Last Words* more disturbing than any painted version of the Crucifixion.[112] They show the likeness of a man too close to "real" life, a recognizable face, but one whose ecstatic expression is tinged with eroticism and sexual abandon. It is an expression matched a half-century later, when George Platt Lynes photographed the face of a man in orgasmic convulsions (*Bill Miller*, 1951). For the viewer of 1898, Day's *Seven Last Words* described the facial cast of carnality, a realization of physical ecstasy reserved for the boudoir.

The treatment of the historical Jesus in literature and art had been gaining prominence in the predominantly Protestant United States since the beginning of the nineteenth century. Evidenced by such popular novels as Lew Wallace's *Ben-Hur* (1880), fictionalized biblical stories captivated the American public. But Jesus' life, and the details of his Crucifixion, remained a relatively sacrosanct topic. Up to and throughout Day's time, the humanized Jesus, described in concrete historical terms and settings, was often found blasphemous. It was feared that realistic depictions of Christ, as demystified in popular fiction, would lead to increased secularization. Day recognized the contemporary debates regarding the historicity of Christ and his representation. The inherent risks in depicting this likeness were only compounded by Day casting himself in the part.

Day's photographs came too close to the "real likeness of a real man."[113] They reduced the heroic figure to a recognizable visage, a mere mortal among men, undermining divinity in a mechanical process of light, film, and paper. With the pretext being that "some controversy has arisen regarding the legitimate use of the camera in this field," Day invited the public to his studio to gauge the damage. He recognized the consequences befalling his elaborate production, and was racing to map out a response. Even more surprising to Day was how divisive the *Crucifixion* and *Seven Last Words* were even within strictly artistic and photographic circles.

For the editors of *Photogram*, "the living Jesus, with face illuminated by the Divine Inspiration [was] beyond the power of the camera."[114] Conceding the camera's capacity to record and document the living, natural world, "realism" was in fact the major problem facing these photographs. American photographers had been critiqued most viciously at "The New School of American Photography" exhibition in London (1900) precisely for their willingness to sacrifice "detail" for "strength of effect," to forgo "likeness" in order to produce a "picture."[115] When Day revealed his relatively "straight" images of Christ, a reverse criticism erupted, with writers struggling to articulate why they disapproved. Ironically, these photographs were judged *too* "realistic." Unlike much of his other work, they were relatively untouched or manipulated for painterly effect. In an attempt to avoid contradicting themselves, critics took issue with Day, calling him irreverent and audacious. The British photographer and critic William Crooke derided Day's images of Christ as "little short of blasphemous."[116] Alluding to the popular perception of Day's personal character, Frank Sutcliffe maintained that "Biblical subjects were too sacred to be touched by any but those with the purest life."[117] The "purest" life was defined neither by decadence, nor by Day's reputation in London as Wilde's American publisher. Although he supported Day's artistry and would sit for one of Day's portraits, James Craig Annan responded this way: "While I admire extremely the very excellent work of Mr. Holland Day, I do not think such subjects suitable for the camera."[118]

There was no way Day could satisfy the high-minded goals of Pictorialism and also please those willing to critique the images for their presumed mockery. At the first Philadelphia Salon, in 1898, the noted American art critic Charles H. Caffin wrote: "The limit of mistake is reached by . . . seven heads crowned with thorns, purporting to represent the 'Seven Last Words' from the Cross. . . . Surely claptrap and misappreciation of the province and mission of art can go no further."[119] For Caffin, writing for *Harper's Weekly* about the second Philadelphia Salon a year later, the *Crucifixion* and *Seven Last Words* were "a divagation from good taste" and "intolerably silly."[120] These subjects had "failed" the photographer, as the influential critic Sadakichi Hartmann noted in his article on Day which appeared in the *Photographic Times* in 1900.[121] Such criticism of Day's Christ photographs throughout the international photographic community, Steichen's portrait of Day acquires new meaning. *Solitude* is a manifestation of defeat, and Day's sense of rejection and alienation.

As Christ, Day became what Oscar Wilde called in *De Profundis* "the most supreme of individualists"[122] Day's self-portraits as Christ were not symbols of personal redemption, nor naïvely meant to conceal his own "sinfulness." Rather, they utilized sacred suffering as a critique for what Day perceived as increasing homogenization in his century. Day's photographs turn on the relation of the "true life of Christ" and "the true life of the artist."[123] As a typology of artistic martyrdom, Day's suffering conveyed the alienation and spiritual loneliness faced by those questioning the order of modernity. Like Wilde, Day saw in Christ a spiritual icon whose profundity had been diminished by the "dead rules" of organized religion, prescribed morality, and social convention.[124]

Day's eroticized Christ was a means to subvert ascetic morality and physical proscription. As in his *Saint Sebastian* (1906), the photographer here presented a mythological view of the experience of oppression. The sacred subjects may be interpreted as Day's fantasy of political and social assertion, or of internalized persecution transformed into liberation. *Crucifixion* and *Seven Last Words* are visual responses to personal and professional crisis. This subversive figuration also rests upon Day's critique of the socialized male body, and how Christian asceticism had diminished its sensuality. This was a literary analog that had been resonating for Day since his years at the prestigious Chauncey Hall School in Boston.

In British literature of the nineteenth century emerged a subtextual critique of ascetic morality and Christian denial of the body. As evidenced by his total work as an artist, this critique appealed to Day and later inspired these two series. In his tribute to Keats, "Adonais" (1821), Shelley metaphorically represented the poet's death while presenting Plato's poetic opinions as a "defense of free love" or sexual acquiescence.[125] In the minds of literary figures such as Shelley, Christ was increasingly perceived as a sensual figure consonant with Plato's teachings, and at odds with ascetic behavior and moral and physical prudery. These perceptions fueled radical interpretations of the life of Christ, which by the late nineteenth century, were embedded in the work of such influential writers as Pater, Symonds, Wilde, and Carpenter. Although Keats has been recognized as the preeminent literary influence on Day's imagery, the romantic poet's own critique of ascetic spirituality has never been linked to the photographer's work. With such a large collection of Keats's materials, Day was possibly the poet's greatest idolater. Day knew the poet's influence on Pater, Wilde, and others. Nor could Day have overlooked the

nuance of sexual pleasure and torment found throughout Keats's work. For example, with his publication of "The Eve of Saint Agnes" in 1819, the poet stood against sexual asceticism, contiguously exploring the torments of pain and pleasure, and sexual acquiescence.[126] "The Eve of Saint Agnes" resonates with Keats's poetic conflation of moral crisis and sensuality:

> They told her how, upon St. Agnes' Eve,
> Young virgins might have visions of delight,
> And soft adorings from their loves receive
> Upon the honeyed middle of the night,
> If ceremonies due they did aright;
> As, supperless to bed they must retire,
> And couch supine their beauties, lily white;
> Nor look behind, nor sideways, but require
> Of Heaven with upward eyes for all that they desire.

Viewed through the filter of Shelley, and the literature of British Decadence, Keats's condition of desire further affirmed for Day a mode of life that tolerated spiritual, sexual, and intellectual alternatives. Day's representation of Christ and his visual prophecy of a utopian society that privileged the individual spirit render Keats's influence in a different light. But Day responded to other, more subversive images of Christ in British literature.

Charles Algernon Swinburne's writings have never been examined as they relate to Day's sacred subjects. The vitriol found in Swinburne's figuration of Christ would have appealed to cultured minds busy critiquing organized religion and modernity. As an enthusiast of Swinburne's work, Day proudly presented a letter by the poet at the dedication to Keats's memorial, arguably one of the most important events in the photographer's life.[127] In "Christmas Antiphones" (1871), "The Litany of Nations" (1871), and "Before a Crucifix" (1871), Swinburne invoked the Passion and Crucifixion as a means to condemn the harm that Christianity had brought the world.[128] It was Swinburne who attacked Christ's heroic stature as a spiritual personality. But as Ian Gibson observed most applicably to Day's photographs, "Swinburne's hatred of Christianity is well known but it is not so widely appreciated that it [was] the Christian denial of the body that he particularly resent[ed]."[129] We can no longer doubt Swinburne's appeal to someone such as Day, nor how the poet's rhetoric found its way into Day's photographs. In "Before a Crucifix" Swinburne wrote:

> Set not thine hand unto their cross.
> Give not thy soul sacrificed.
> Change not the gold of faith for dross

Of Christian creeds that spit on Christ.
Let not thy tree of freedom be
Regrafted from that rotting tree.

This dead God here against my face
Hath help for no man; who hath seen
The good works of it, or such grace
As thy grace in it, Nazarene,
As that from thy lips which ran
For man's sake, O thou son of man?

Swinburne's invective was representative of a long history in British literature of subversive, anti-Christian figurations. Having previously been employed in photography as a measure to calm concerns about the exposed male body, Christ's representation was an erotic pretext that confused viewers — it bordered contemporary notions of licit and illicit, pious and pagan, chaste and impure. A transition occurred in representation around the 1880s in which the ambiguities of masculinity and femininity blurred in a new spectacle of the male body displayed in a state of emotional and physical struggle. Confronted with agonized nudity, viewers were also left to reconcile the eroticized body of Christ, partially draped, and in a passive position vulnerable to objectification — a position usually reserved for female representation. As Eve Kosofsky Sedgwick has persuasively argued, in the late nineteenth century it was the figure of Christ that maintained a "unique position in modern cultures as images of the unclothed or unclothable male body, often in extemis and/or ecstasy, prescriptively meant to be gazed at and adored."[130]

As a sacred subject Christ's image offered a veil for the eroticized male body, but as an image of the "agonistic male constitution," it was also a signal of effeminacy and sentimentality.[131] Day's Christ can not be properly interpreted without acknowledging the interplay of these rhetorical issues, and how they link the *Crucifixion* and *Seven Last Words* to the photographer's more assertive, less confining images of the male nude. The crisis in representation brought forth by Day's sacred subjects shows him suffering an ideal epitomized in his later mythological images derived from antiquity.

Final Compensations:
Myth and the Neoclassical Body

The blending of life and art in ancient Greece was a fundamental inspiration for Day's mythological images of the male nude after 1905. Born of an idealizing vision that melded fantasy with pagan mythology, these photographs were his last refuge from reality. Having always aspired to a higher ideal in photographic art, Day let go of his ambition. It no longer mattered to him what people thought.

It has been said that modernity was the most acute manifestation of fear of "decadence," the advancing decline of civilization.[132] What we find in Day's mythological photographs after 1905 is a renewed vigor in representation. The mythological photographs from this period do not retreat from the perceived decadence of neopaganism, but rather embrace it in a death grip. They clutch at the last breath of an era, but in reckless fashion. With his artistic goals failing him, and aware that his utopian dreams were quickly fading, Day made an effort to fabricate a world that offered final compensation. He believed that modernity had been in perpetual descent from the pinnacle of Greek culture. As he had written in 1898, "Since the days of the simple purity and beauty of Greek Art, reflected from the purity and beauty of Greek Life, the race seems to have been steadily retrograding in its manner of viewing both Art and Life."[133] Made between 1905 and Day's self-imposed exile to the Norwood mansion in 1917, his last photographs suggest that he clung to a notion of physical perfection embodied in youth.

The final compensation Day found in myth transcends moral issues. The photographs created between 1905 and 1915 speak to a mythological experience of oppression, alienation, and suffering. Like the *Crucifixion* and *Seven Last Words*, these photographs embody a fantasy of self-assertion and autonomy. They show Day striving for absolute, free-flowing abandon in photographic representation.

Ancient mythology was a vehicle into the hidden world of dreams and the imagination. Mythology was the penultimate hiding place; a realm where male beauty was recompense for the photographer's own spiritual decay. As Dorian Gray, the character of Wilde's famous novel, muses about his own beauty, and how it appealed to the painter Basil Hallward: "It was not that mere physical admiration of beauty that is born of the senses and that dies when the senses tire. It was such love as Michelangelo had known . . . and Winckelmann." In these late pictures Day's love of beauty was similarly eternal. Beauty fostered dream states for him. But as his own body aged and his interest in photography fully waned around 1915, ideal beauty became a harsh reminder of his fears.

As Basil Hallward shudders at the sight before him, Dorian Gray proclaims that "each of us has Heaven and

Hell in him." The "hideous face on the canvas" now smiling at Hallward is not the "marvelous beauty" he once painted.[134] Both men having worshiped an ideal, Dorian and Basil are left to concede the painting's likeness is rather more like a "satyr," with the "eyes of a devil. . . . Through some strange quickening of inner life, the leprosies of sin were slowly eating [Dorian's portrait] away."[135] The portrait of Dorian Gray became a simile for Day when he left photography entirely. It matched his perception of a culture in perpetual state of decline. The final, crushing blow, which would forever change his course in photography, was delivered on November 12, 1904, when fire destroyed his studio. Containing the bulk of his original negatives and prints and large collections of drawings, prints, photographs and other curiosities, the studio became a lost time capsule of Day's life in art.

Day had begun experimenting with mythological subjects long before 1905. In *Hypnos* (1896), one of the earliest photographs, the Greek god of sleep dons feathered headgear, his chest expanding in a moment of sensorial intoxication. The young man's soft, pursed lips touch the bud of a poppy as its stem strains in his hand, and the top of his left nipple is just visible within the picture plane. *Hypnos* alludes to the drug-induced hypnosis of opium, and is an anthem to male youth and beauty. The photograph makes faint reference to oral-genital contact, which doubtless instills the image with erotic tension. As perhaps the most direct of his mythological images utilizing the male body, *Hypnos* enthralled viewers when it was unveiled at the New York Camera Club in 1898. But as with *Beauty Is Truth, Truth Beauty*, the stirrings of an erotic subtext somehow tormented critics. The English photographer-editor A. Horsley Hinton was to write in *Camera Notes* that Day's photograph touched a "deeper chord. . . . He makes one feel – Feel what? Well, I need not attempt to define. Has not my reader listened to music which thrilled him through, and could not have said that such and such music made him feel – Feel what? Simply this, it made him feel."[136] Hinton's was another example of the veiled criticism that would envelop Day's earliest mythological photographs, a double entendre or sleight of hand.

The "purely Greek point of view" that Day was accused of having implicated him in the contemporary debates concerning the legitimacy of the male nude in photography.[137] What developed in his work as a result of these tensions was an "imaginative space" in which mythology, dream, and aesthetic contemplation fostered a more pronounced retreat from society.[138] The subdued eroticism of *Ebony & Ivory*,

Hypnos, and *Beauty Is Truth, Truth Beauty* gave way to even more eroticized, less confining, images. Utilizing the mythological characters of Orpheus and Pan, Day's imagery, after 1905, moved to a less inhibitive sphere, where athleticism converges with emotive male beauty.

Orpheus was the perfect myth for Day. From 1905, until the very last years he remained active as a photographer, he extensively mined the Orphic myth, and in the process created one of his most lasting impressions. Orpheus articulated the dimensions of Day's own troubled past, and his utopian fantasy of the future. According to the myth, the celebrated Thracian musician made such beautiful music with his lyre that wild beasts were soothed into docility.[139] But, for artists such as Day, Orpheus also represented sexual ambiguity and spiritual truth. He merged the symbolist fascinations with adolescence and androgyny. Constructed with the visage of youth, Day's Orphic images neither subscribe to nor negate the classic narrative of Orpheus' death, but rather play into the particular homosocial connotations ascribed to the myth by earlier poets and artists. Posed at his summer retreat in Five Islands, Maine, the young boys of the Orpheus series possess the beauty thought most desirable to the gods. In photographs such as *The Last Chord* (1907), *Nude Youth With Lyre* (1907), and several images in which boys are posed before rocky caves and tree-lined grottoes, Day evoked Orpheus lamenting.

Orpheus gave a pretext to the figure of the male nude, already complicated by the young age of Day's sitters. Safeguarding the ability of his work to be viewed as art, Day rarely depicted his model's genitalia, but rather accentuated and emphasized the smooth, effeminate qualities of their youthful bodies. Their lithe movements, and refined features signal the sensuousness of adolescence. But they are as much symbols of purity, artistic genius, and the inner self, as they are paeans to physical acquiescence, and the love of youth associated with Greek love. As Symonds had written in "A Problem of Greek Ethics": "What the Greeks called *paiderastia* or boy-love, was a phenomenon of one of the most brilliant periods of human culture. It is a feature by which Greek social life is most sharply distinguished . . . in moral and mental distinction."[140] Symonds's justification for the physical and sexual attraction to youthful male bodies had parallels with the proliferation of the visual representation of such themes in decadent art. But like Symonds, Day would have avoided the obvious connotations, preferring instead the noble or high-minded and aesthetic defense of youthful beauty. Although the boy-love relationships were not always "free of sensuality," Symonds

wrote they "did not degenerate into mere licentiousness." Day's photographs retained this proprietary creed. Though the mythological photographs are often highly eroticized, and, at times, connote sexual acquiescence, they do so in a matrix of aesthetic convention through which subconscious desires emerge. They show Day commingling art, life, and nature in their most ideal forms. The Orphic images represent a pinnacle in representation, the precipice from which his work would plunge.

The "satyr" with "eyes of a devil" that Basil Hallward recognized in *The Picture of Dorian Gray* alluded to lecherous depravity, as well as moral and spiritual decline. Wilde's evocation brings to mind Day's images of Pan. Pantheistic, pandemoniacal, and even panicked, Day's images of this Greek god were suggestive of the excess of modern man in the age of the machine. Even more so, they predicted the subsequent chaos of Day's personal life. Commingling the pagan spirit with art-historical precedence, these photographs are at once anthems to desire and resistance to the material age. As D. H. Lawrence wrote, Pan "became the Christian devil . . . who is responsible for all our wickedness, but especially our sensual excesses." Written in the 1920s, Lawrence's essay "Pan in America" is today an eloquent summation of the neopagan spirit so prominent in Day's work after the turn of the century. For him Pan, the old goat, with hoofs, horns, and tail symbolized the power and beauty found in nature, no less the sensual pleasures associated with the ancient, pre-Christian, past. But as the god was often depicted as an ill-tempered, ugly man, who had to be flogged in order to be stimulated, Pan also signaled physical decline.

Day's images of Pan were transformations of the ancient myth. By rendering the lascivious and perverse god with ideal male beauty, Day expressed disillusionment. The aged Pan is remade into the boy-Pan, an evocation of a life that no longer seemed possible for Day. *Nude Man in Woods* (c. 1907), perhaps better than any of the more literal evocations of Pan, evokes the pagan god's shrewd gaminess, his devilish playfulness associated with "sensual excess." Standing amidst thick foliage, Day's model gazes into the forest clearing and what appears to be an open "sanctuary." He appears fully nude, with the warm afternoon sun dappling his soft skin. With his shoulder visible and his left leg partially obscured by underbrush, this youth seems less human than animistic. Like the photographer, he is mutable, as if in the throes of a metamorphic change. With pointed nose and ears, dense, curly hair, and the markings of a nascent beard, the young man's face bears the stereo-typed appearance of Pan. But he is a fiendish illusion to a moment gone by. The youthful Pan is a mockery of both the past and the future, a signal of fear and of self-loathing.

Even though Day was in a state of spiritual decay when he made this photograph, it ranks among his most beautiful images. *Nude Man in Woods* summons desire, the erotic dream of masculine beauty that Day felt was continually distanced by age and spiritual confusion. As Lord Douglas, the infamous lover of Wilde, mused in his poem "Hymn to Physical Beauty," one of a collection of poems sent to Day for publication in 1896, "the untrammeled shapes of glorious nakedness" and "the curve and line of sun-browned youth, must hide."[141] Like Orpheus, Pan offered compensation for a life sacrificed to ideal beauty.

Though Day could not have realized it in the summer of 1889, the Norwood mansion was to become his private keep, a veritable asylum in which, after 1917, he hid from the outside world. Busying himself with his family's genealogy and the details of local history, Day removed himself from photography as if he had never been interested in it to begin with. He divorced himself from the medium; it was the culmination of a slow decline that had begun with the opening years of the twentieth century. Having given up all the aspirations his privileged life had once permitted, Day turned away from the aesthetic that earlier had branded him as decadent. He became the decrepit satyr of Basil Hallward's portrait of Dorian Gray, given over to a "happy state of hypochondria."[142]

With his mother's death in July 1922, Day's decline accelerated, as his physical and mental health began to deteriorate. "Are you all alone in that large Norwood house?" a friend wrote to Day.[143] In his mother's absence, and with their sometimes antagonized relationship finalized, Day "swathed himself in blankets pinned with meticulous care about his wrist."[144] He stayed in bed for weeks on end, declining to see guests. After 1923, his state of mental and physical deterioration belied the aesthetic to which he had always aspired. Reducing "physical effort to a minimum . . . nursed, nourished and waited on by devoted attendants," Day remained bedridden, his accomplishments "comparable to the perpetual egg-laying of a queen bee."[145] He had suffered his ideal long enough. Diagnosed with cancer one year before, Day died practically forgotten as a photographer on November 2, 1933.

PLATES

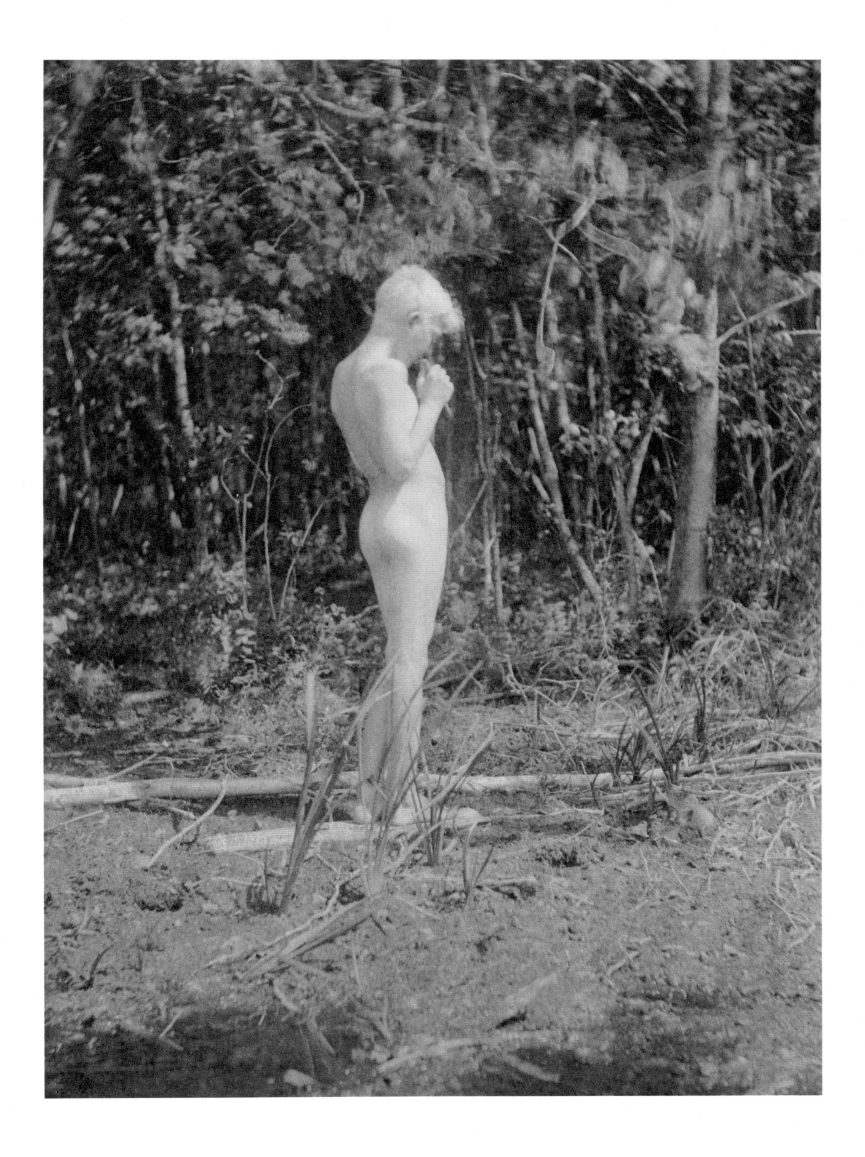

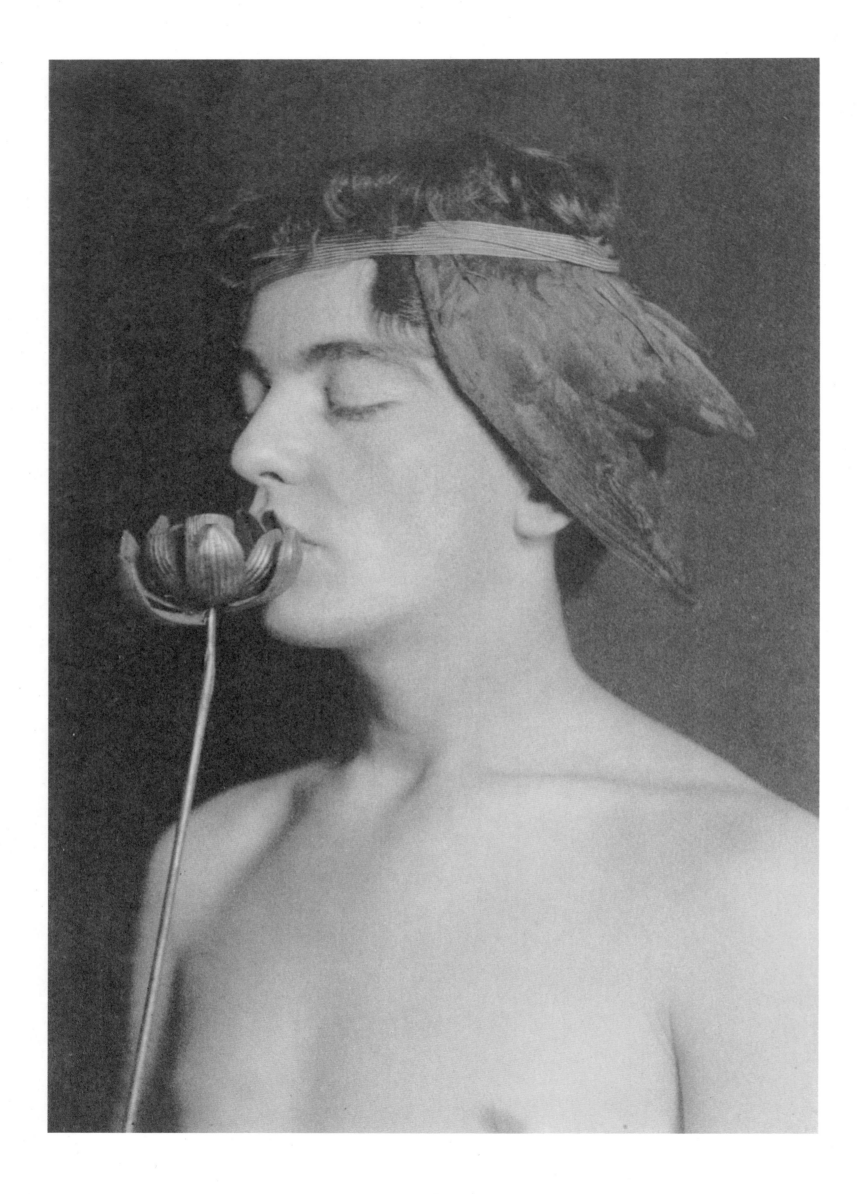

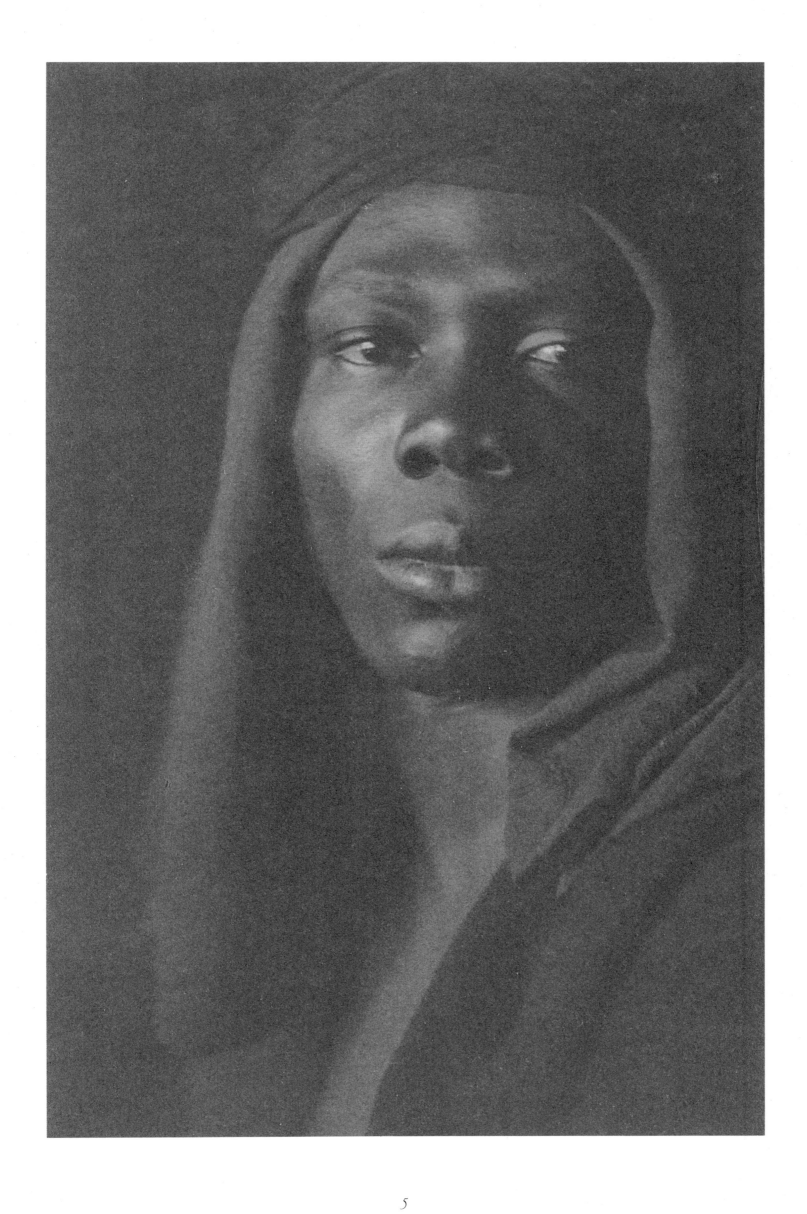

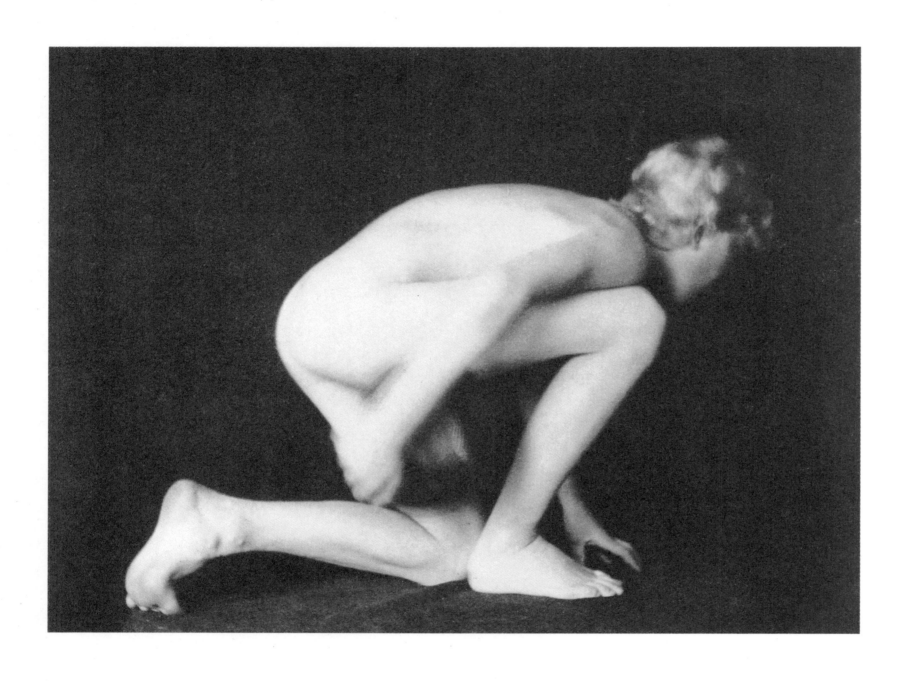

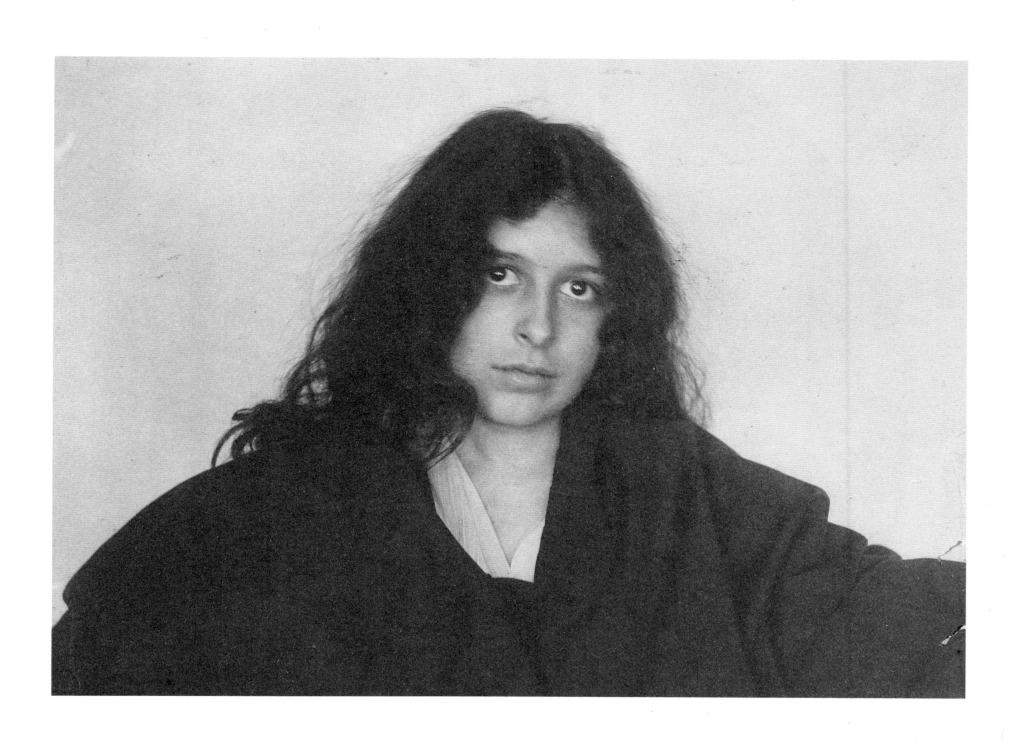

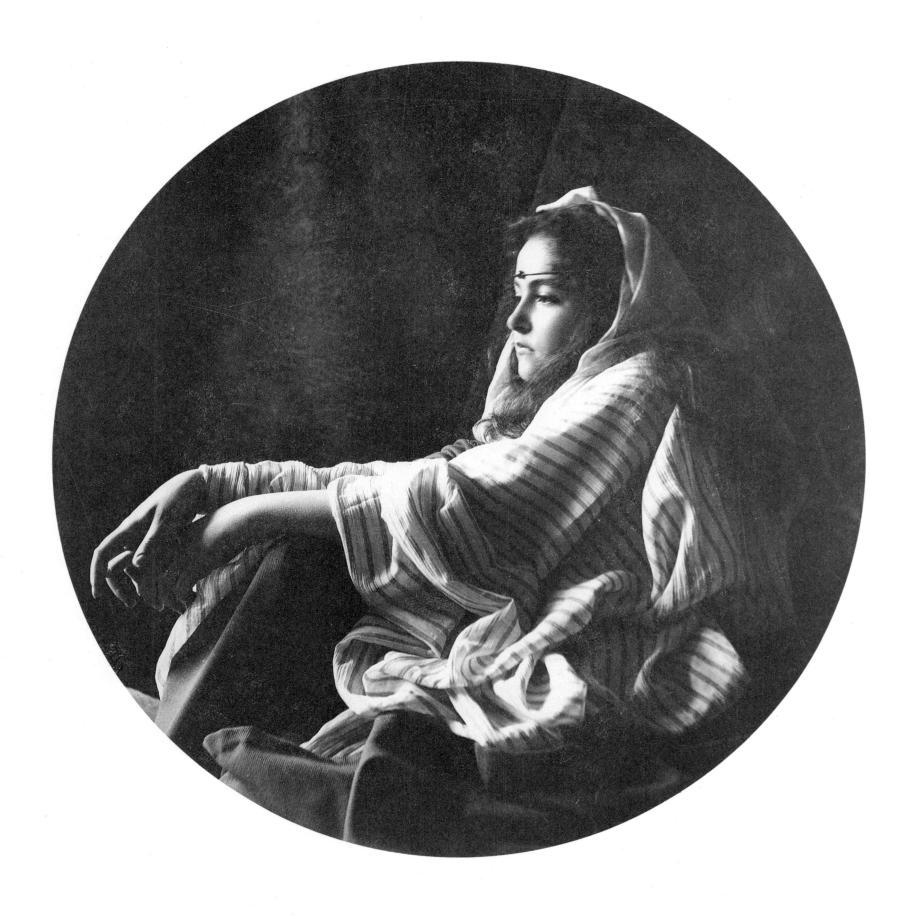

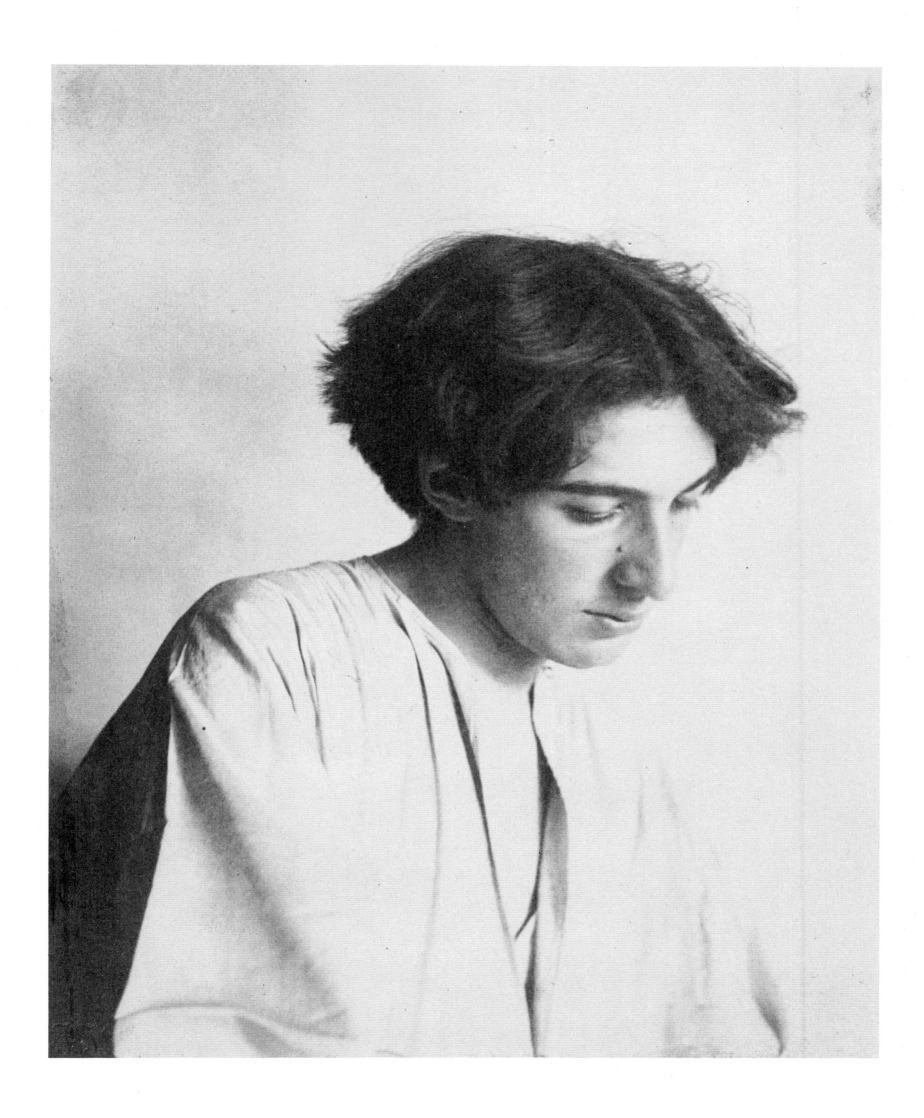

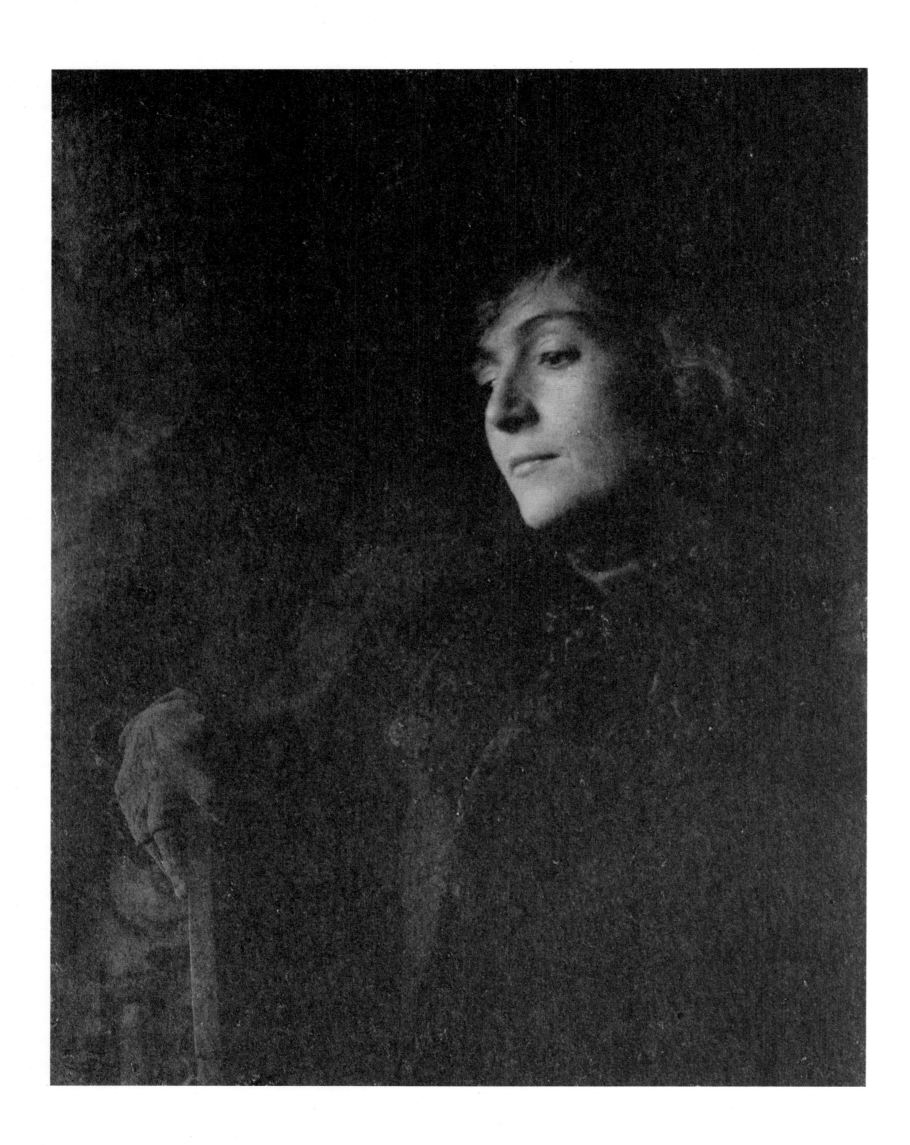

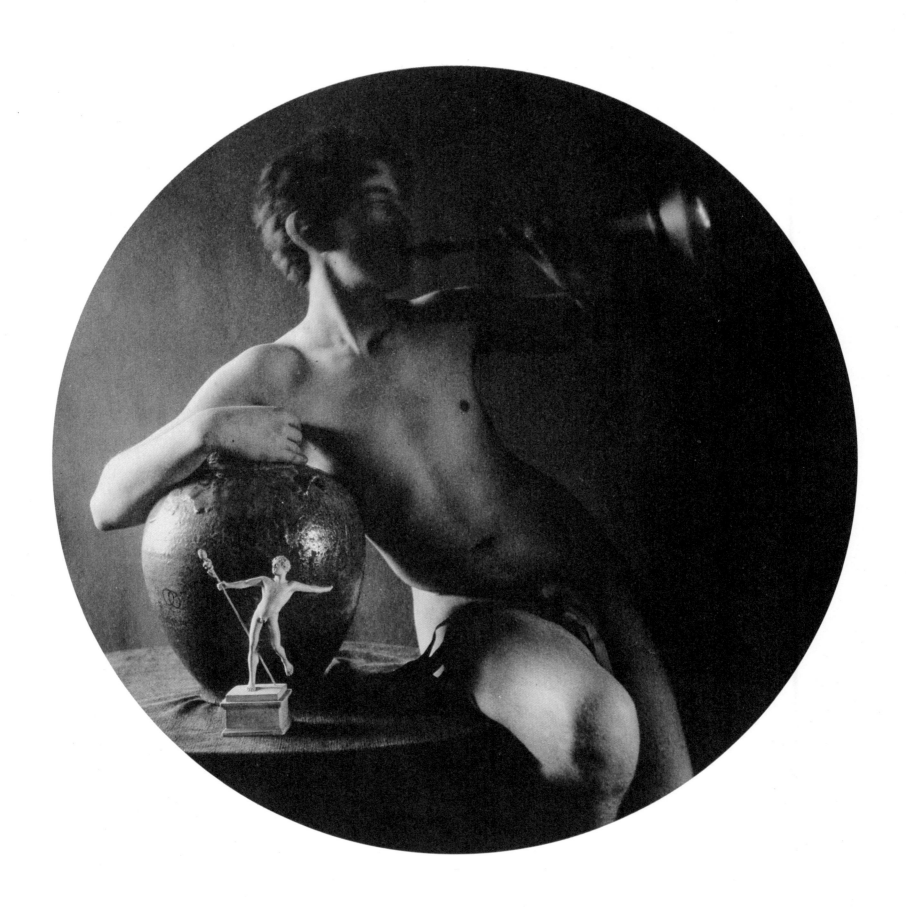

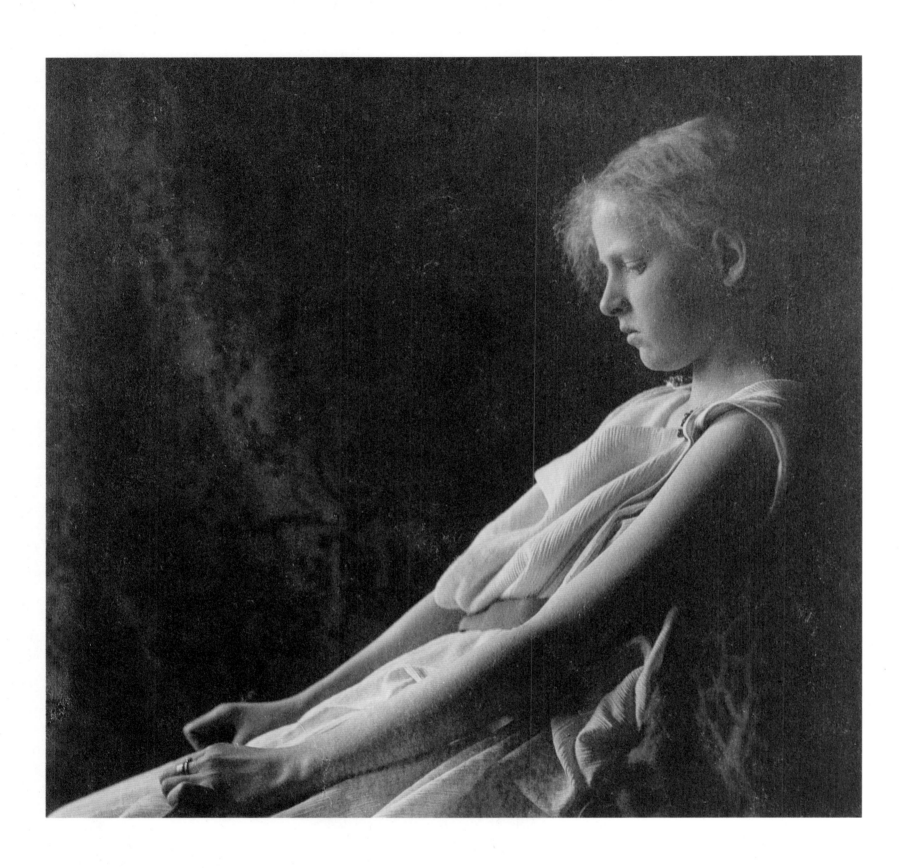

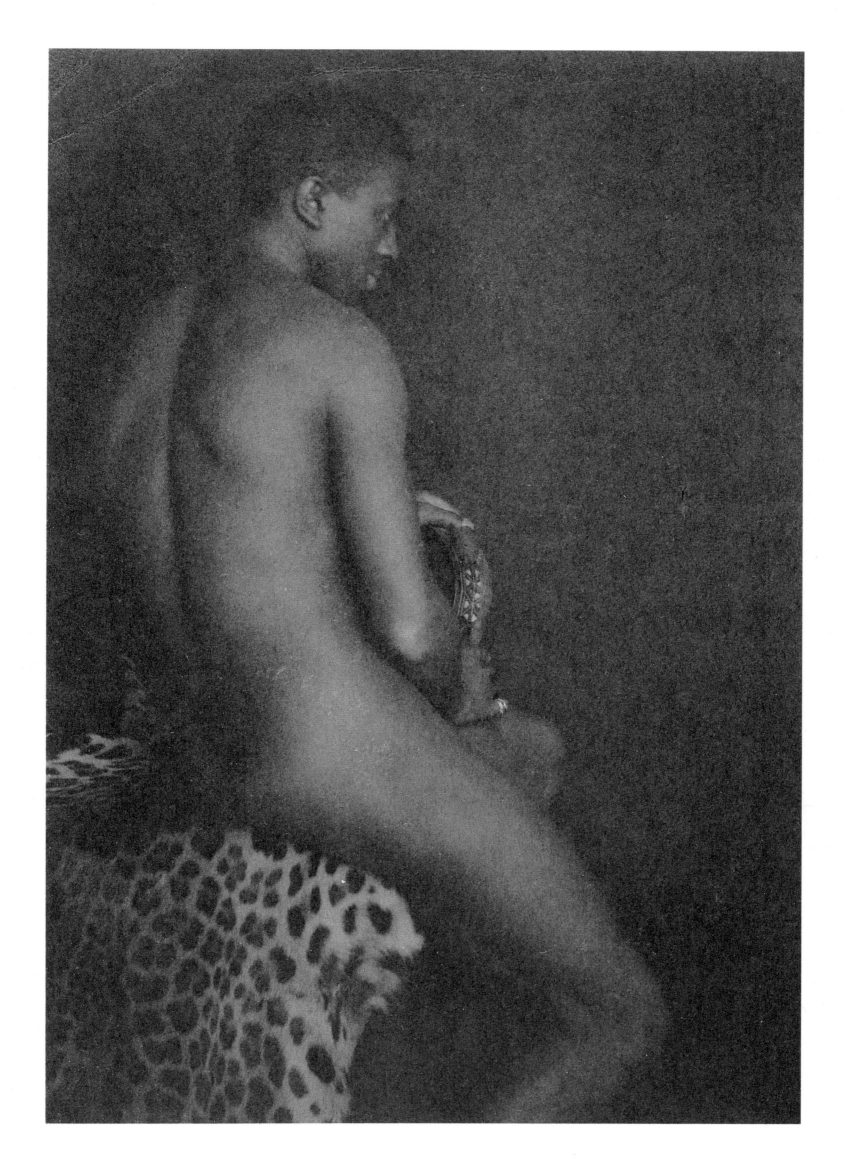

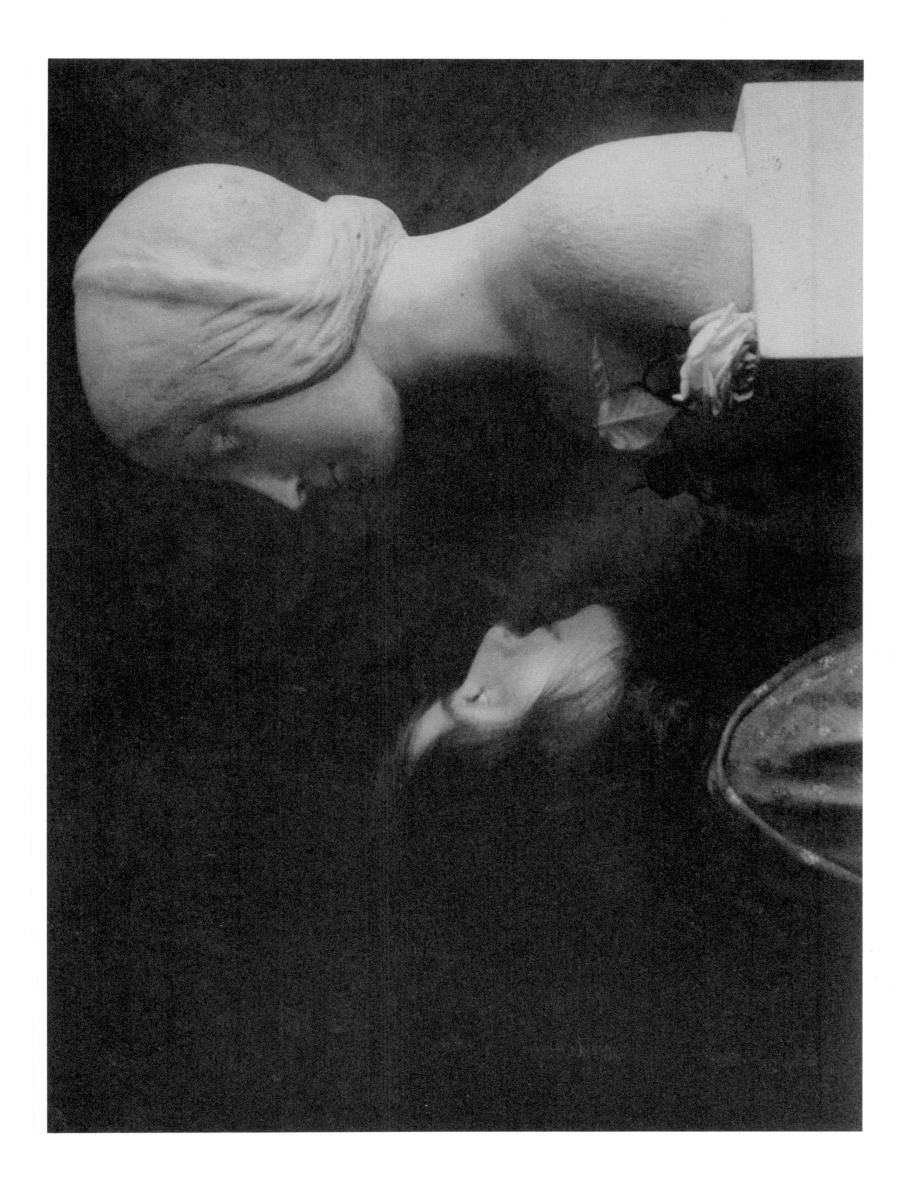

14

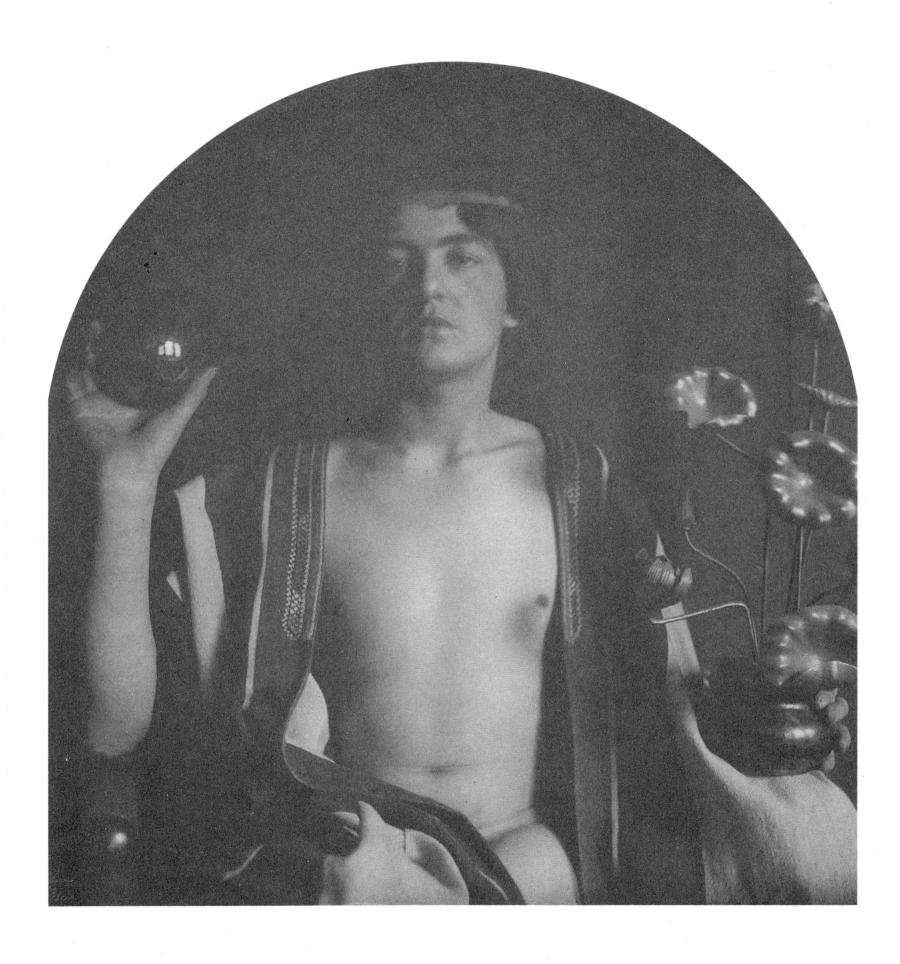

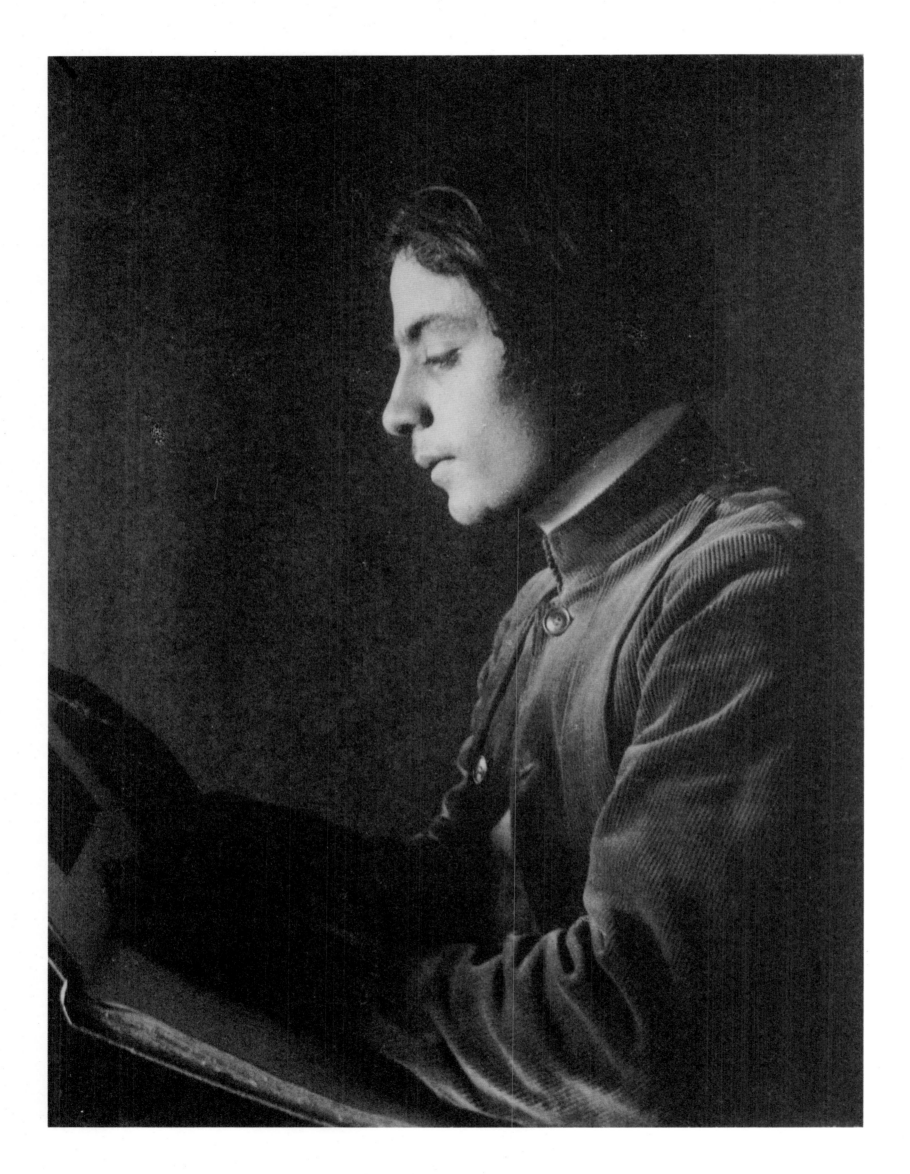

17

17

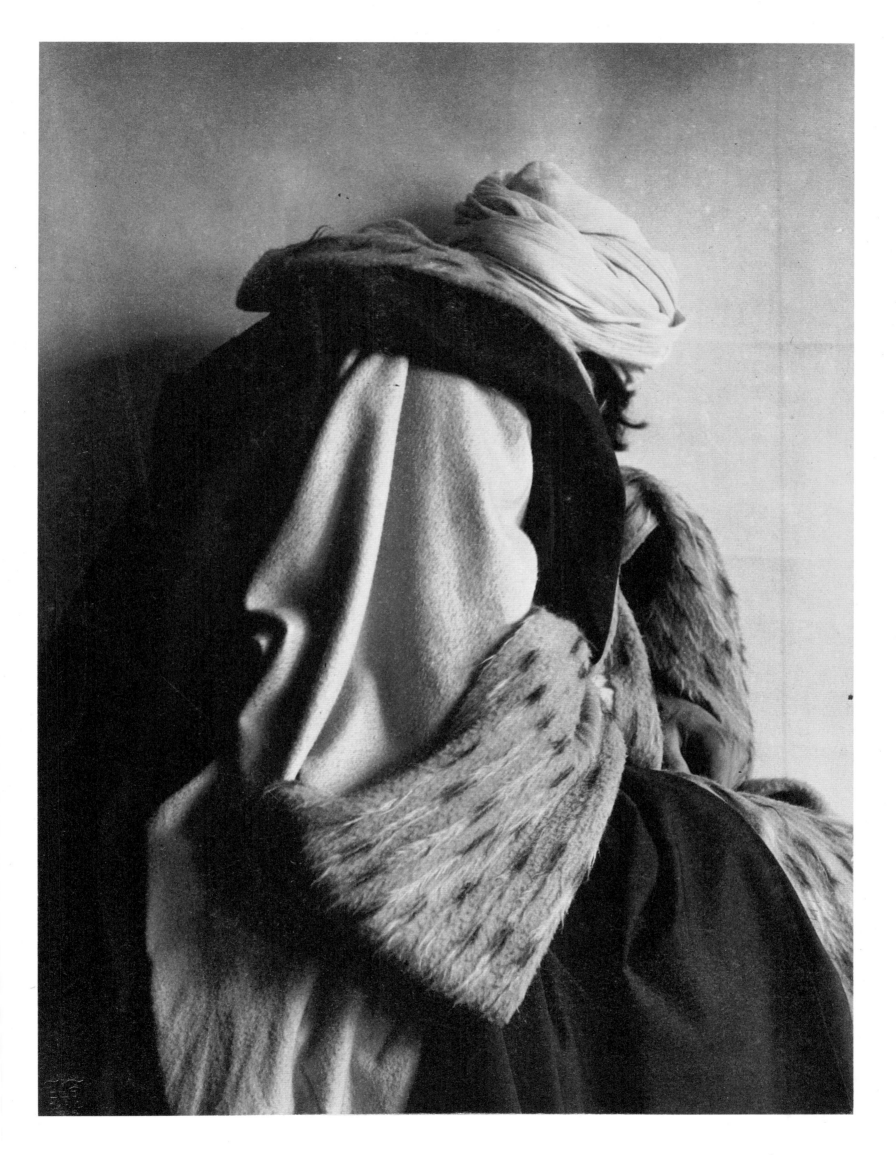

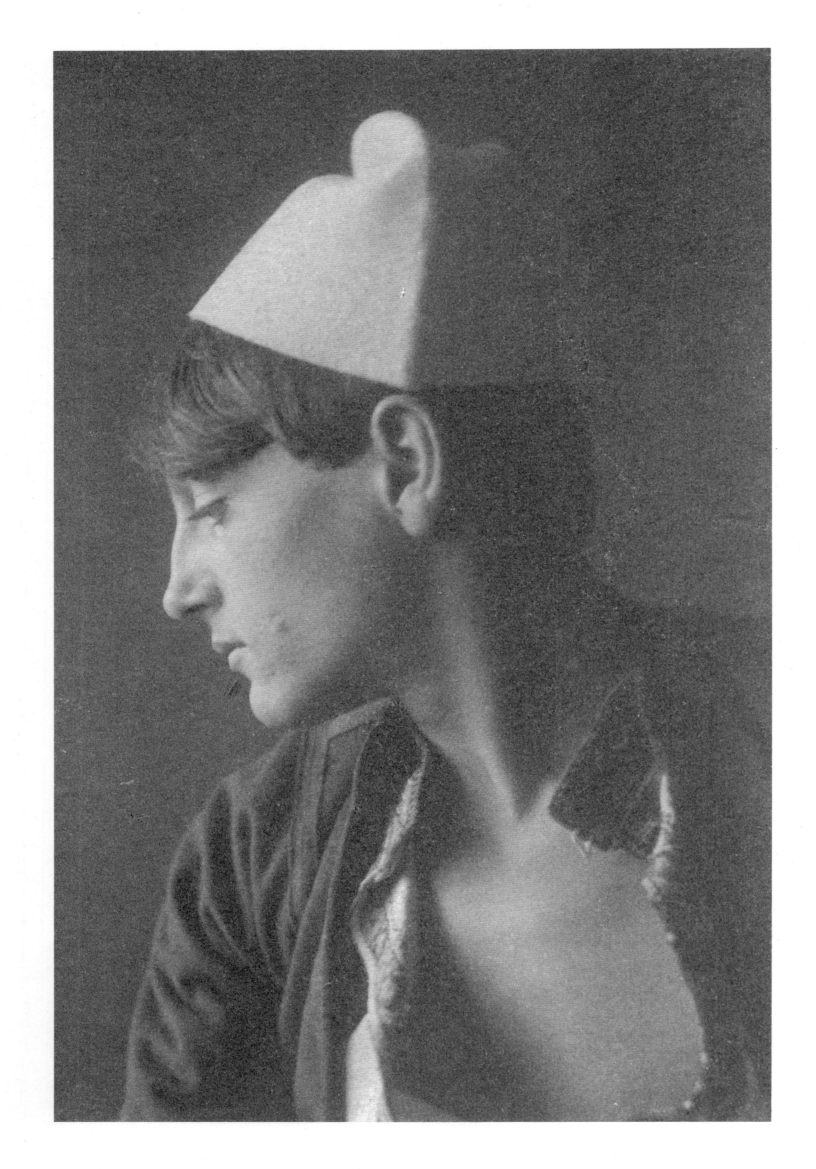

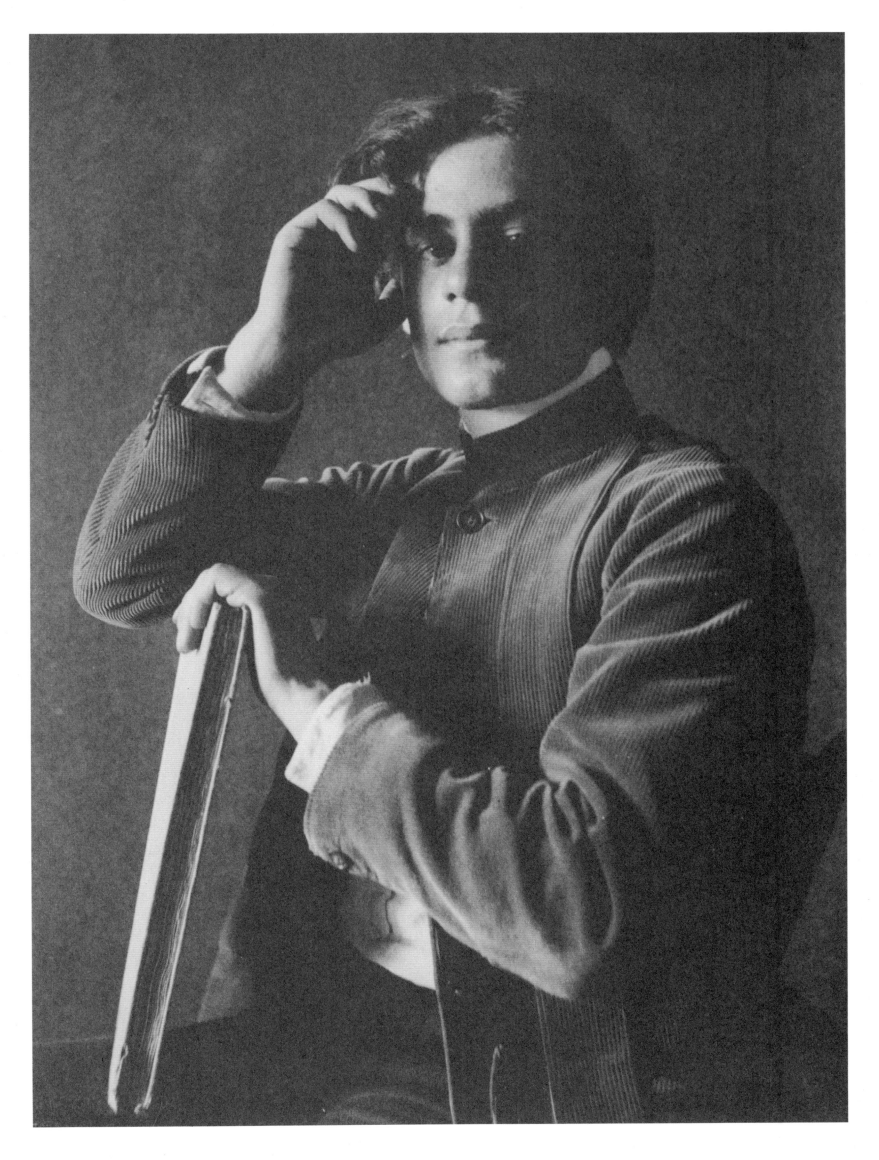

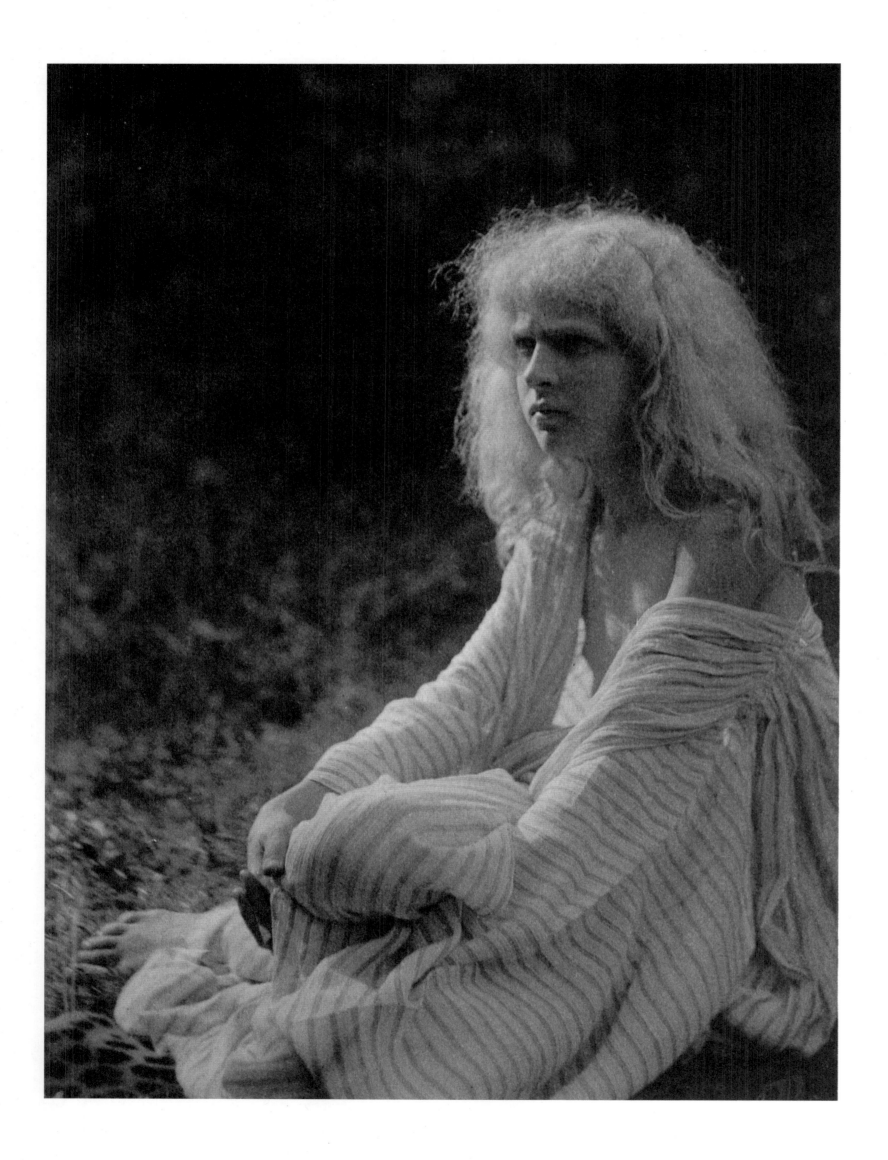

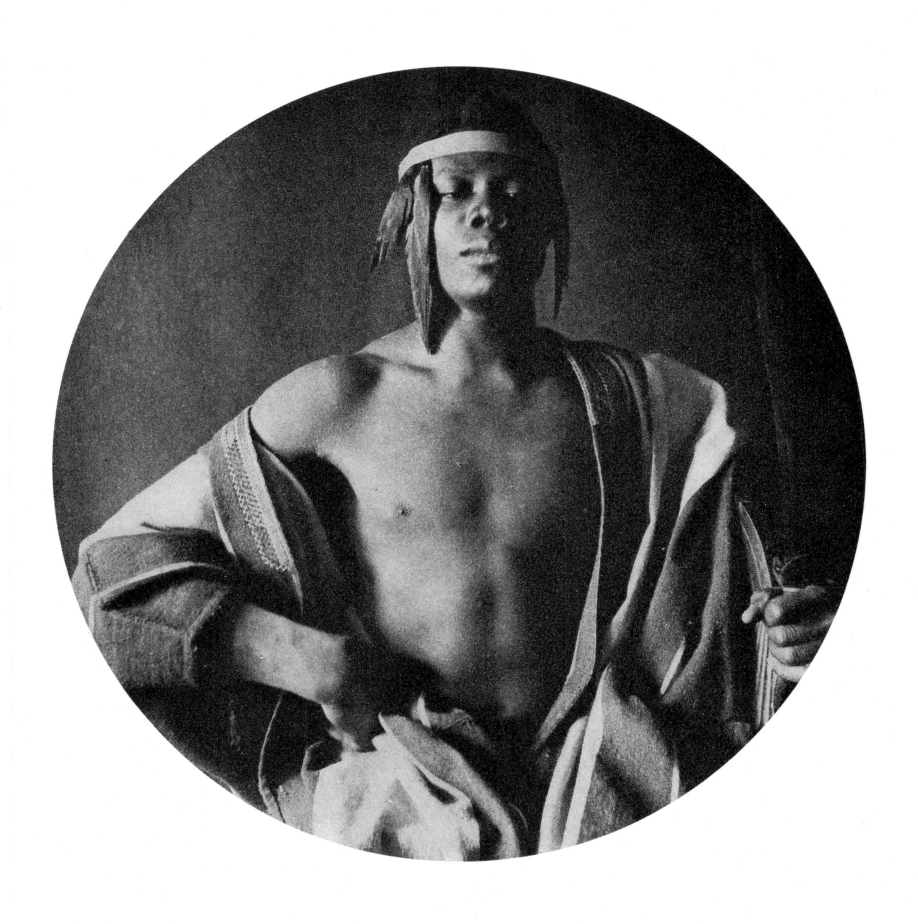

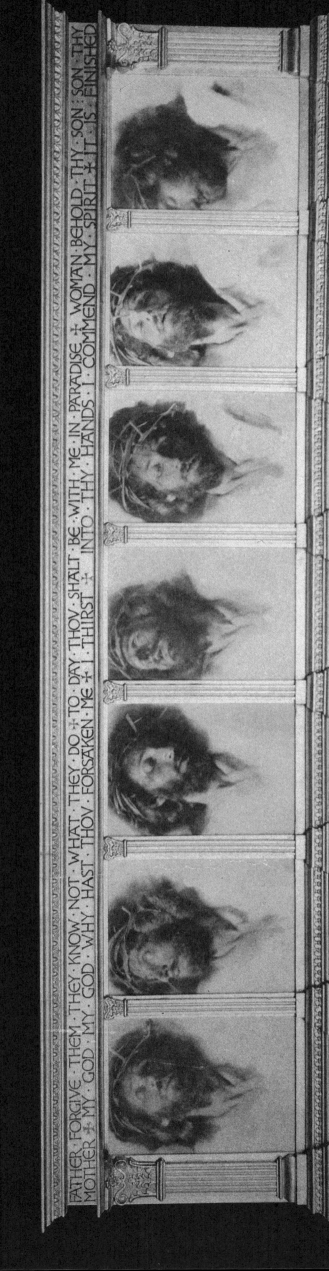

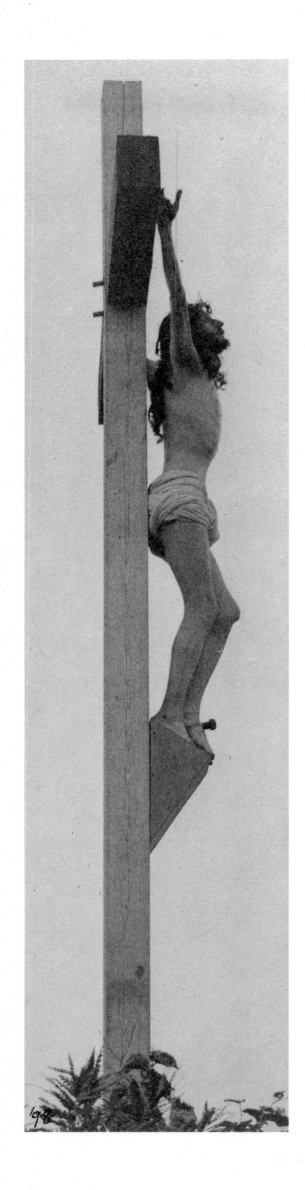

24

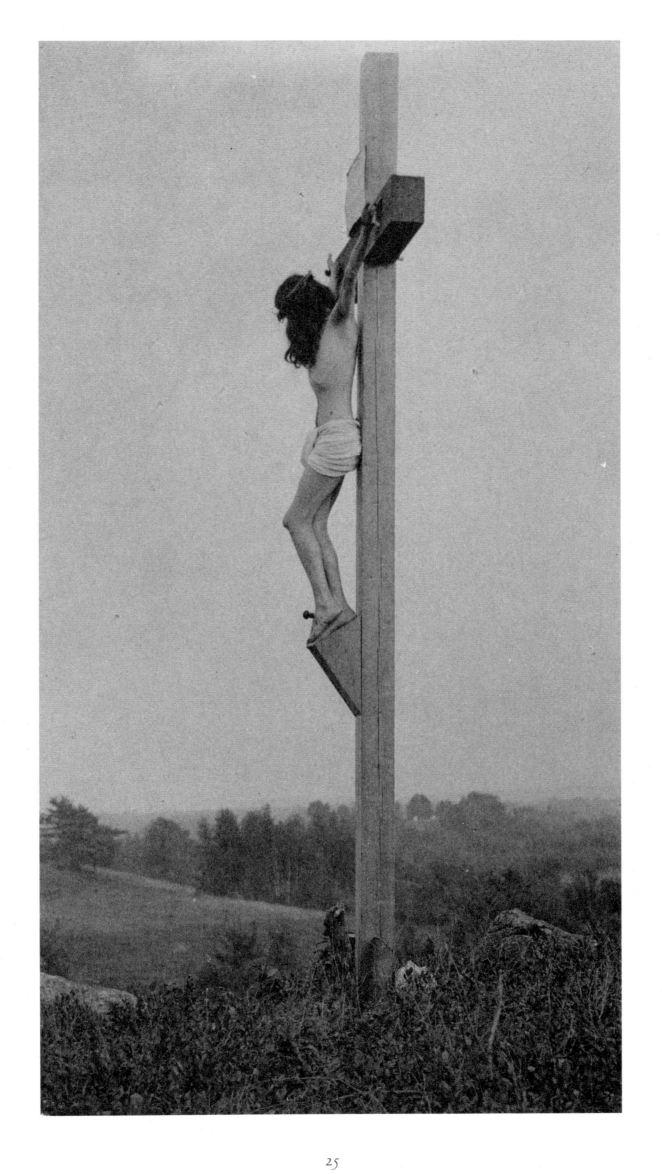

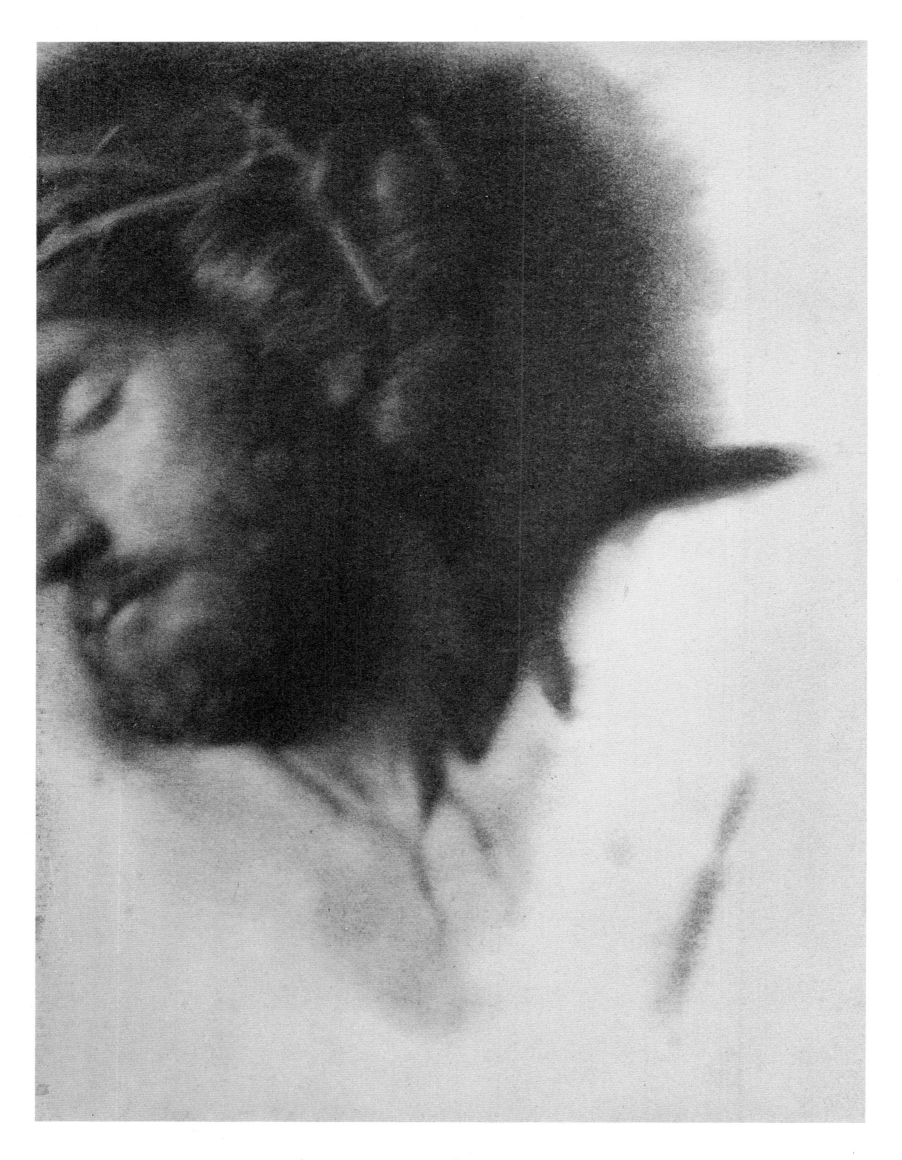

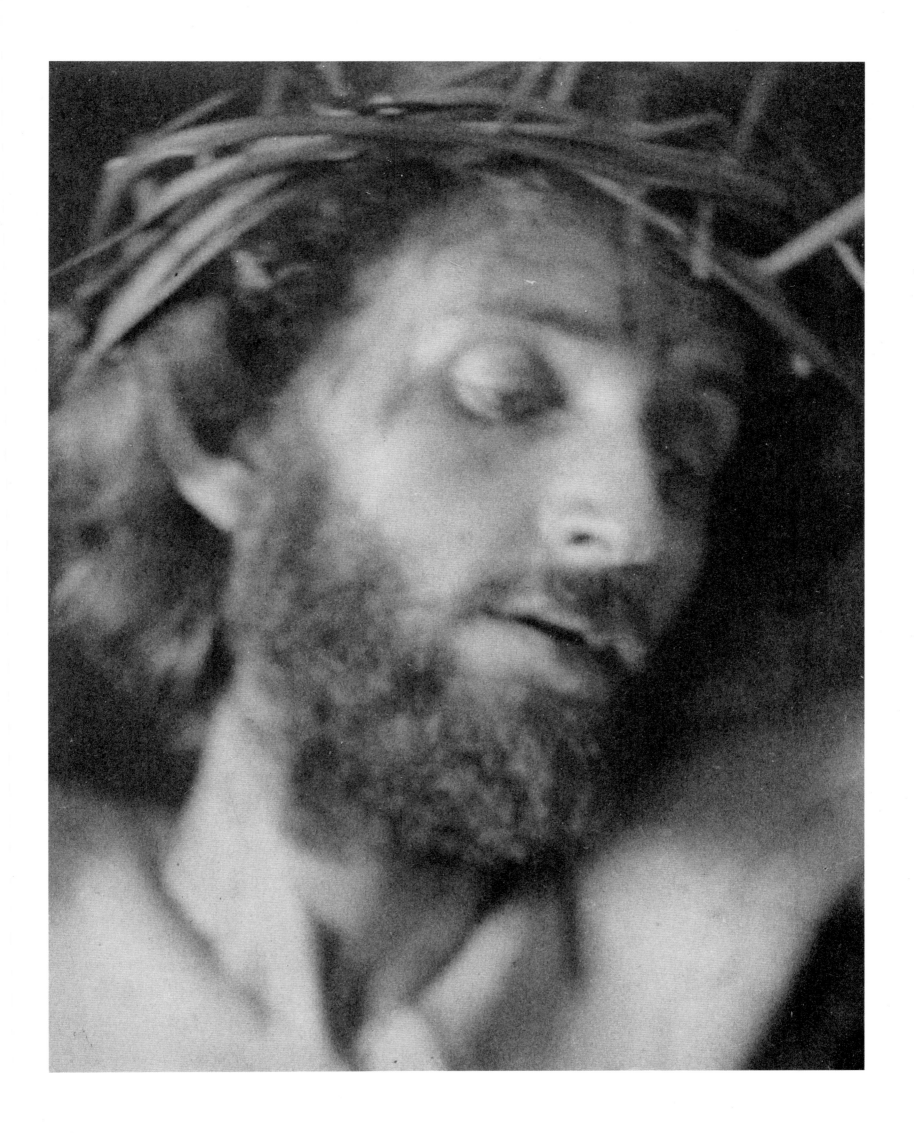

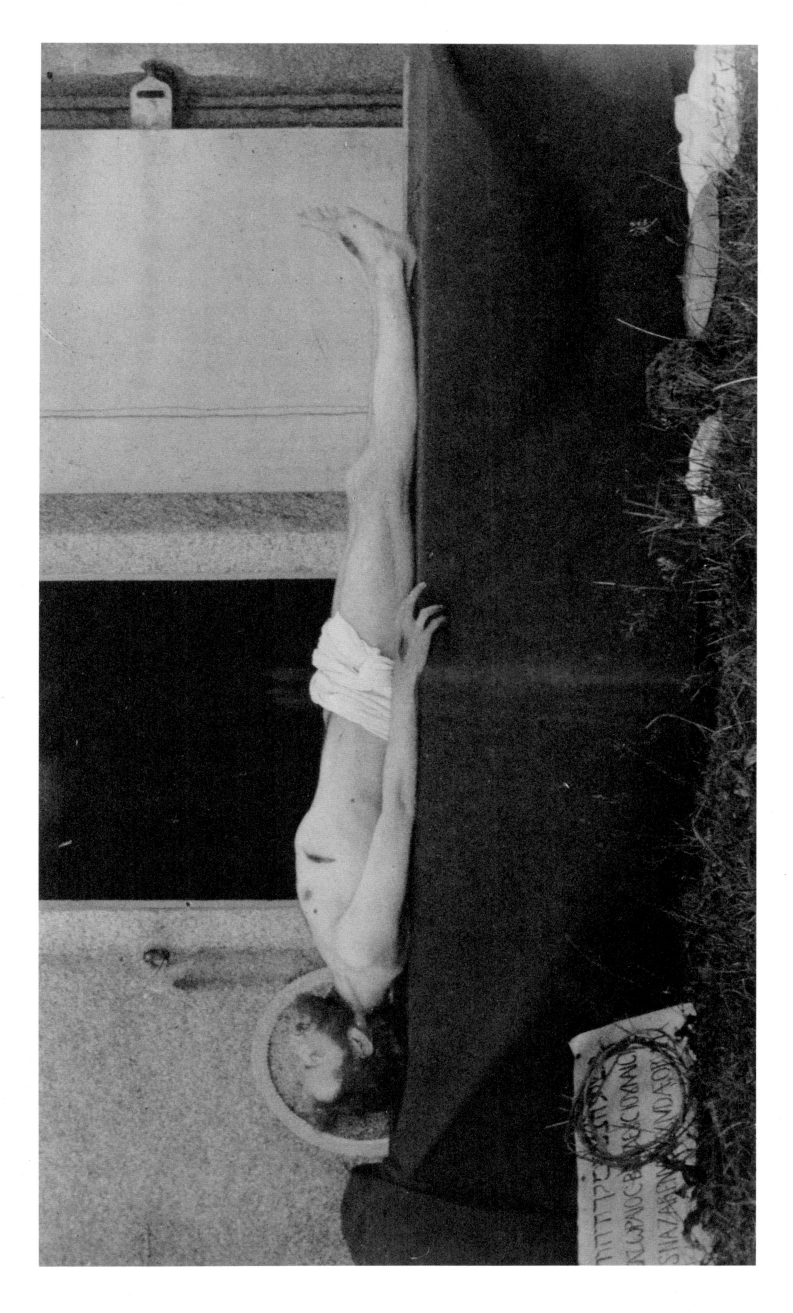

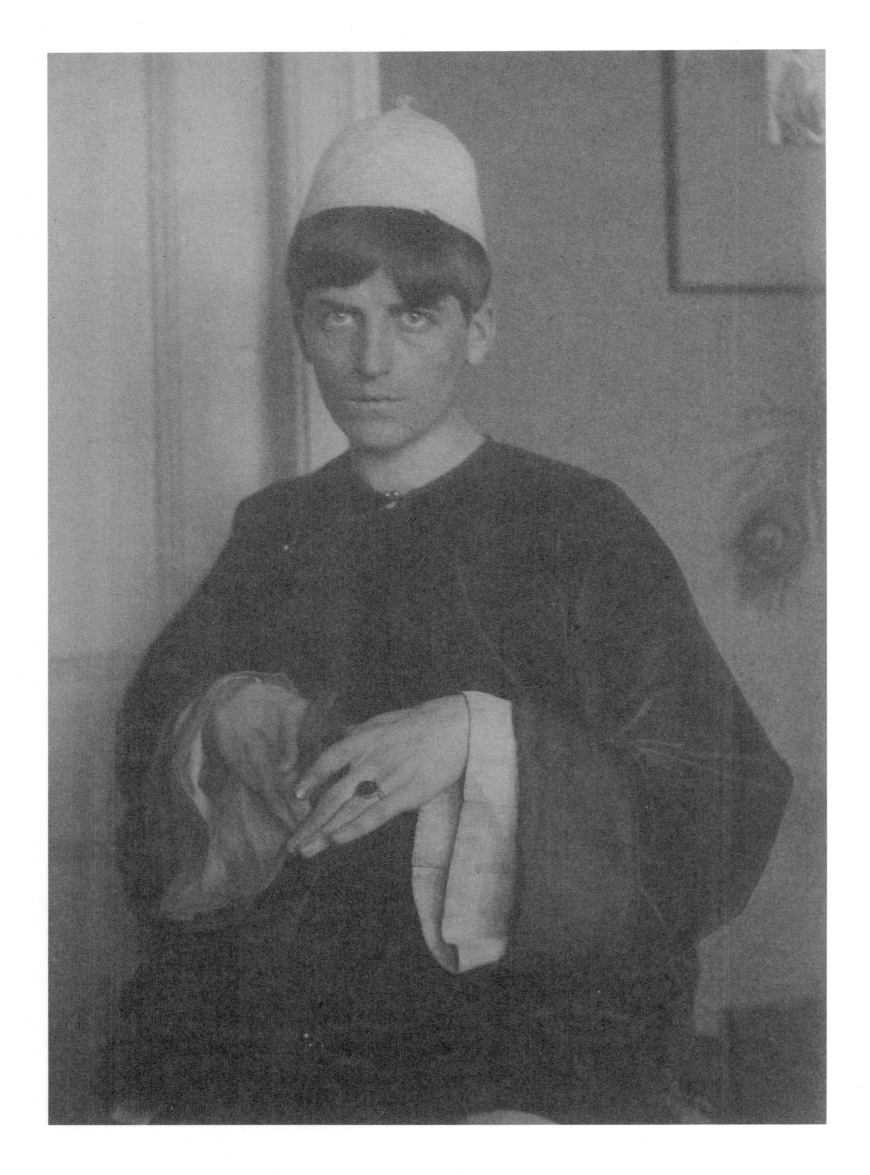

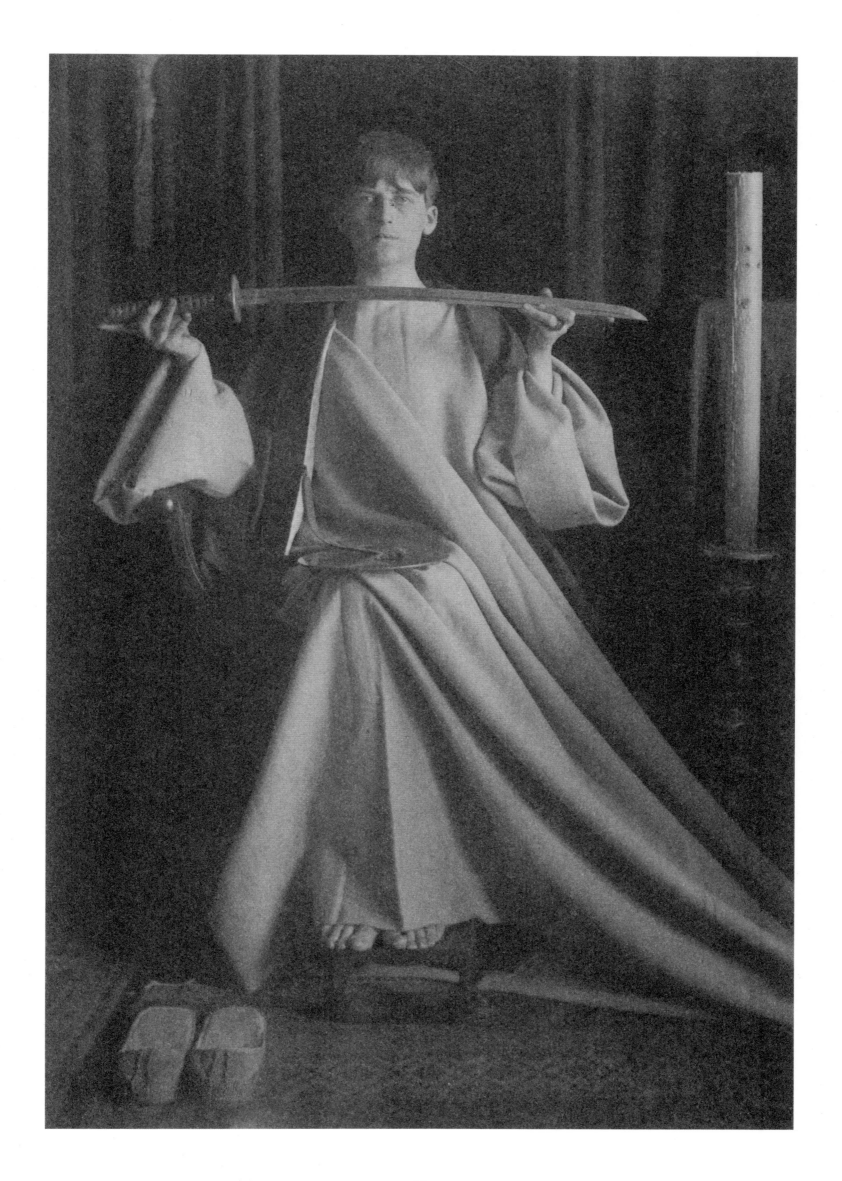

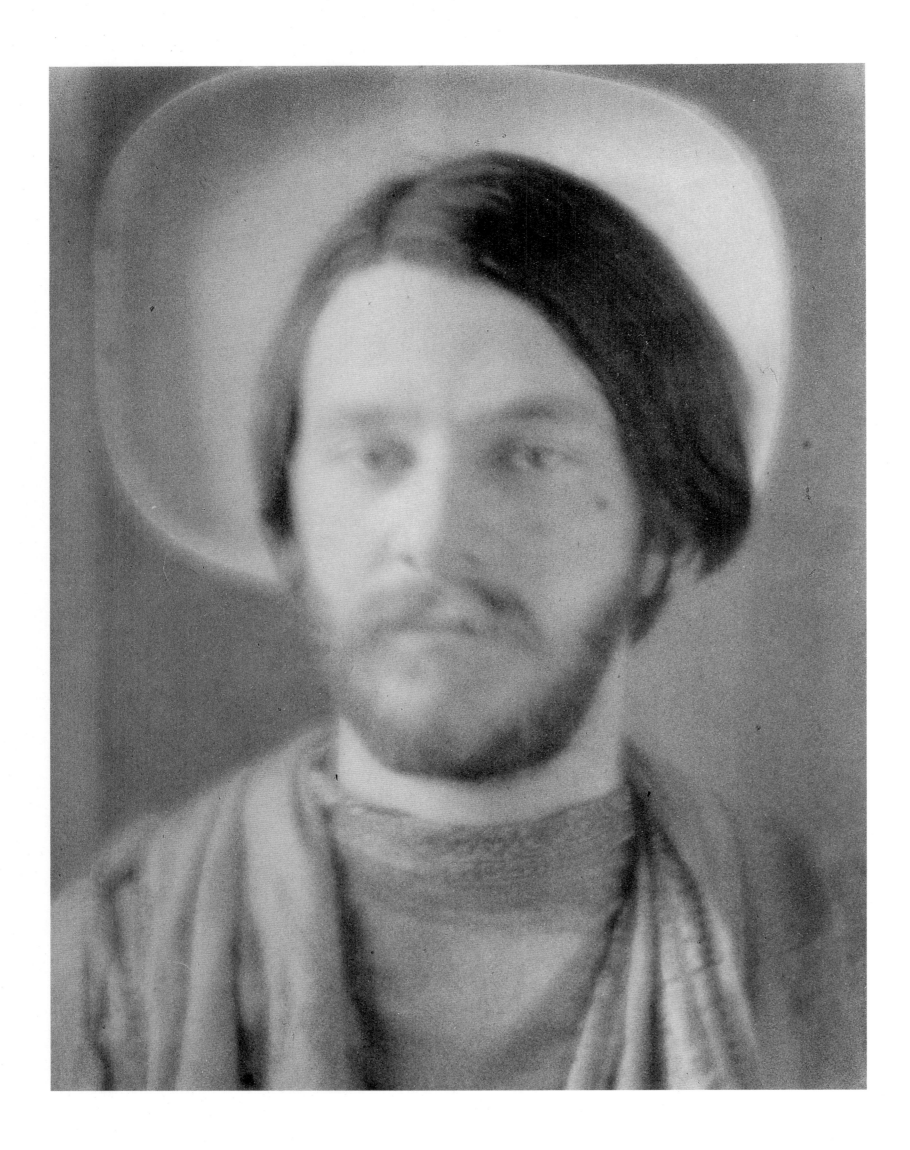

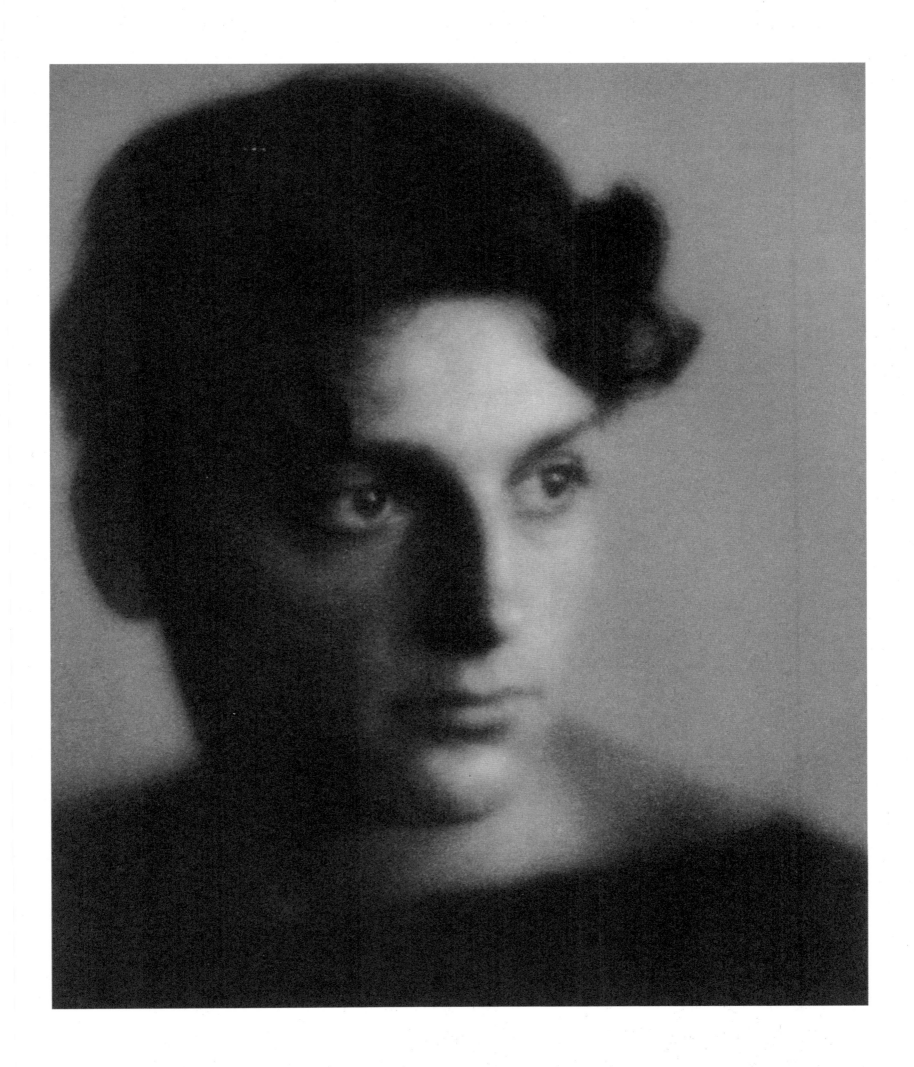

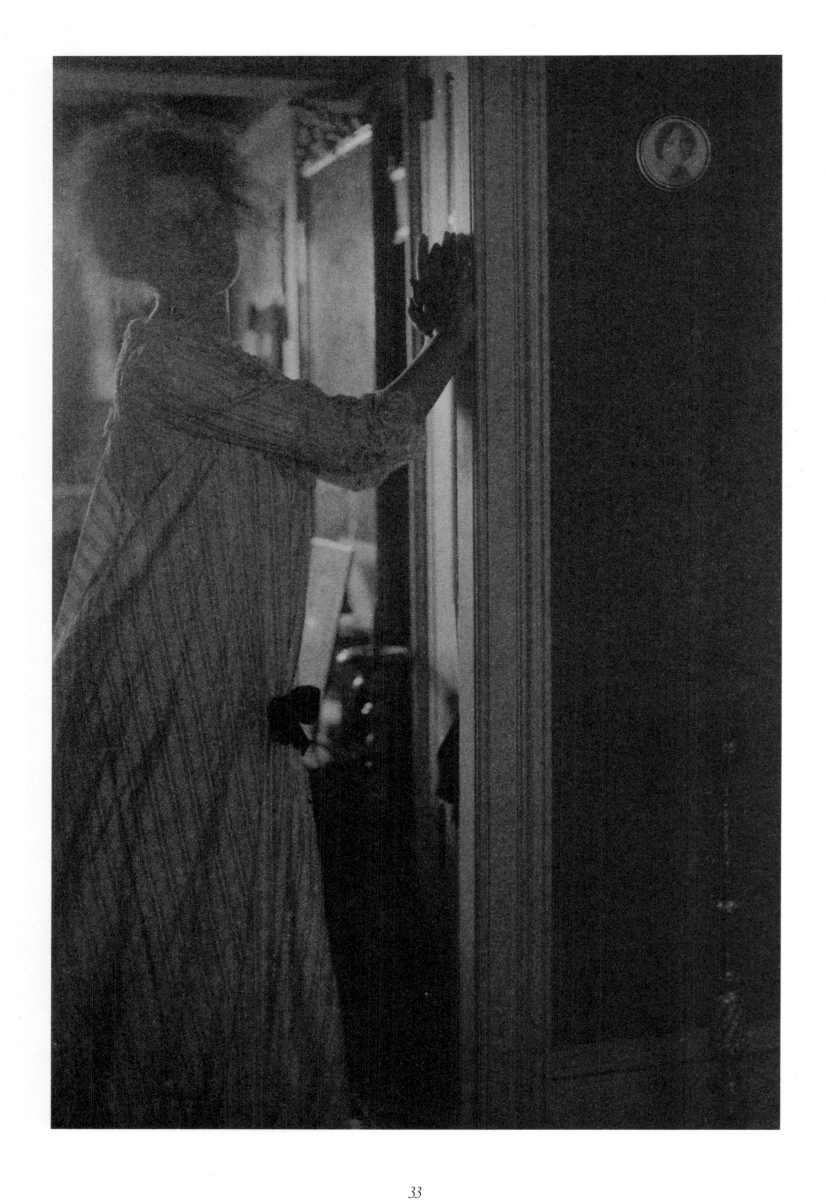

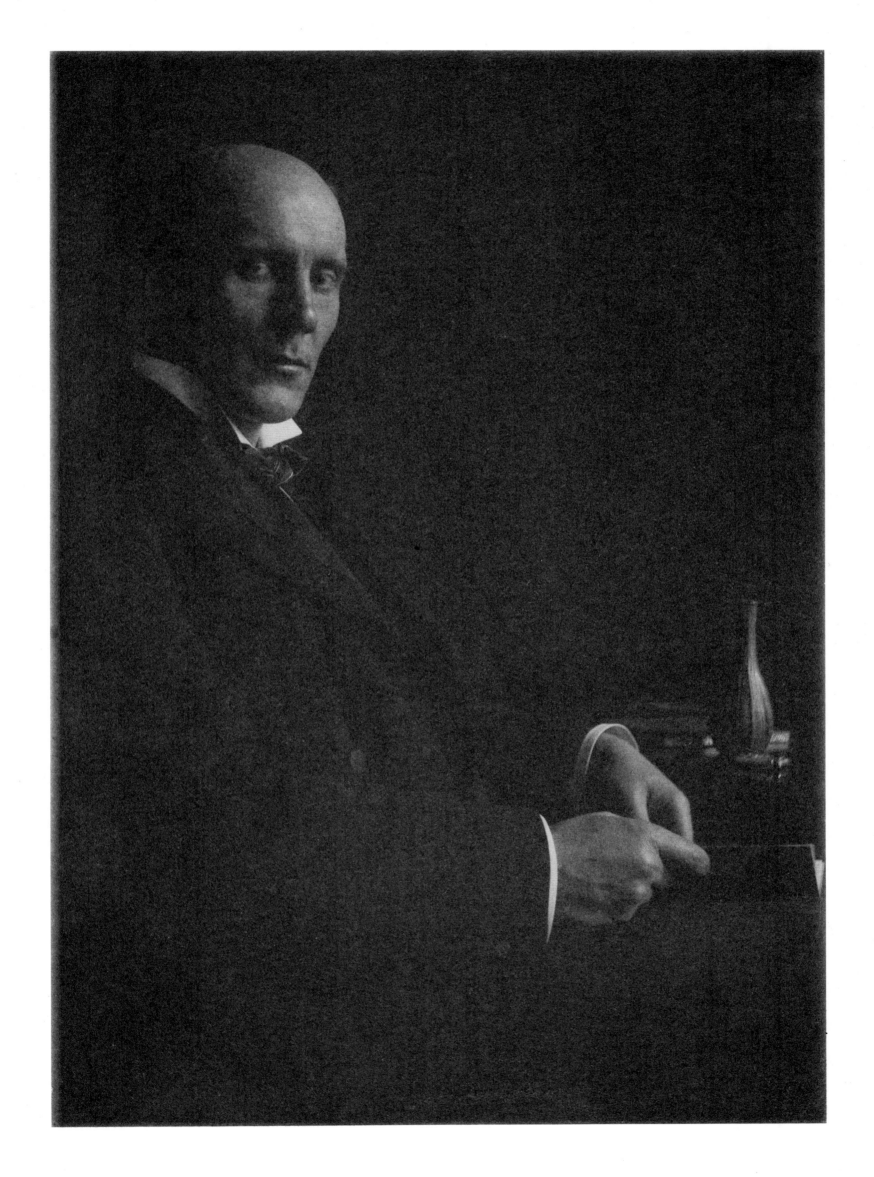

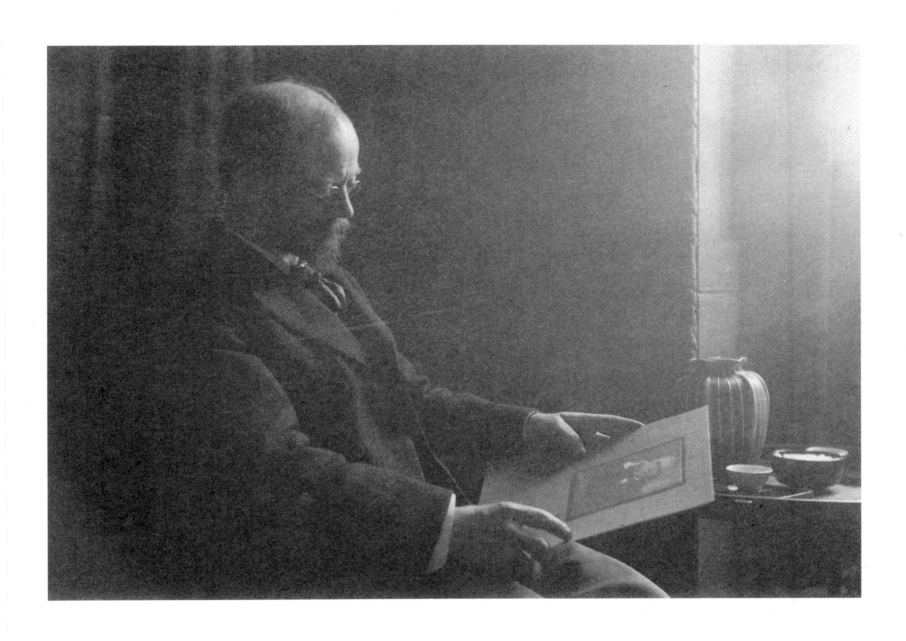

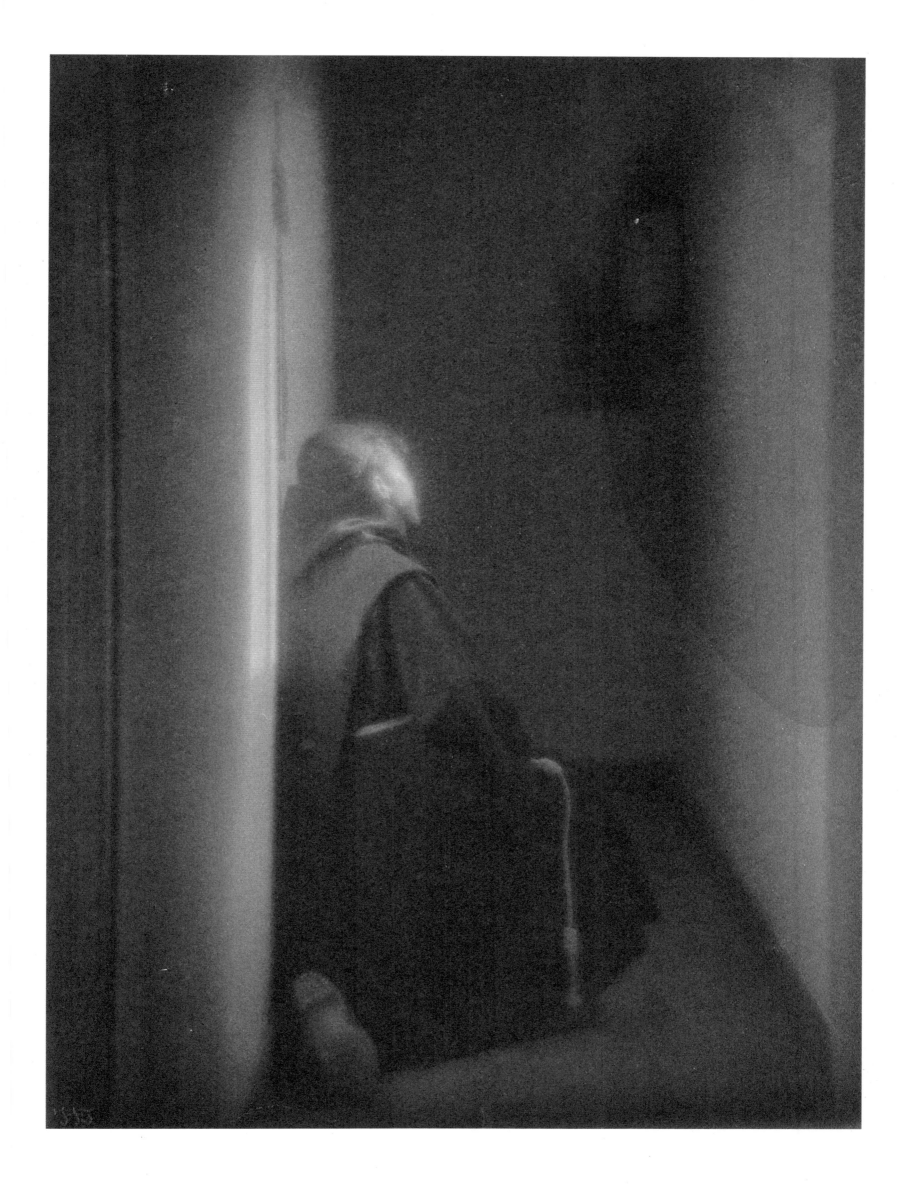

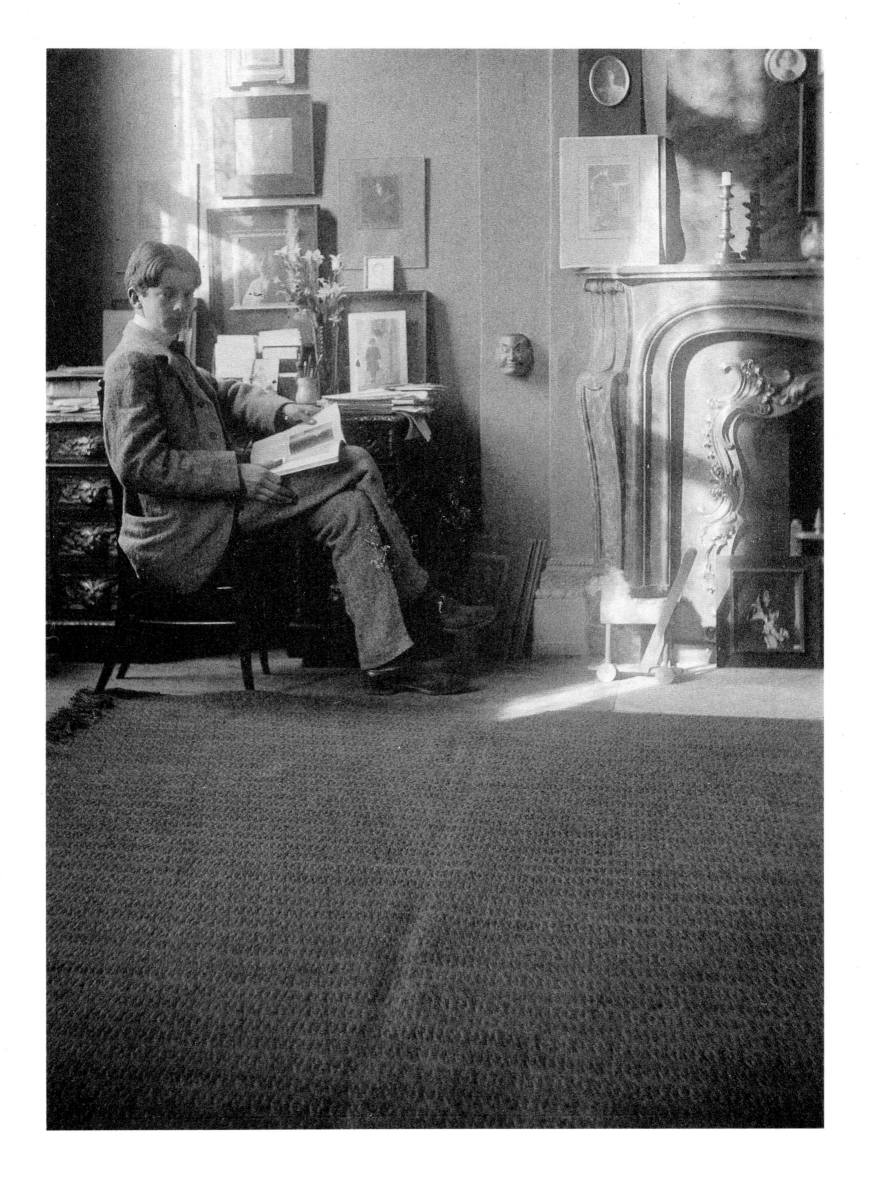

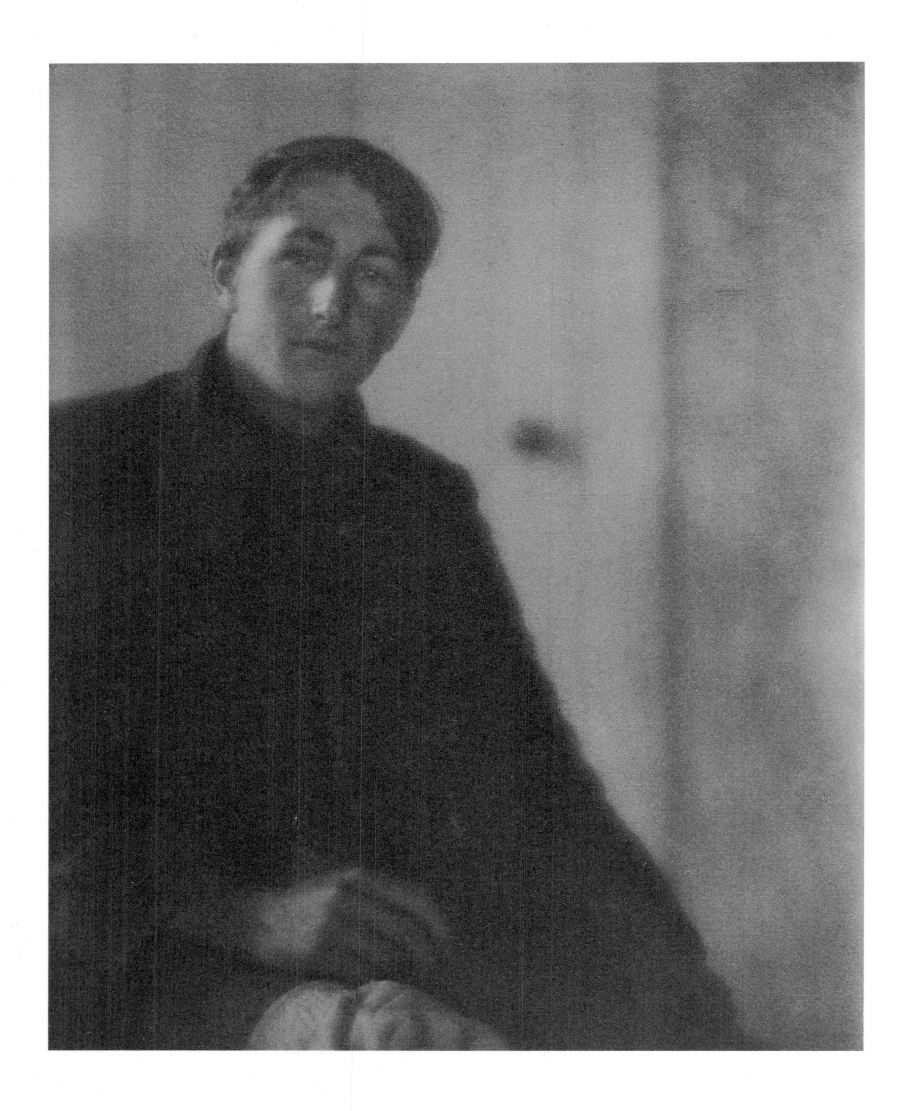

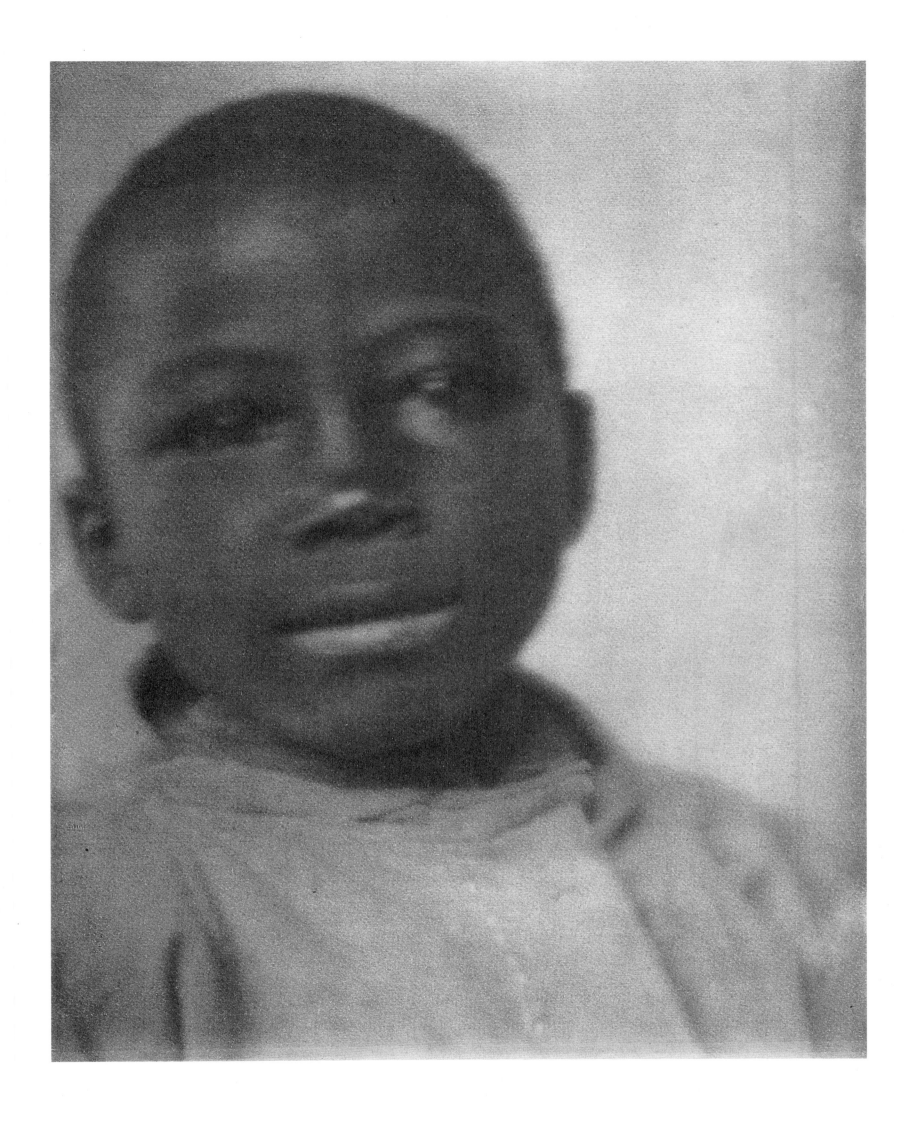

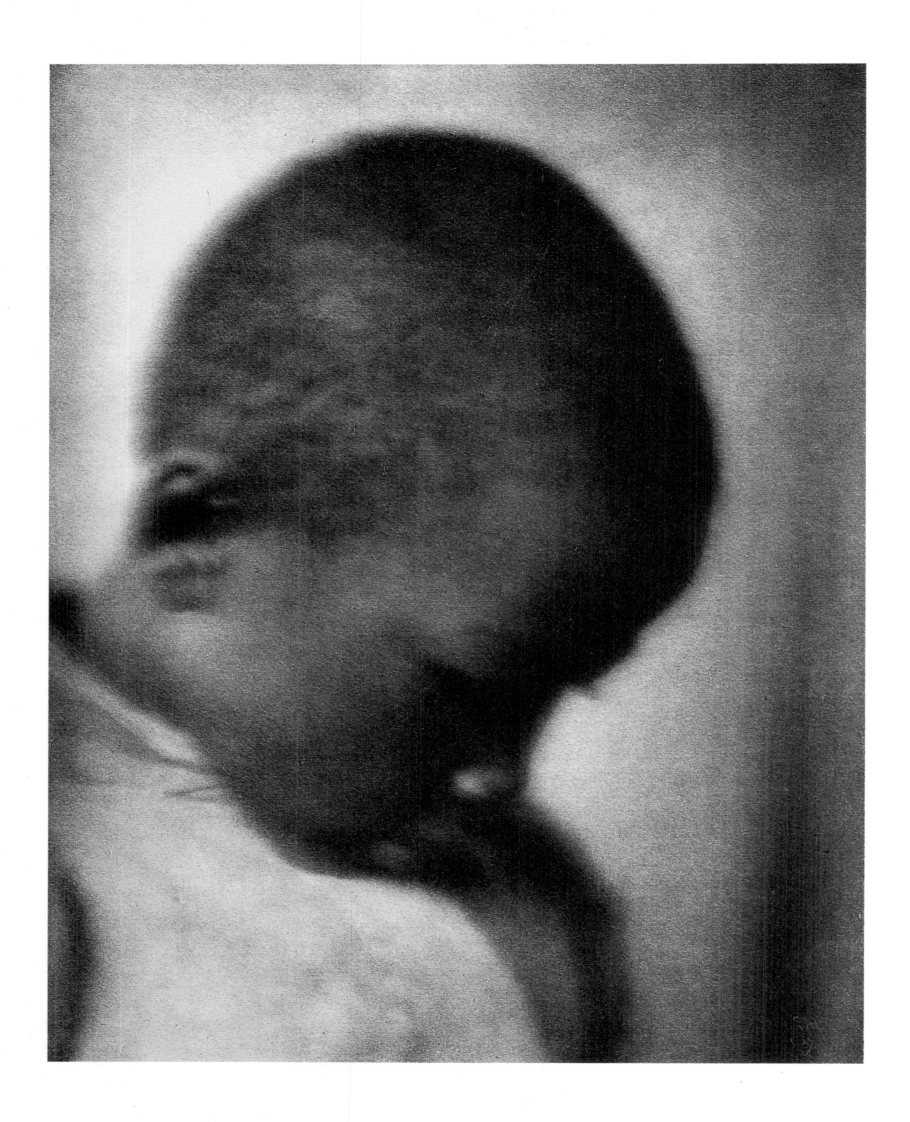

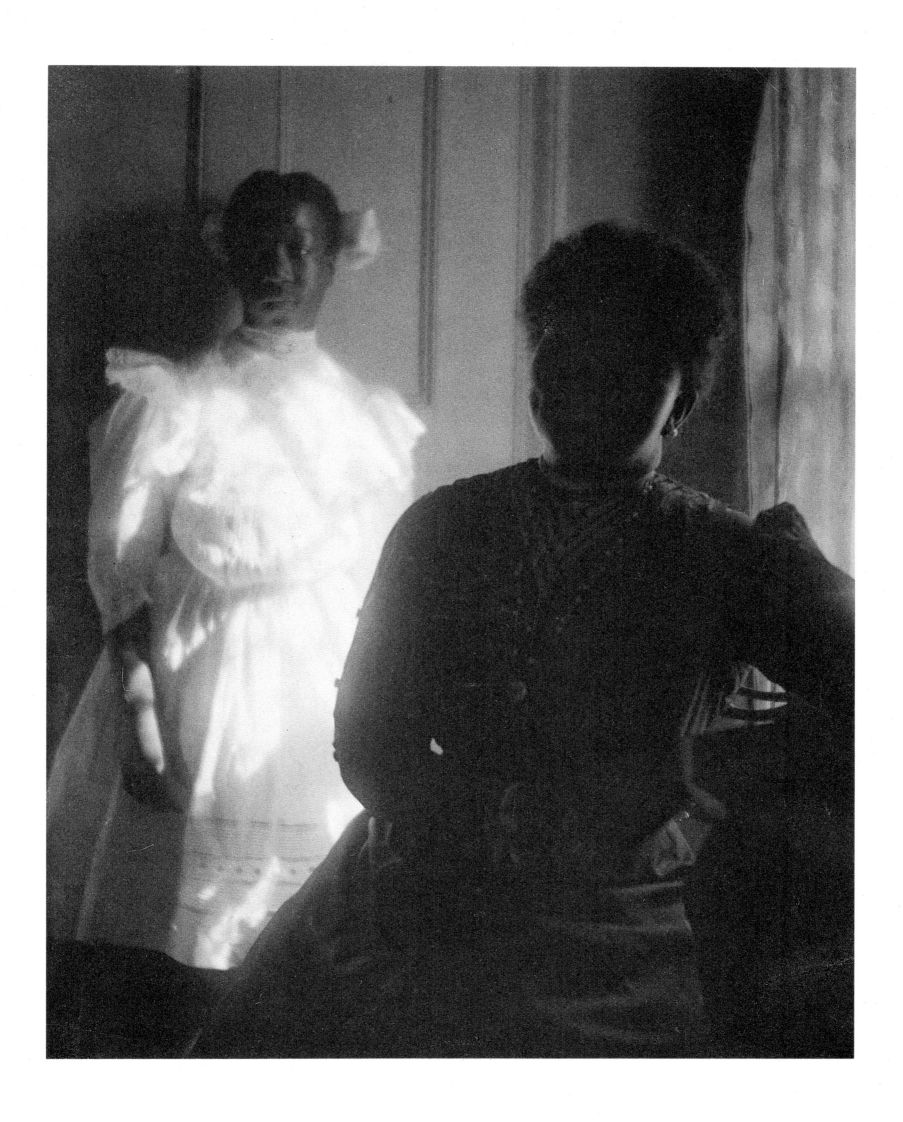

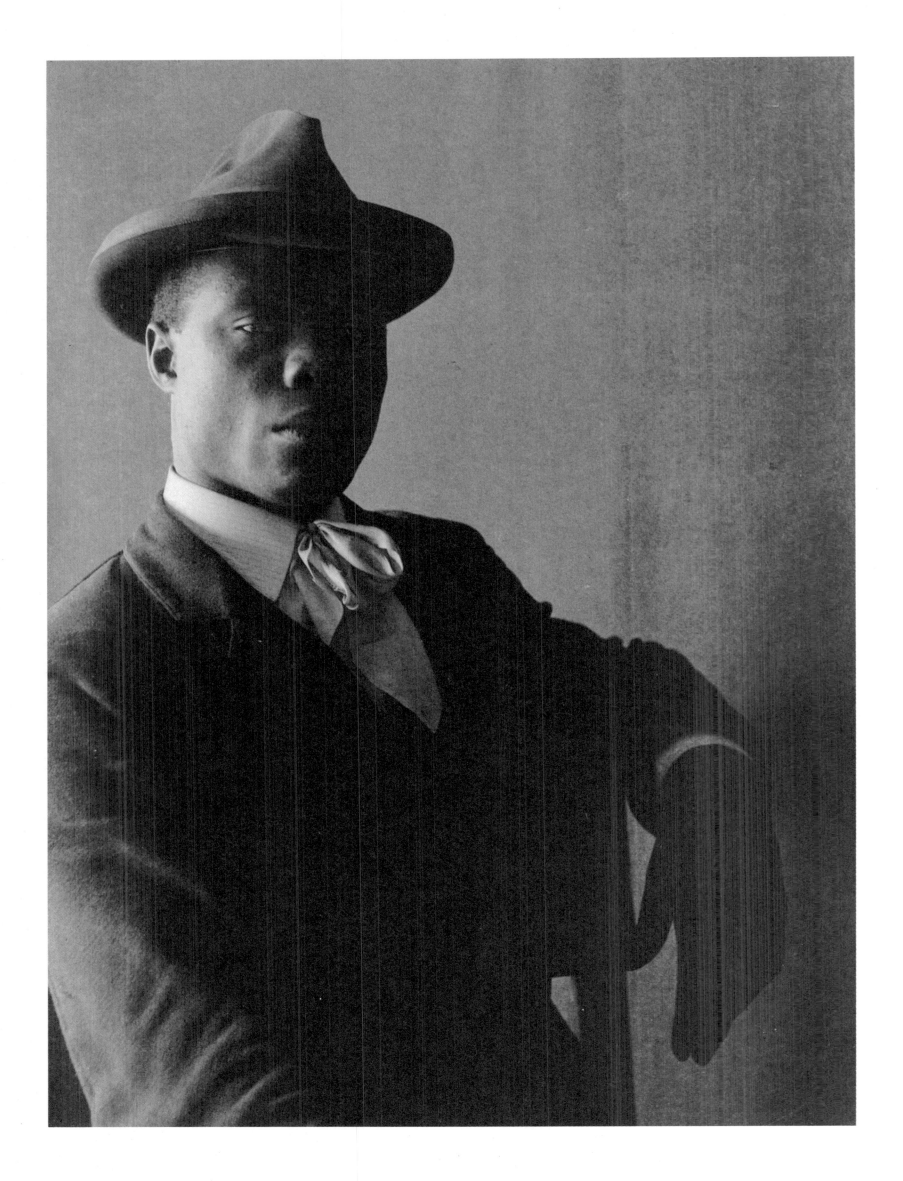

44

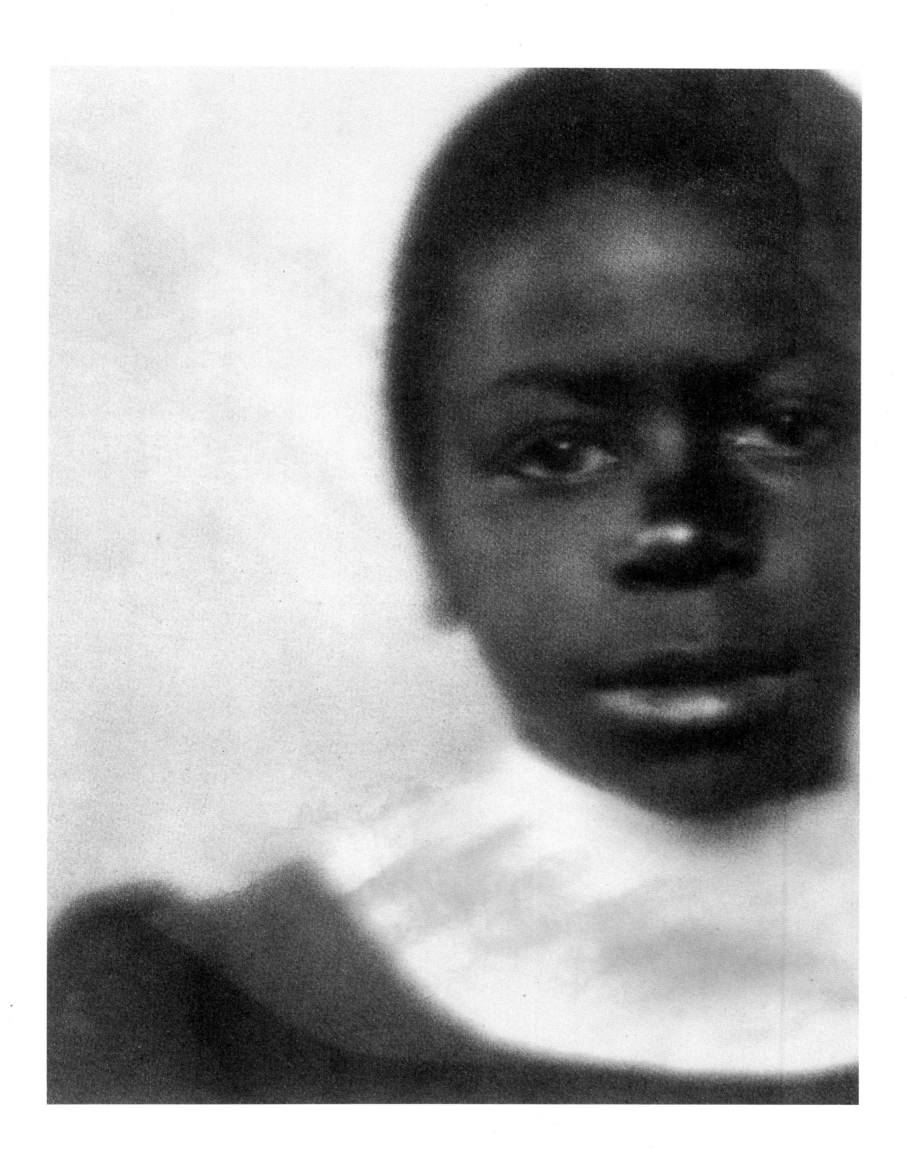

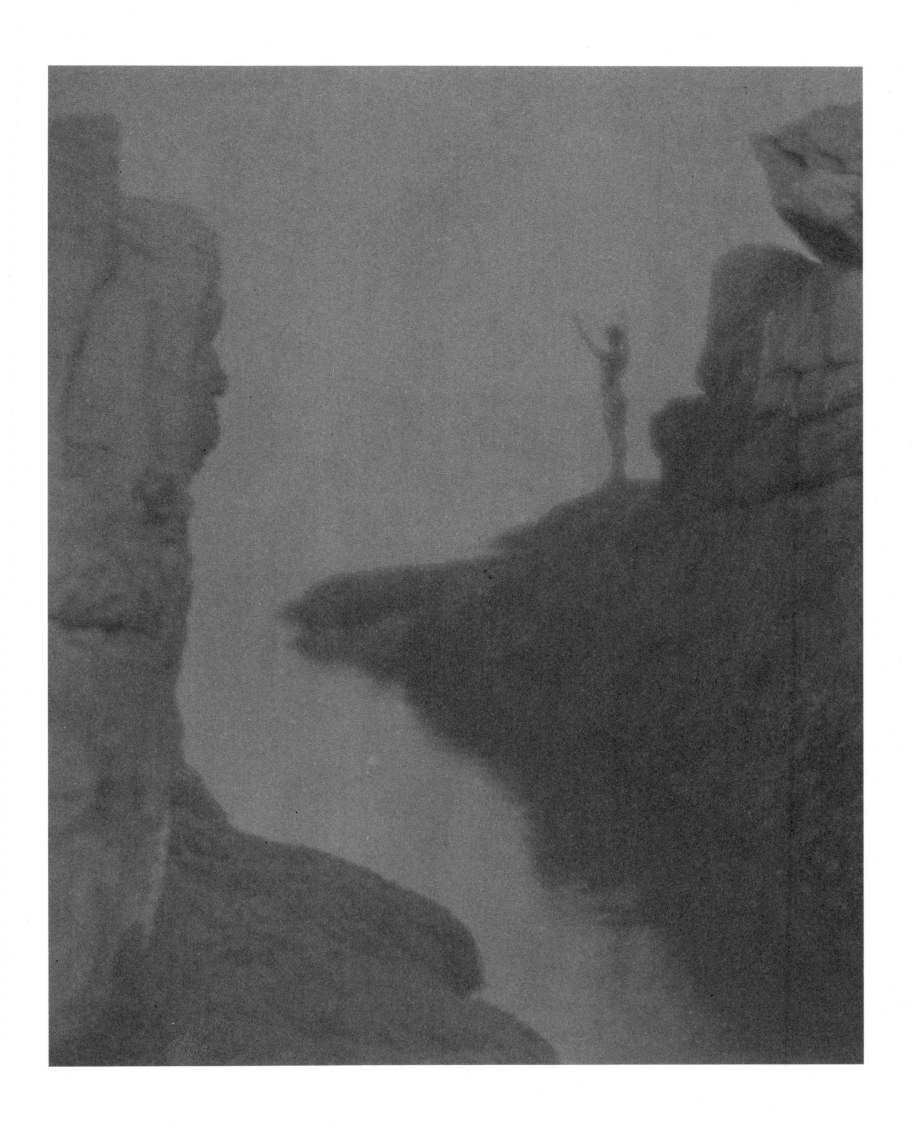

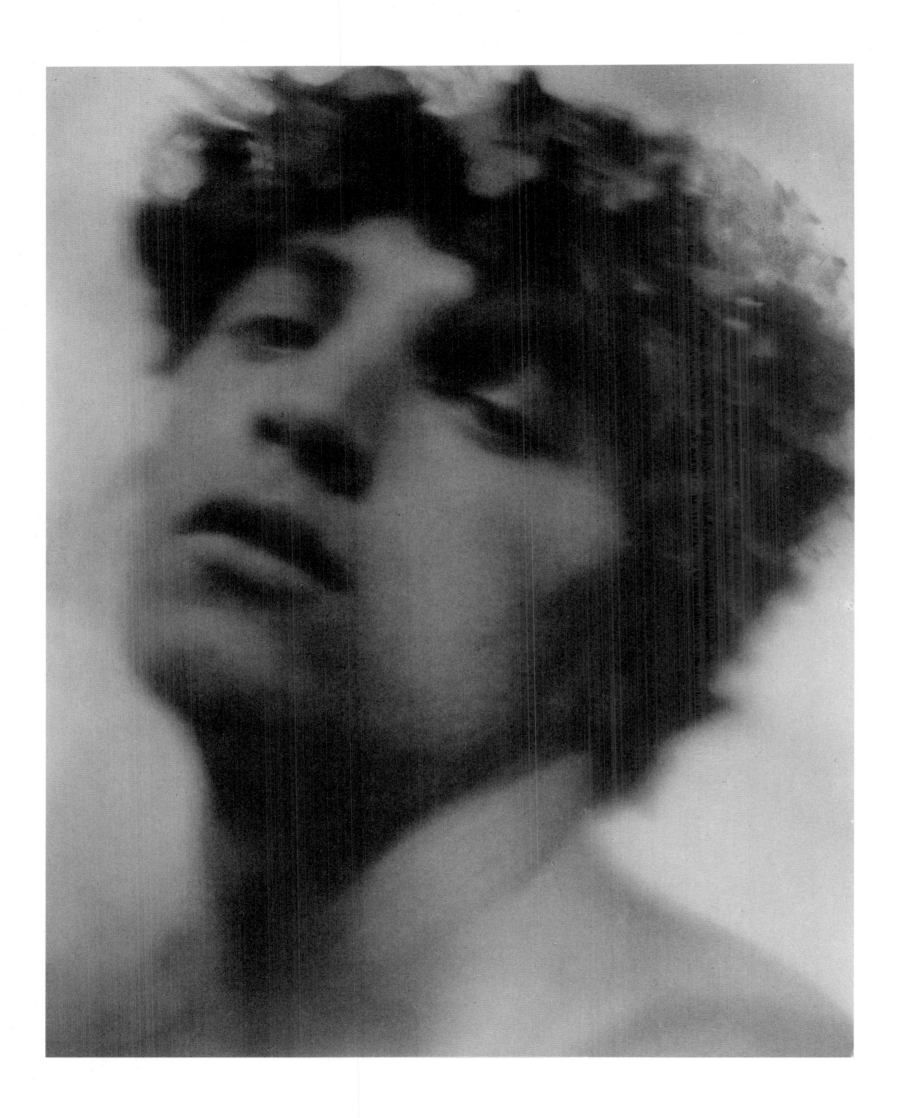

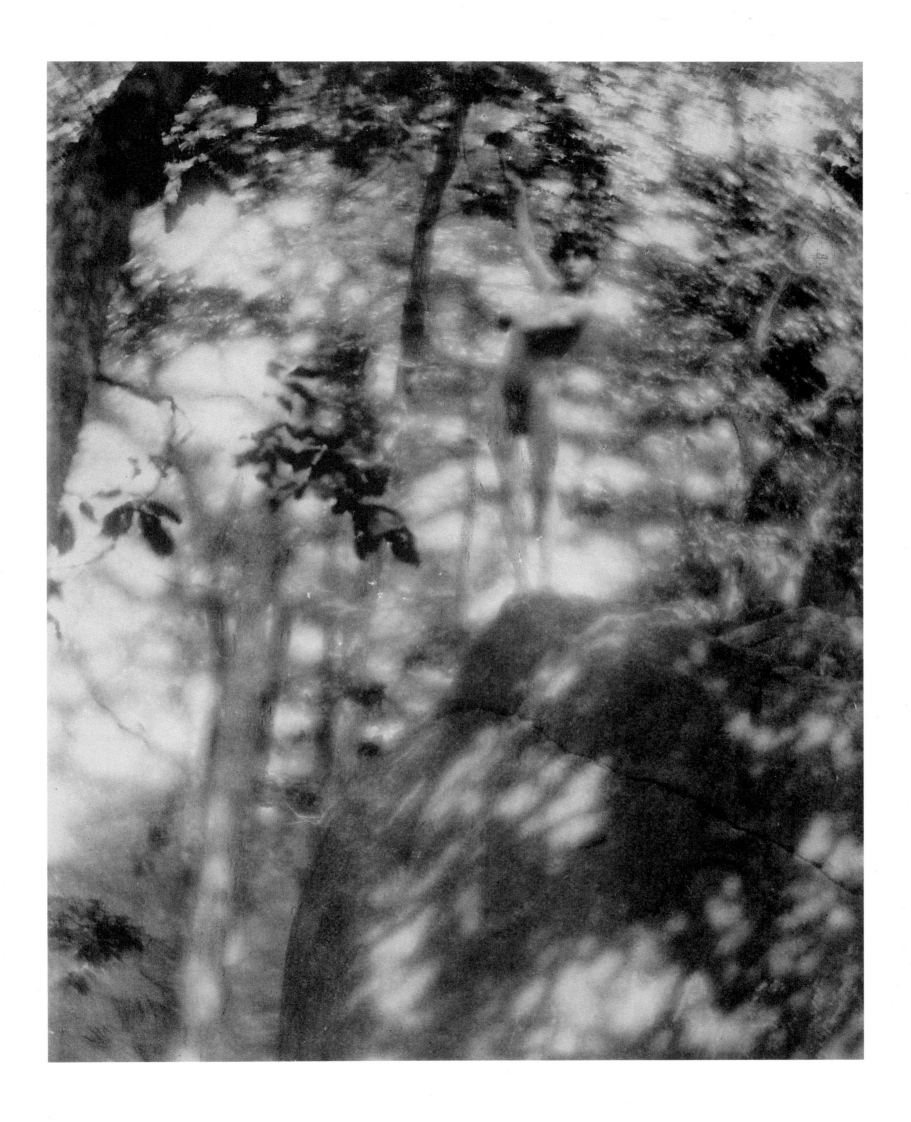

48

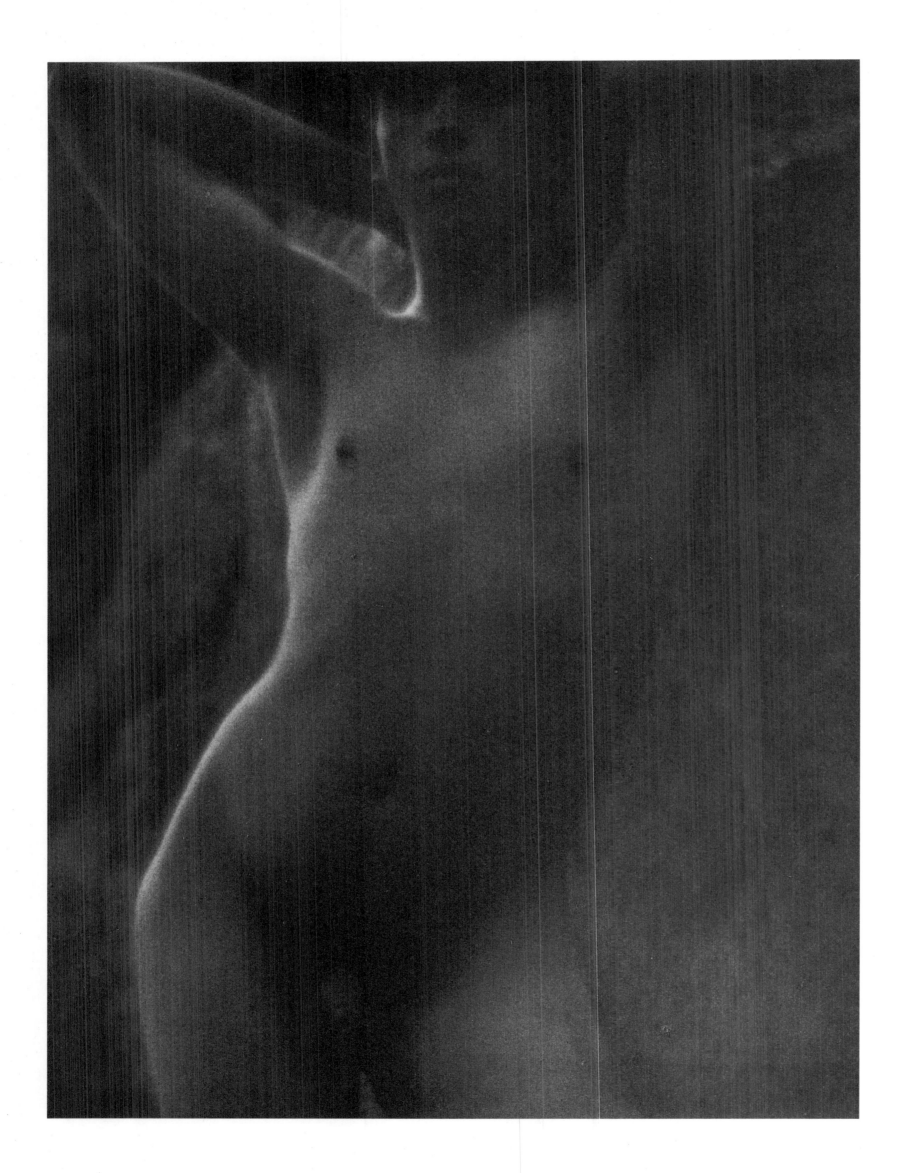

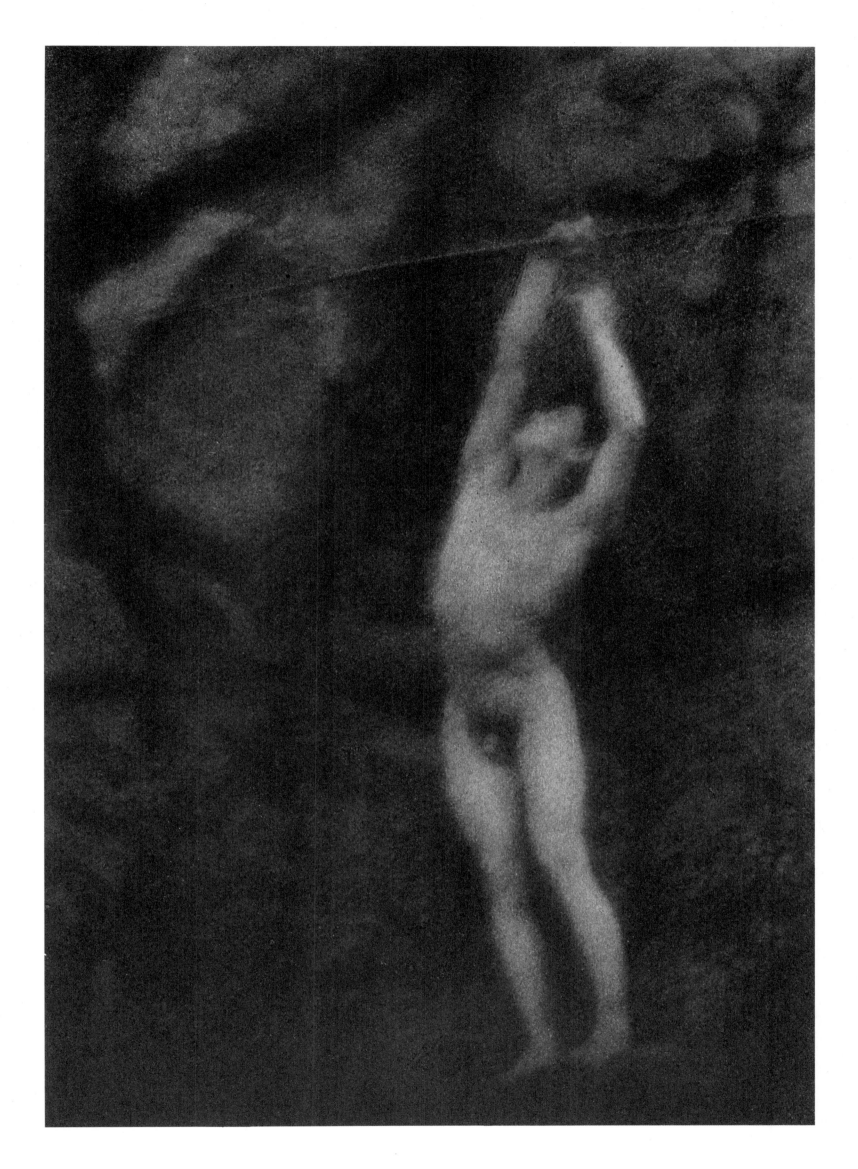

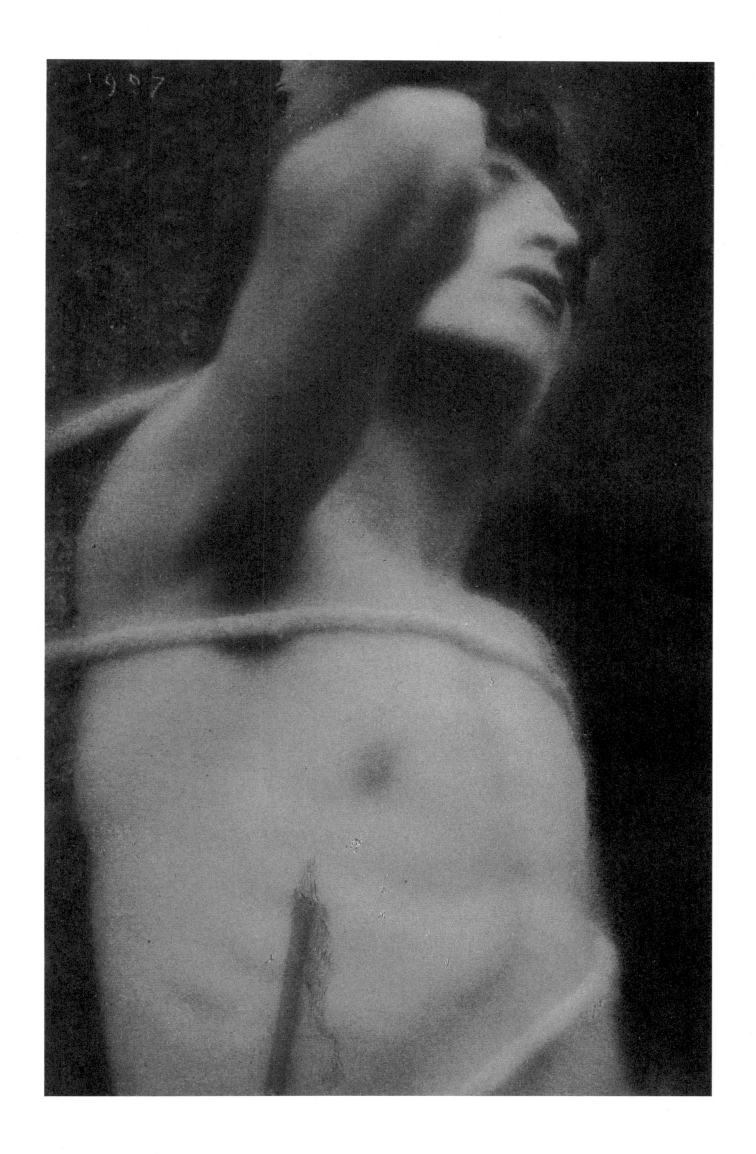

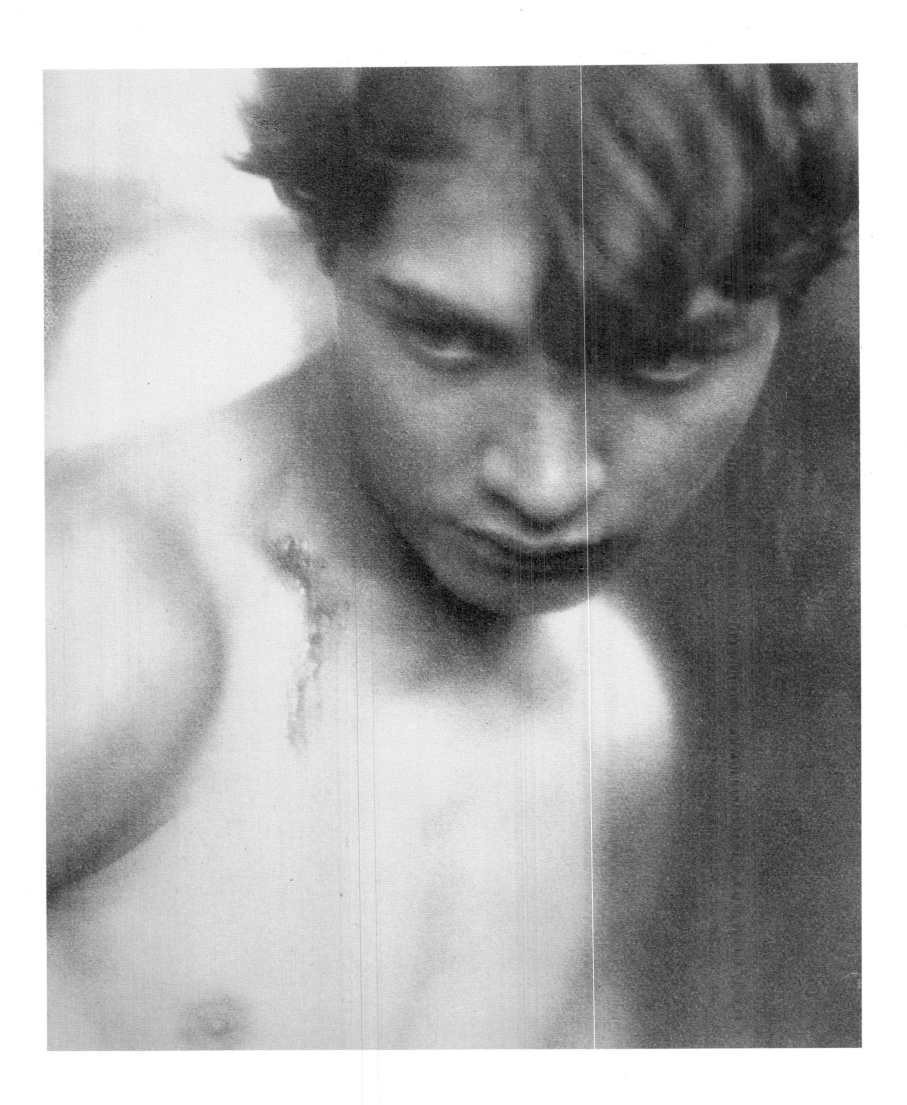

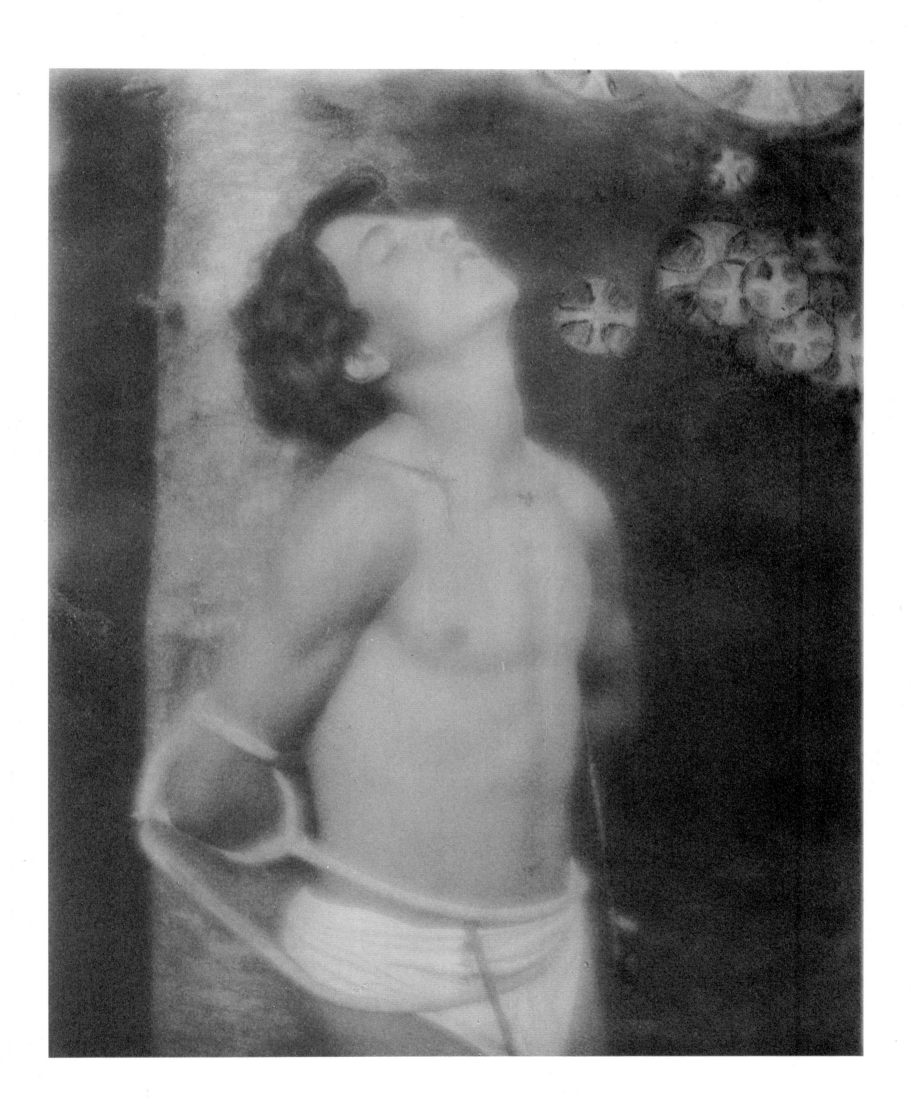

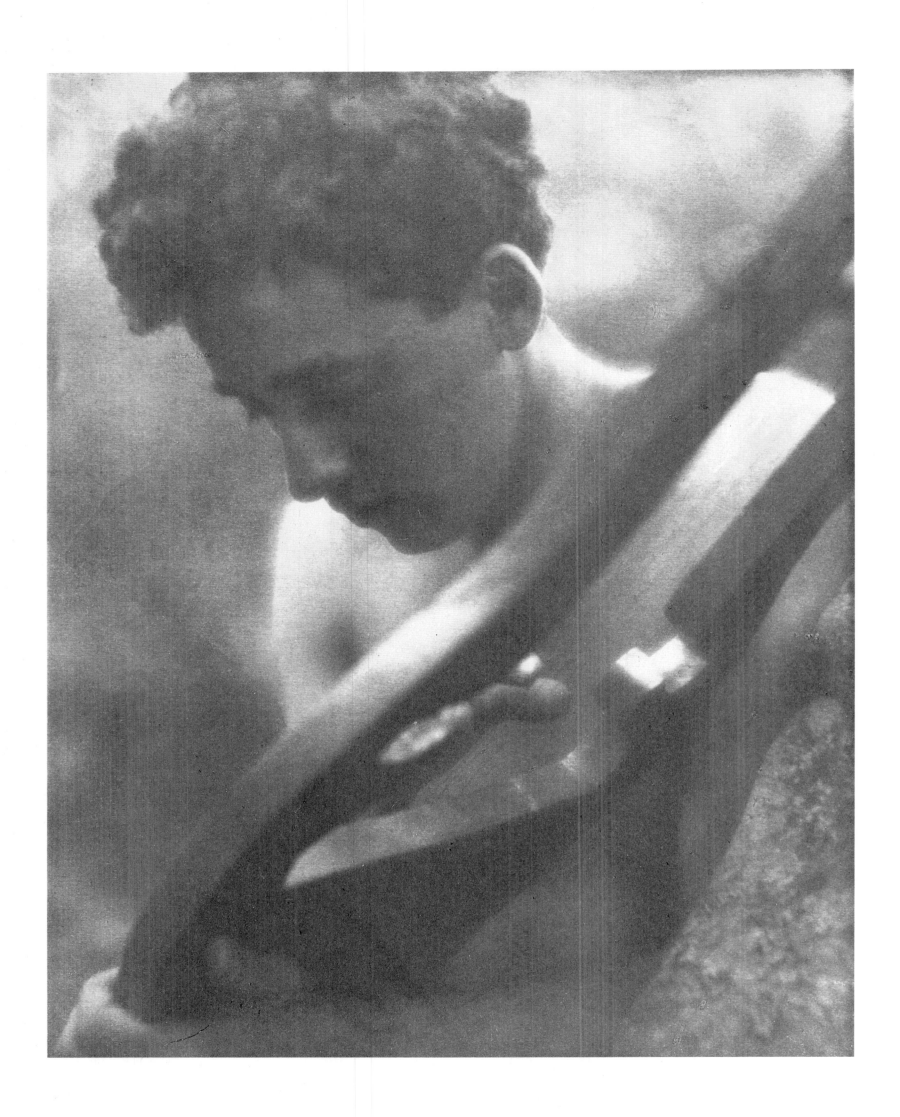

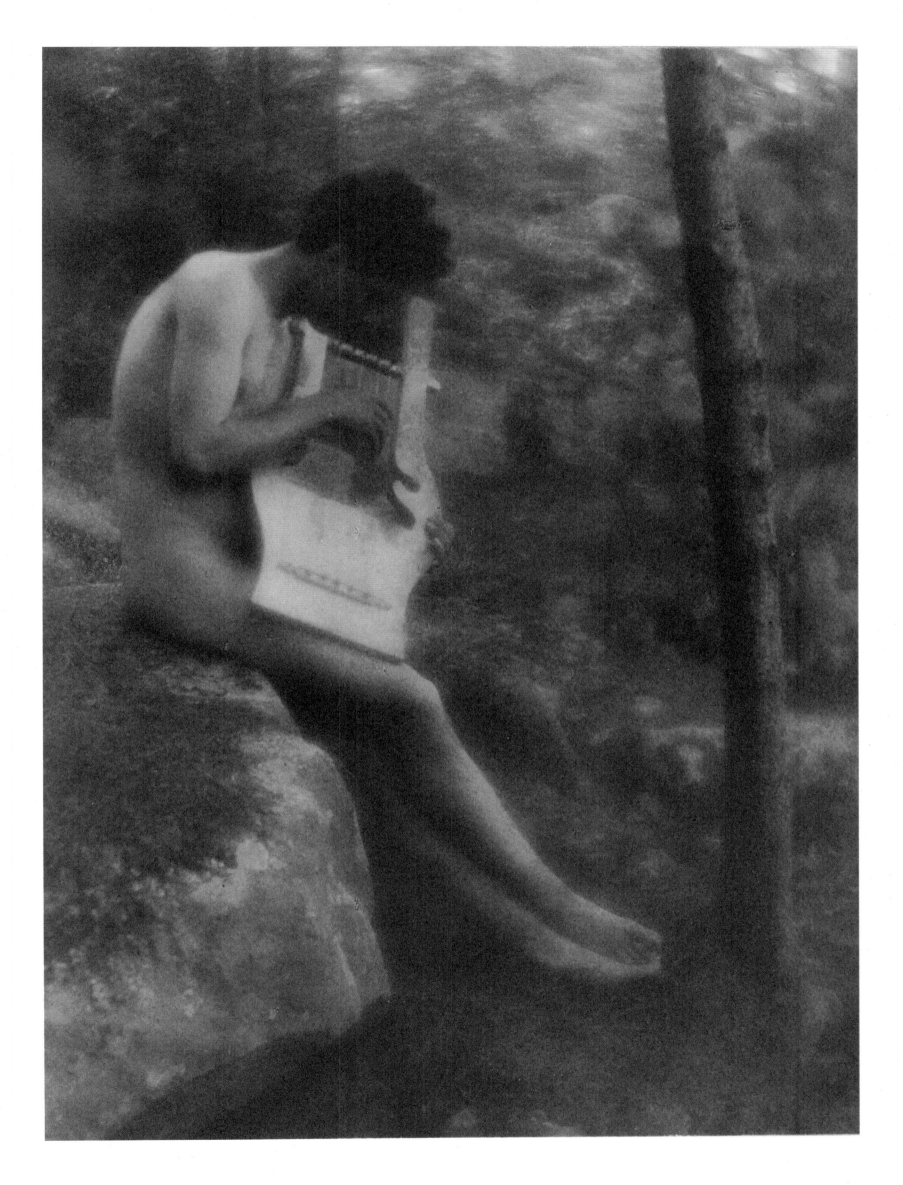

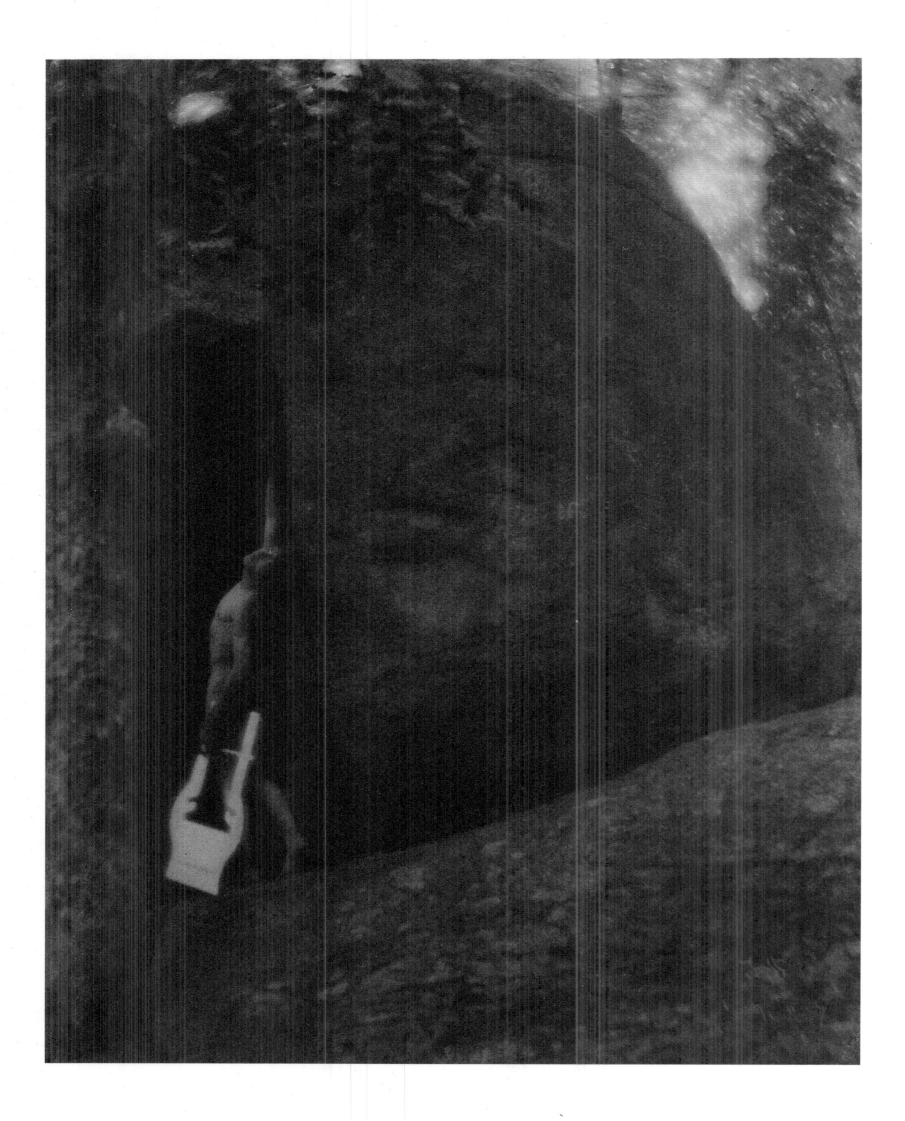

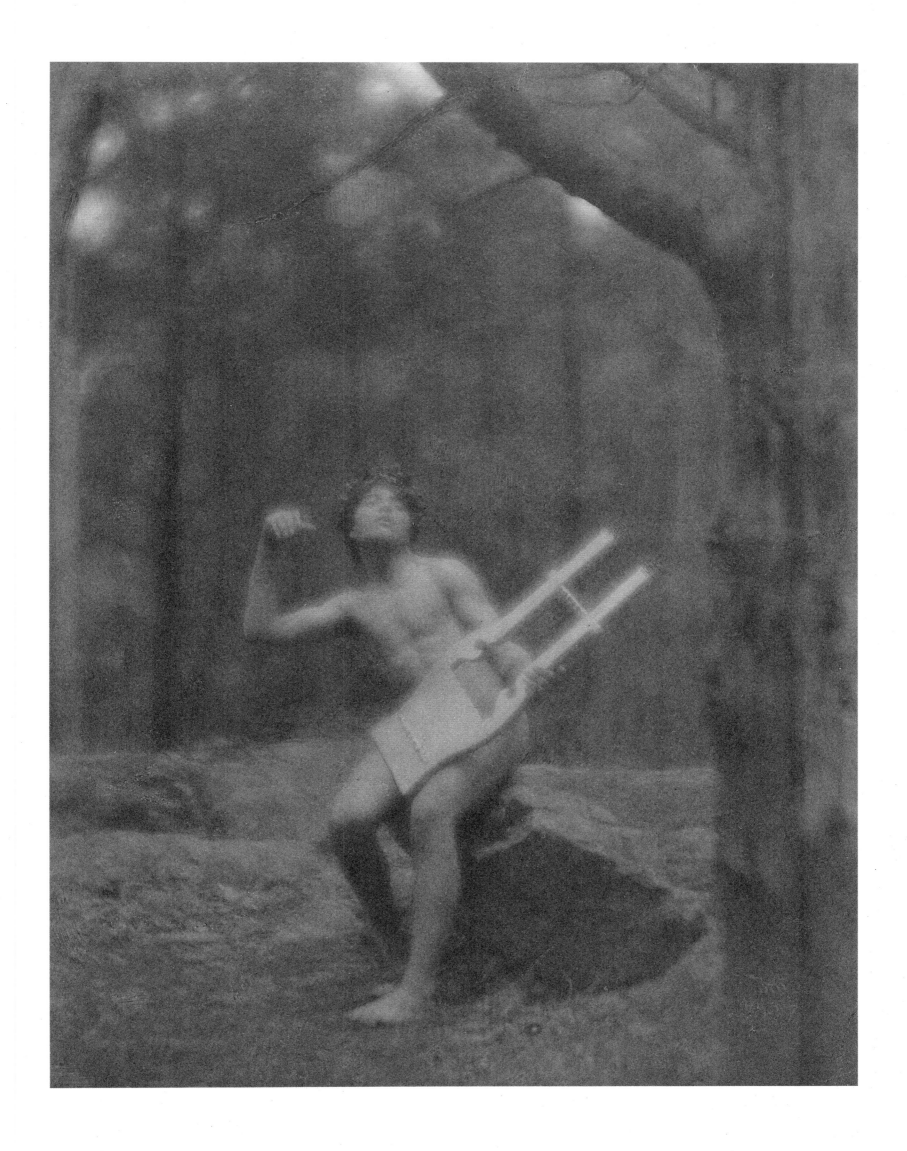

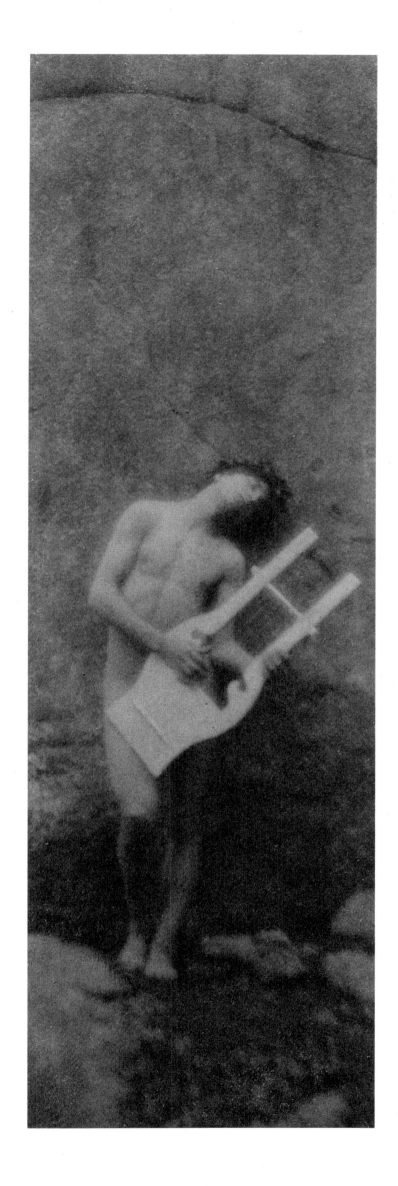

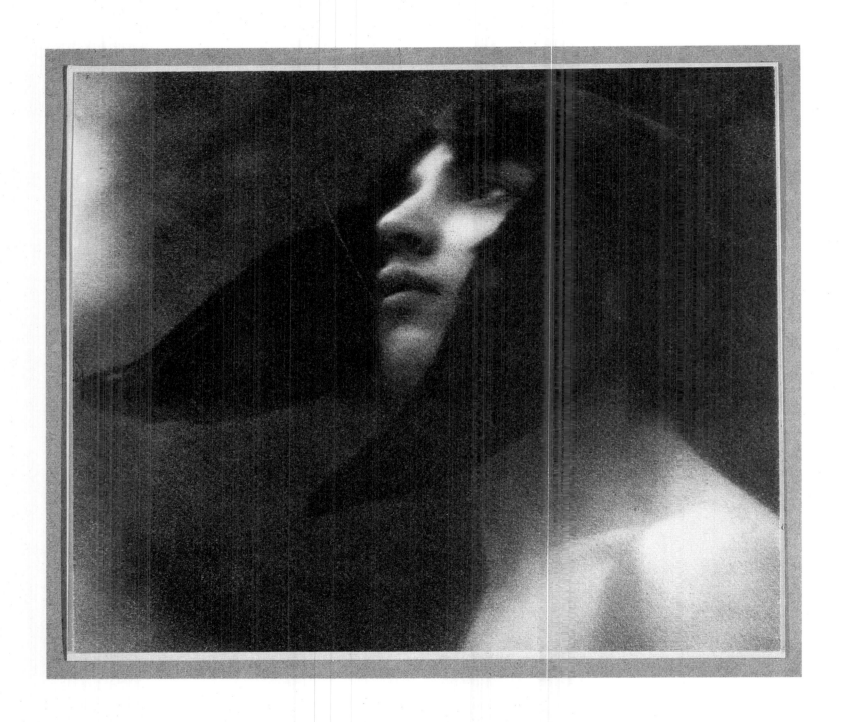

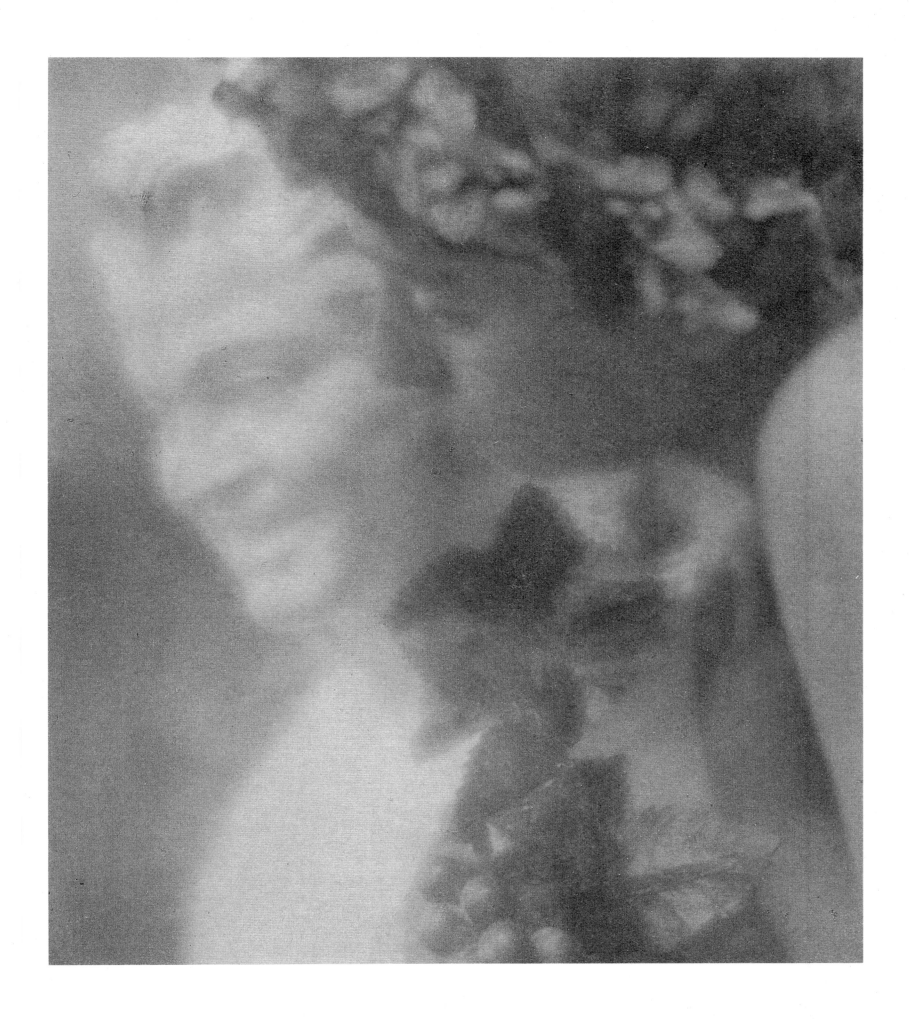

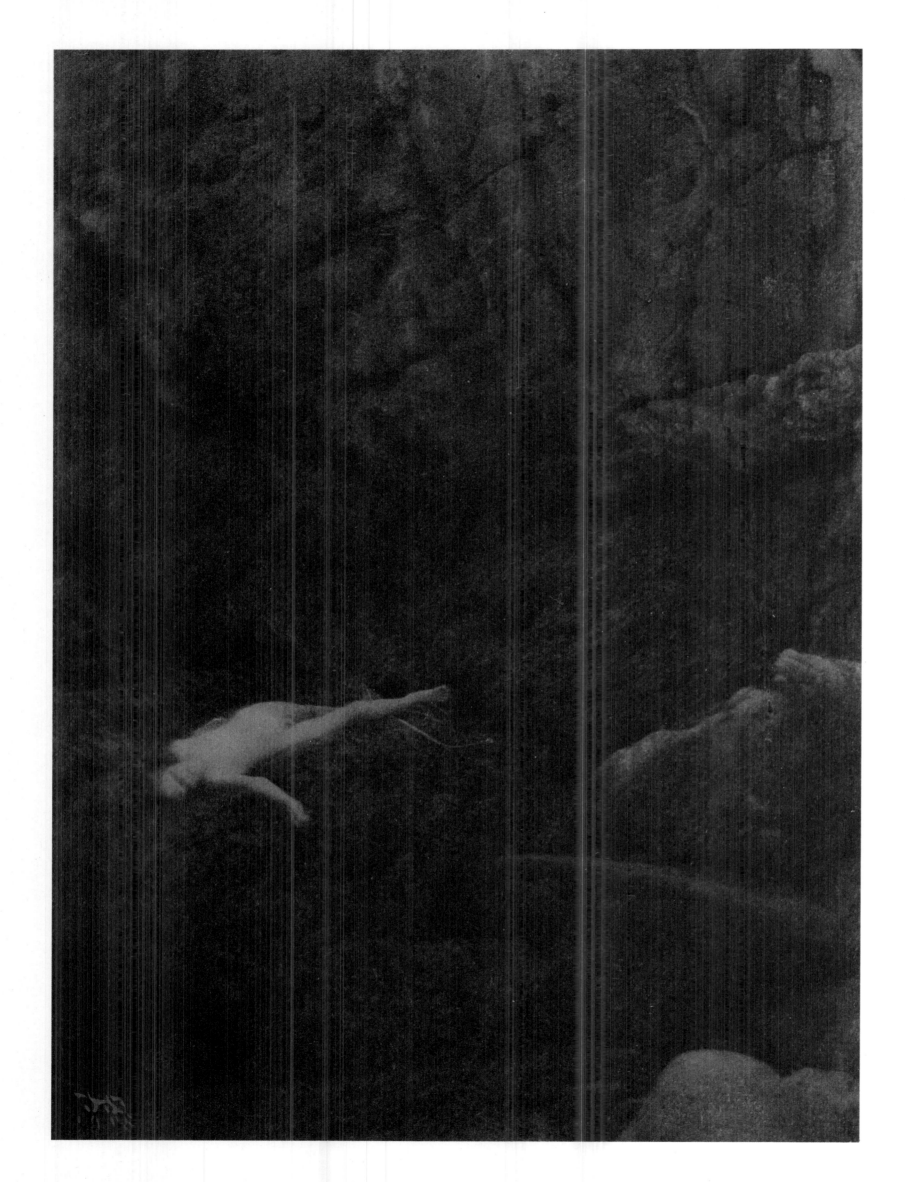

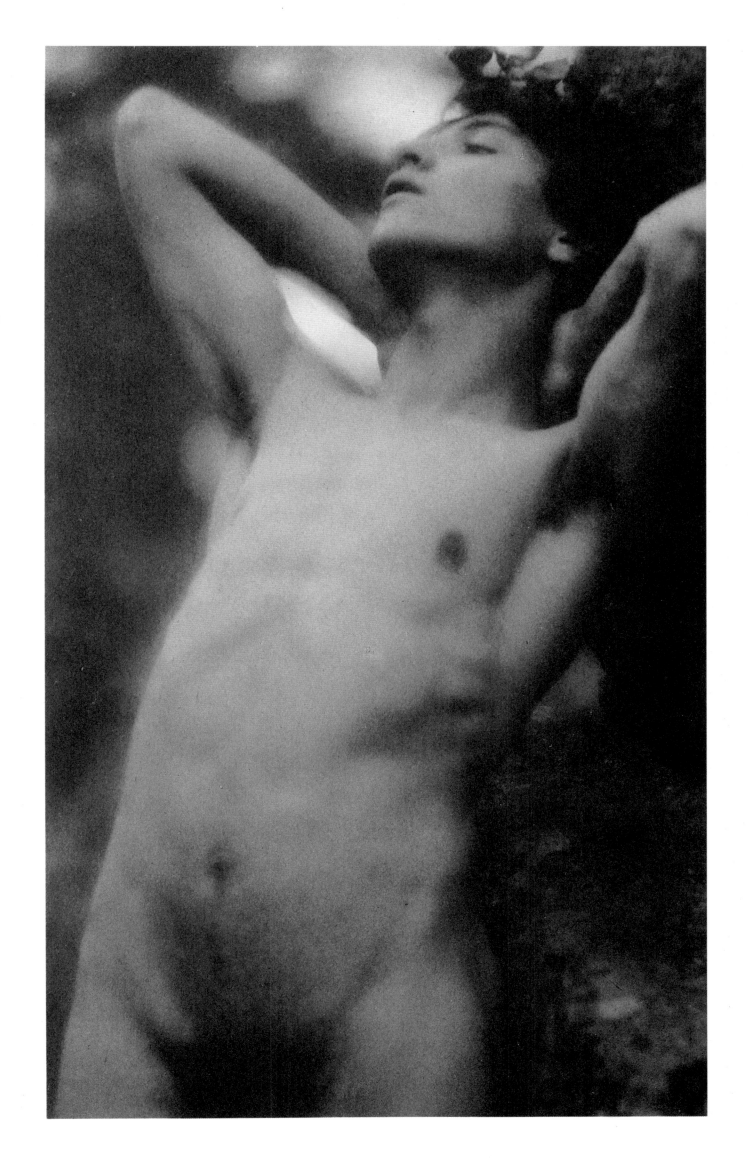

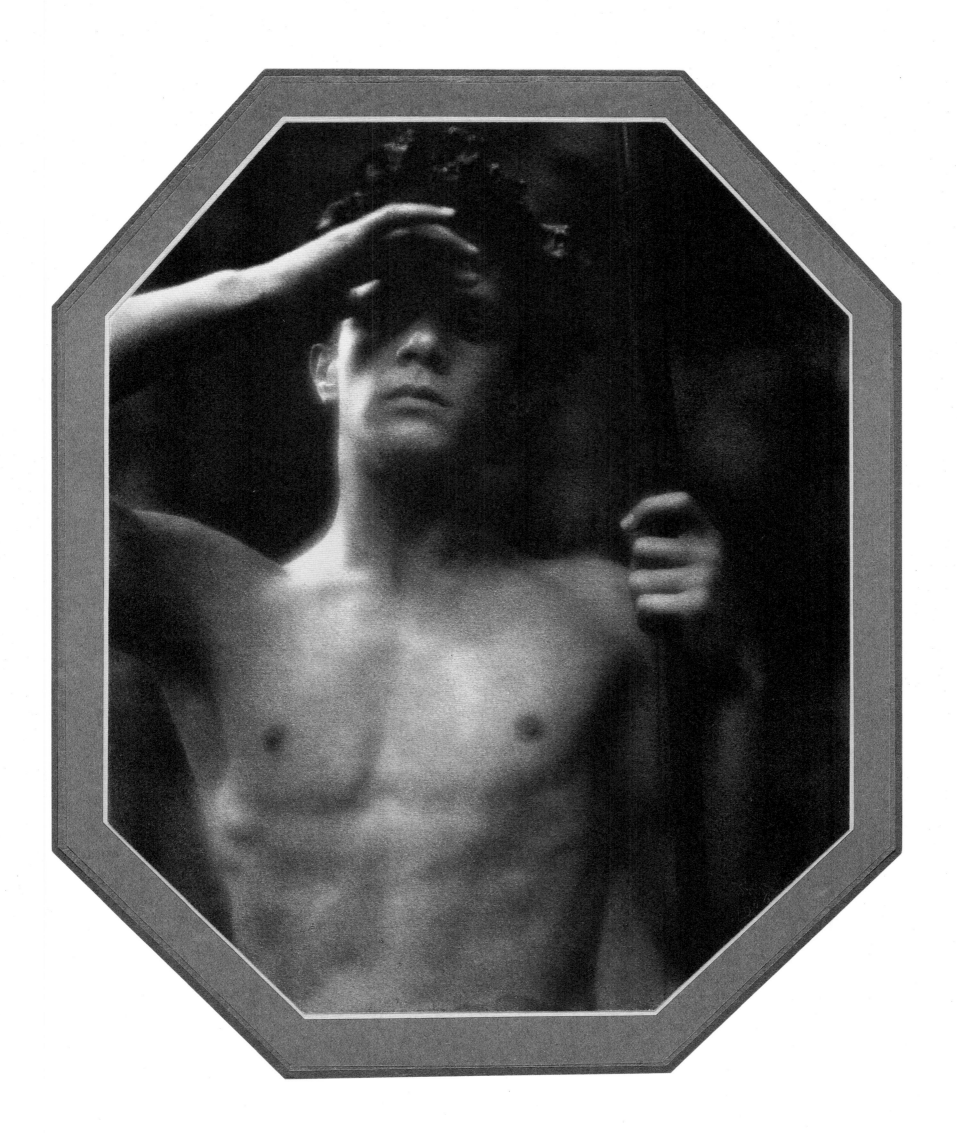

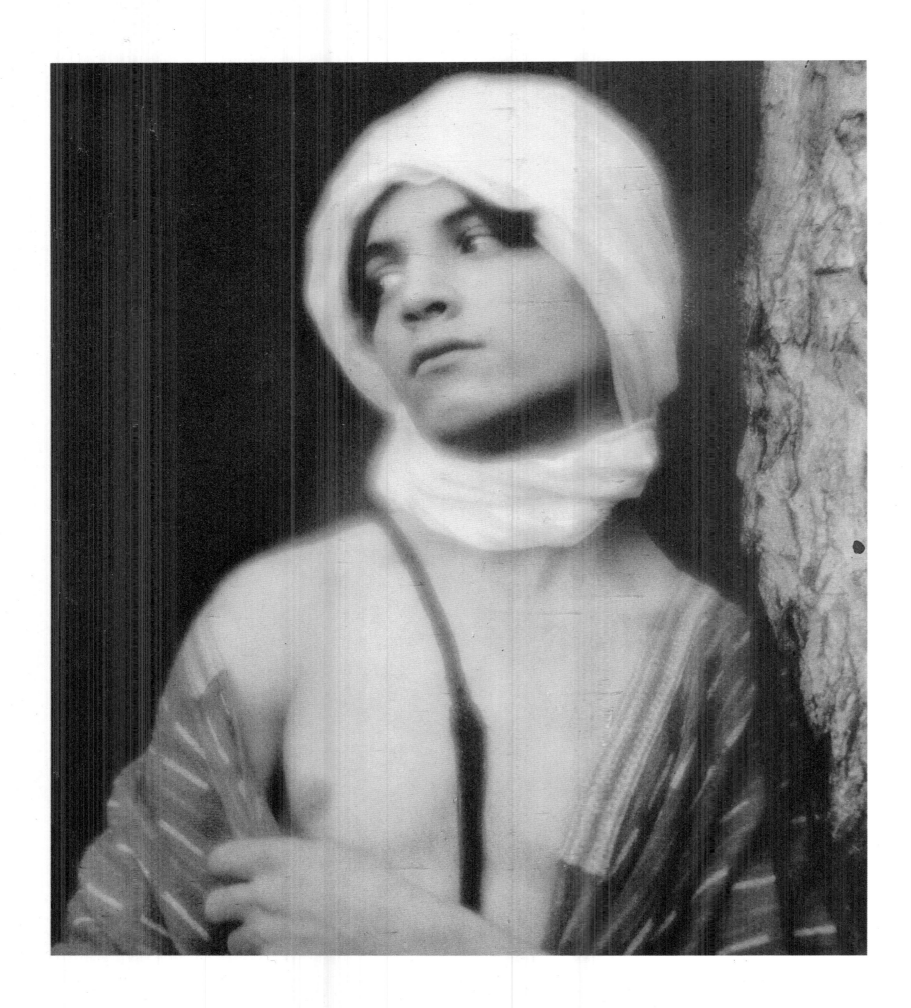

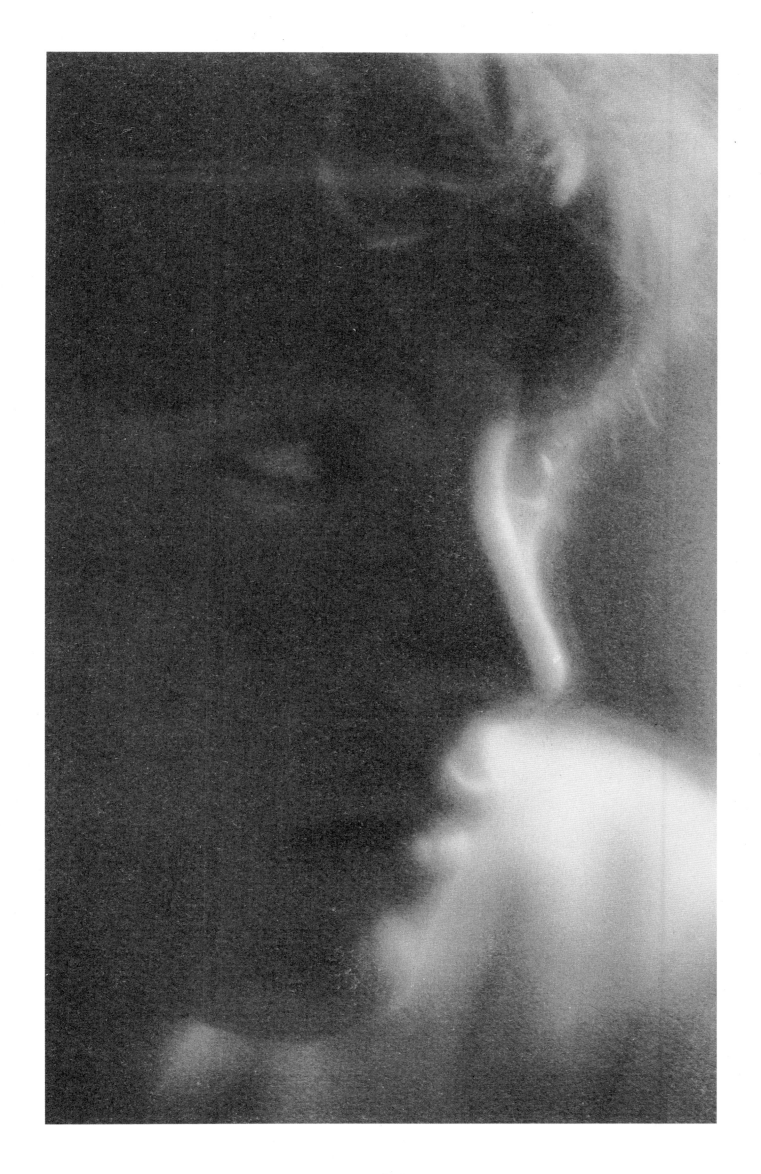

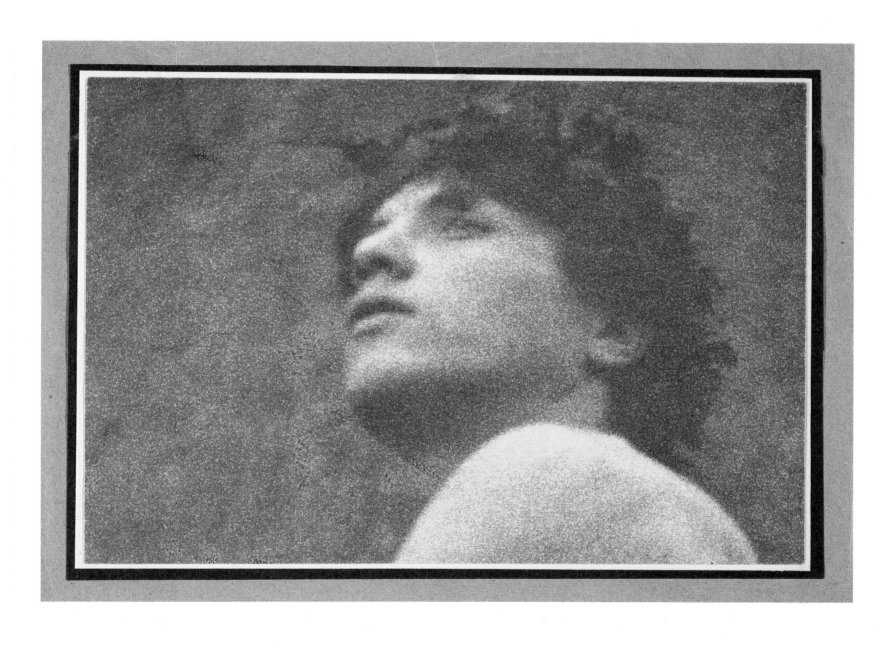

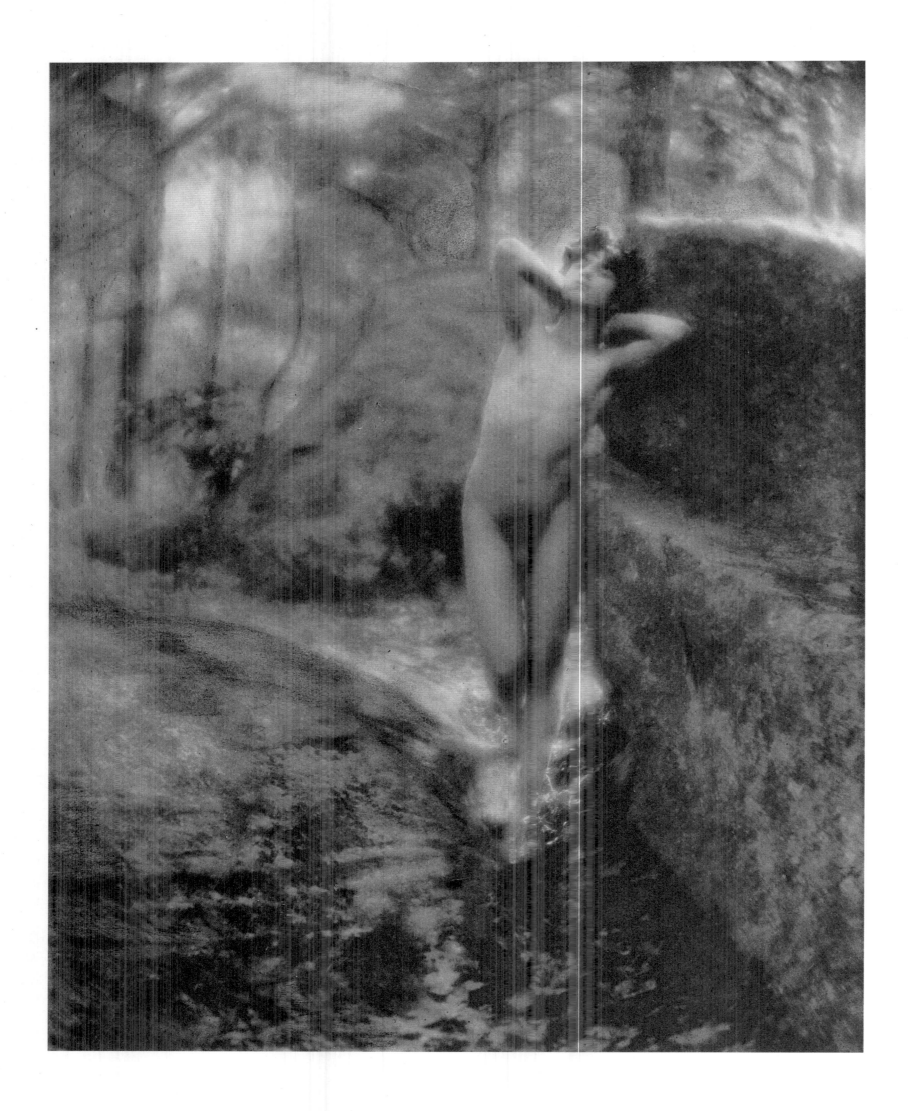

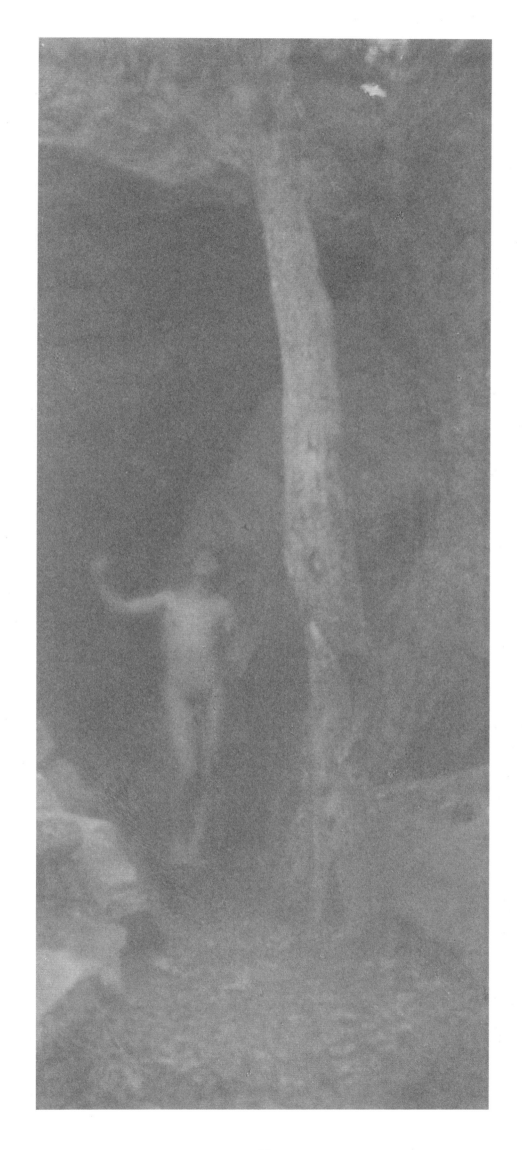

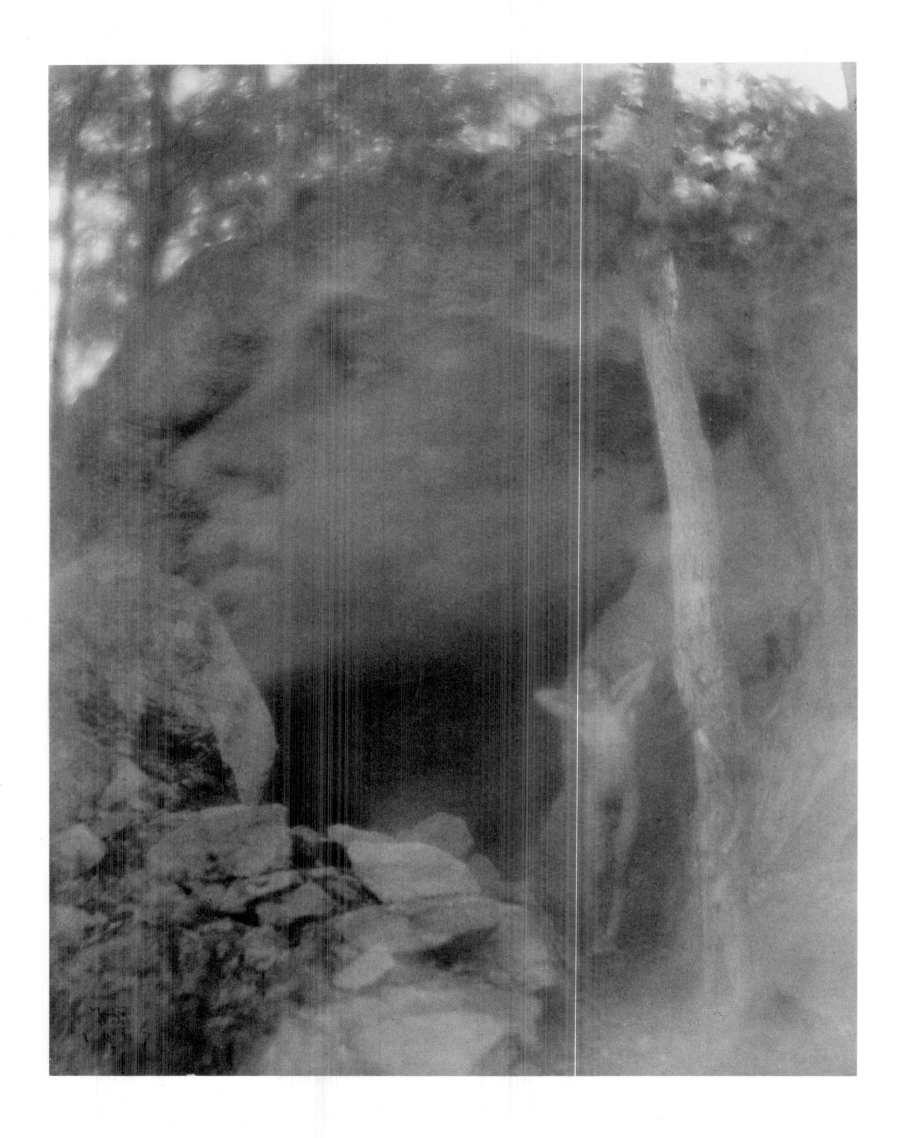

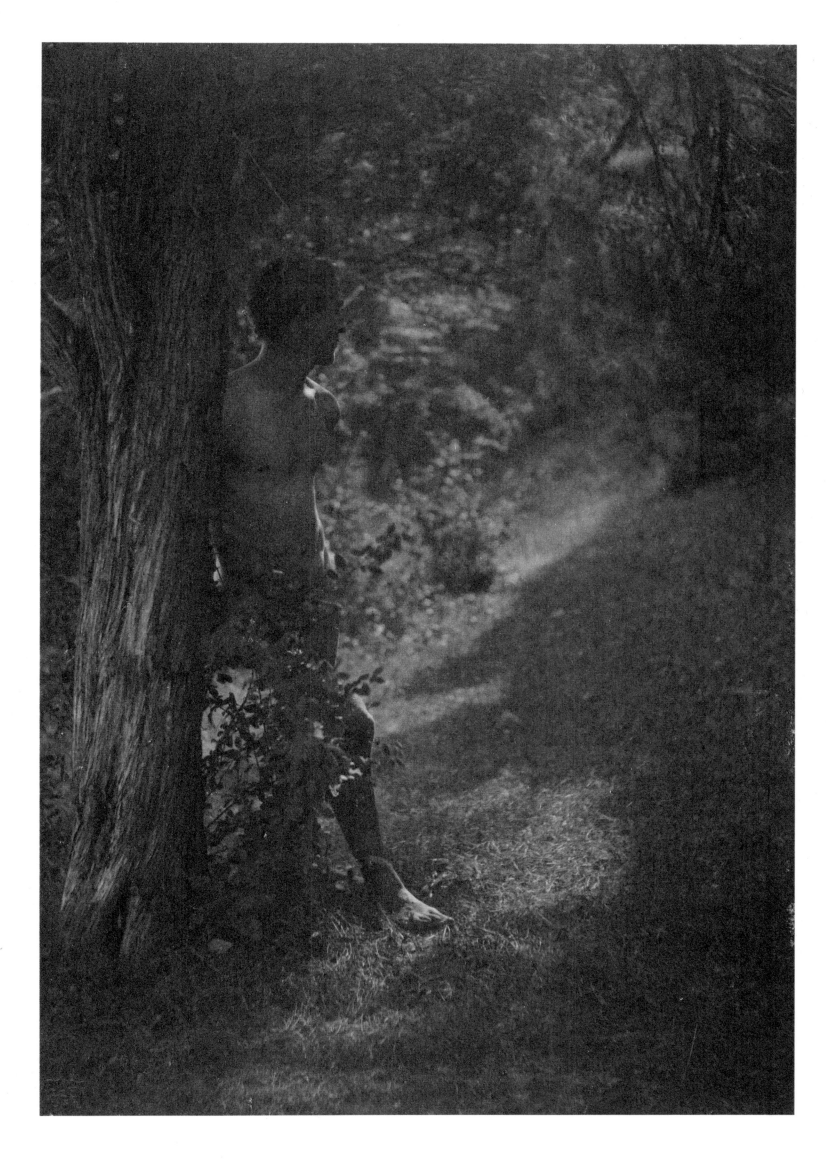

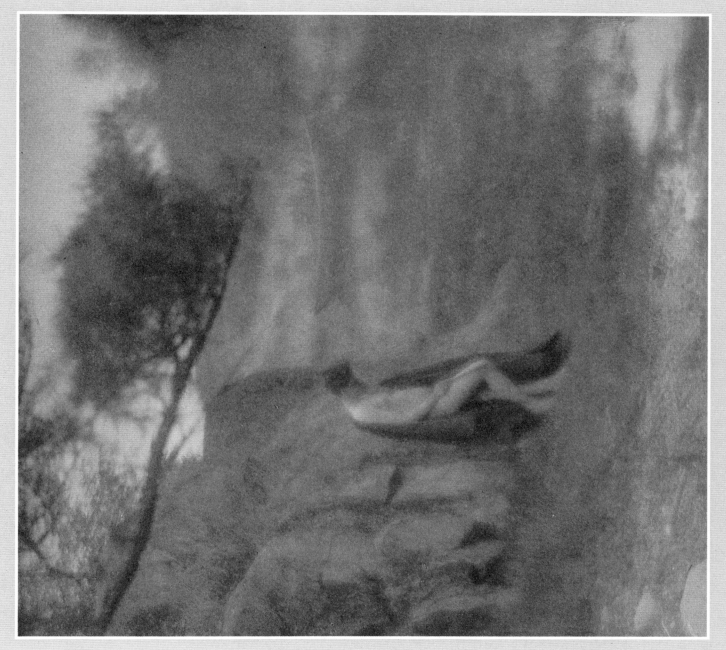

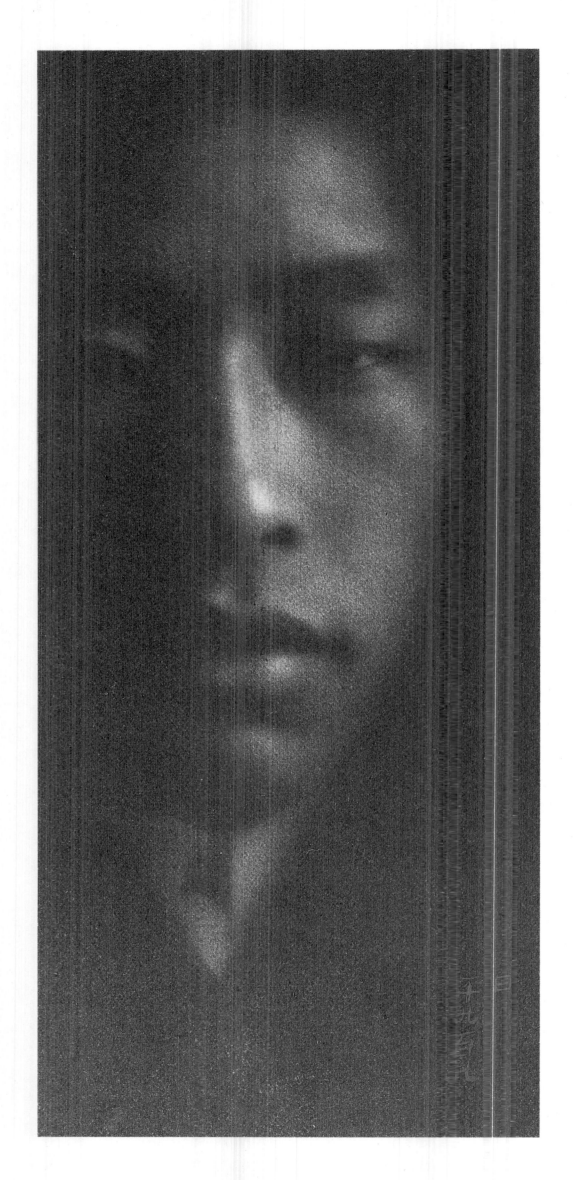

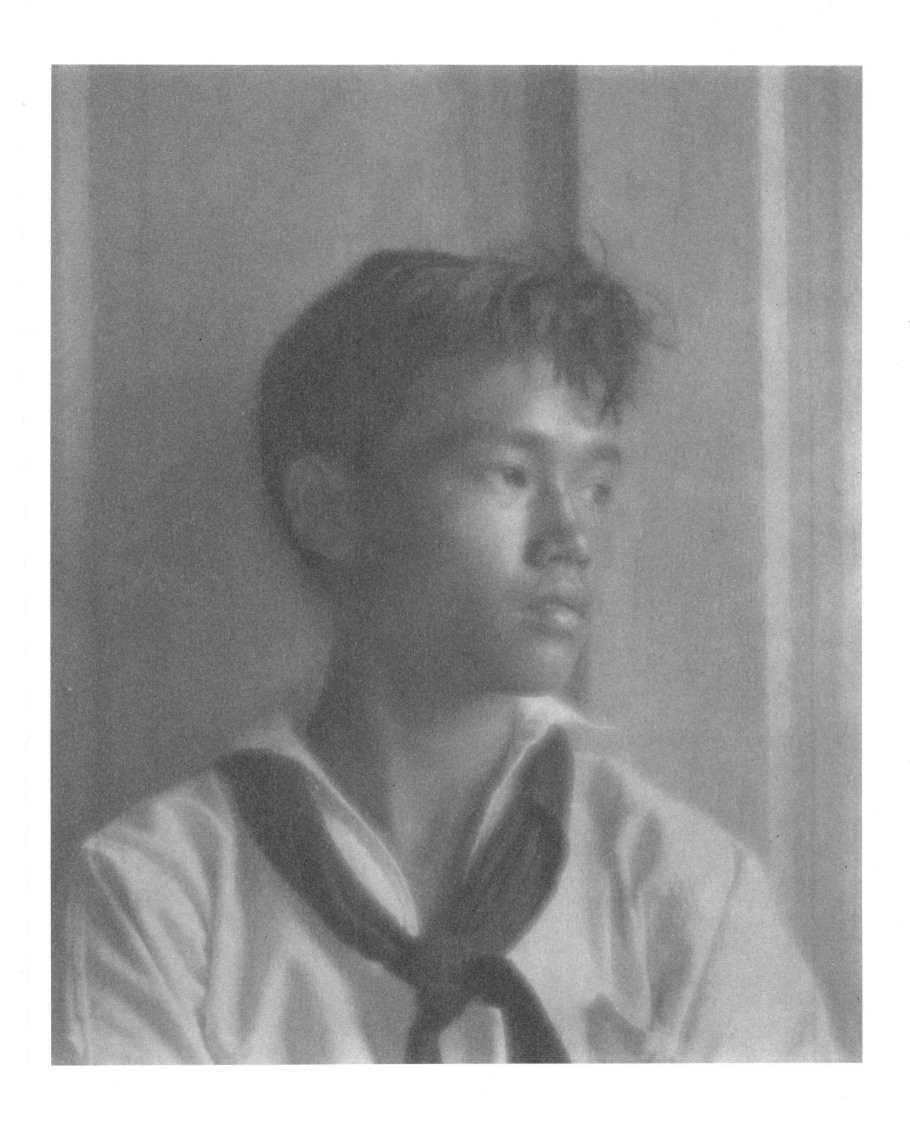

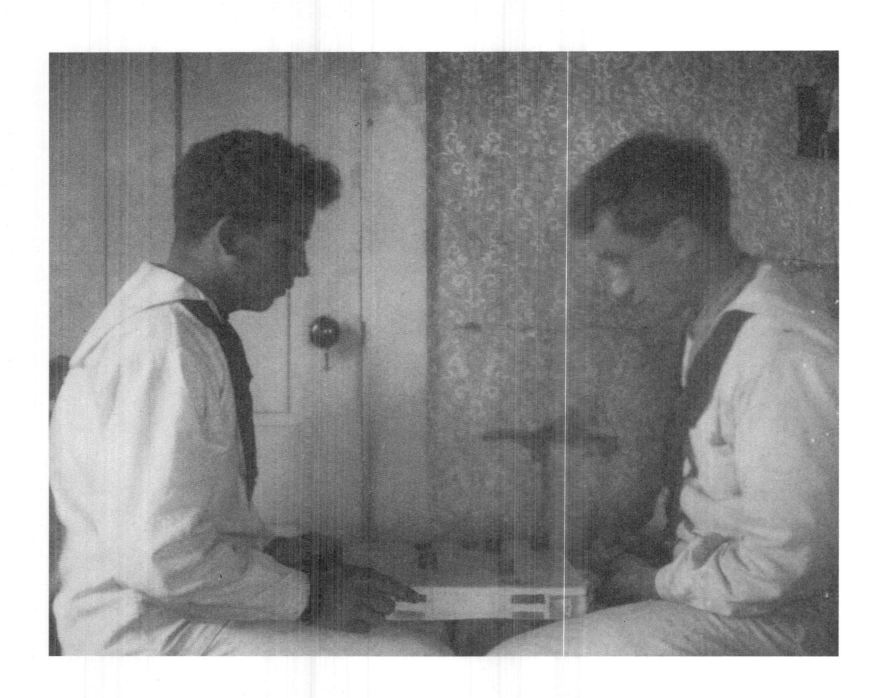

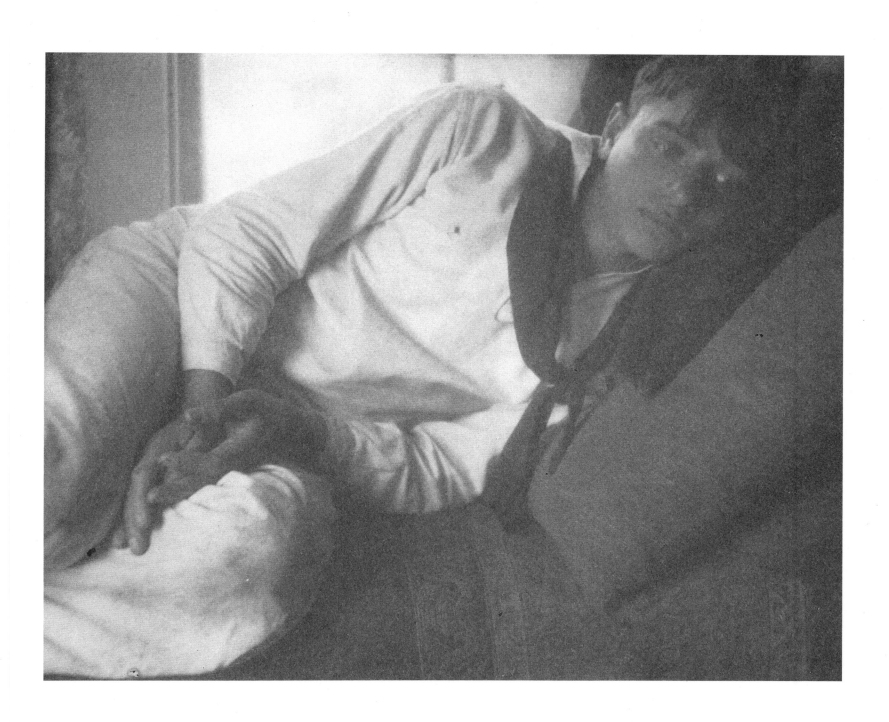

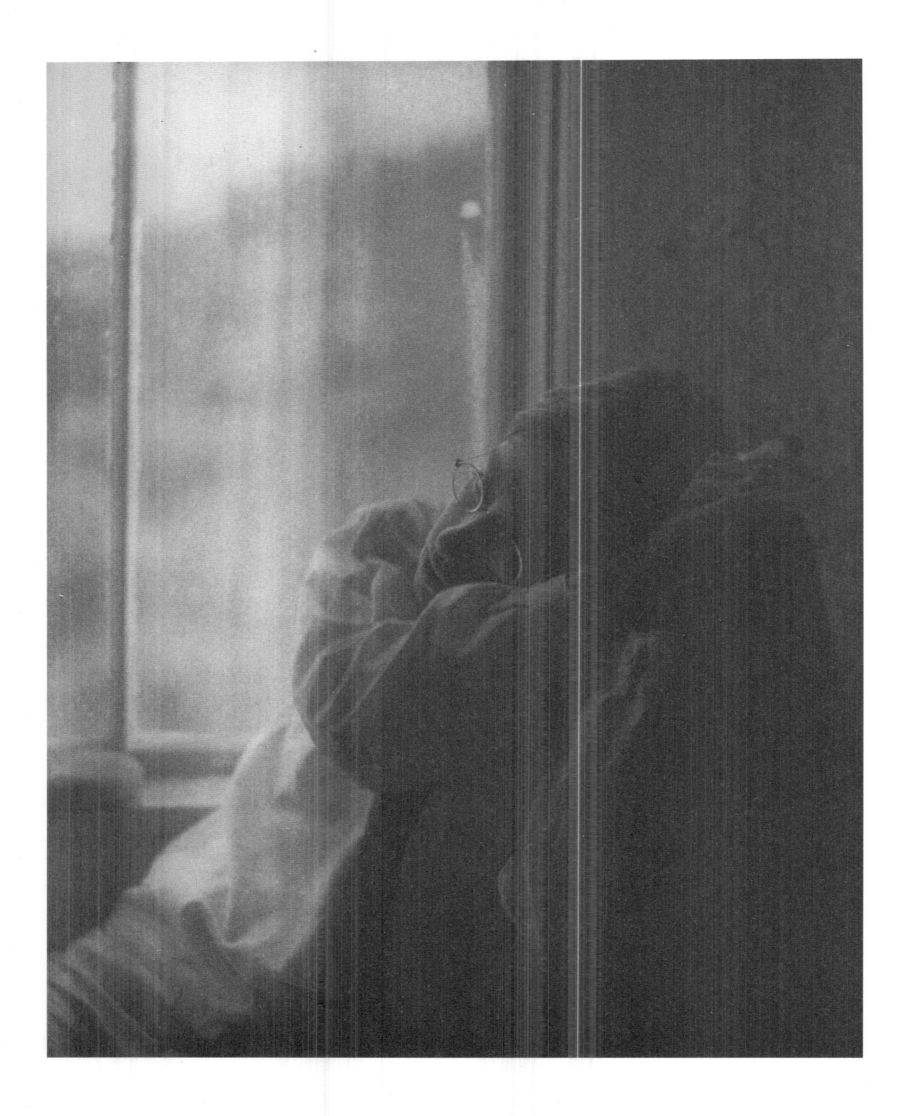

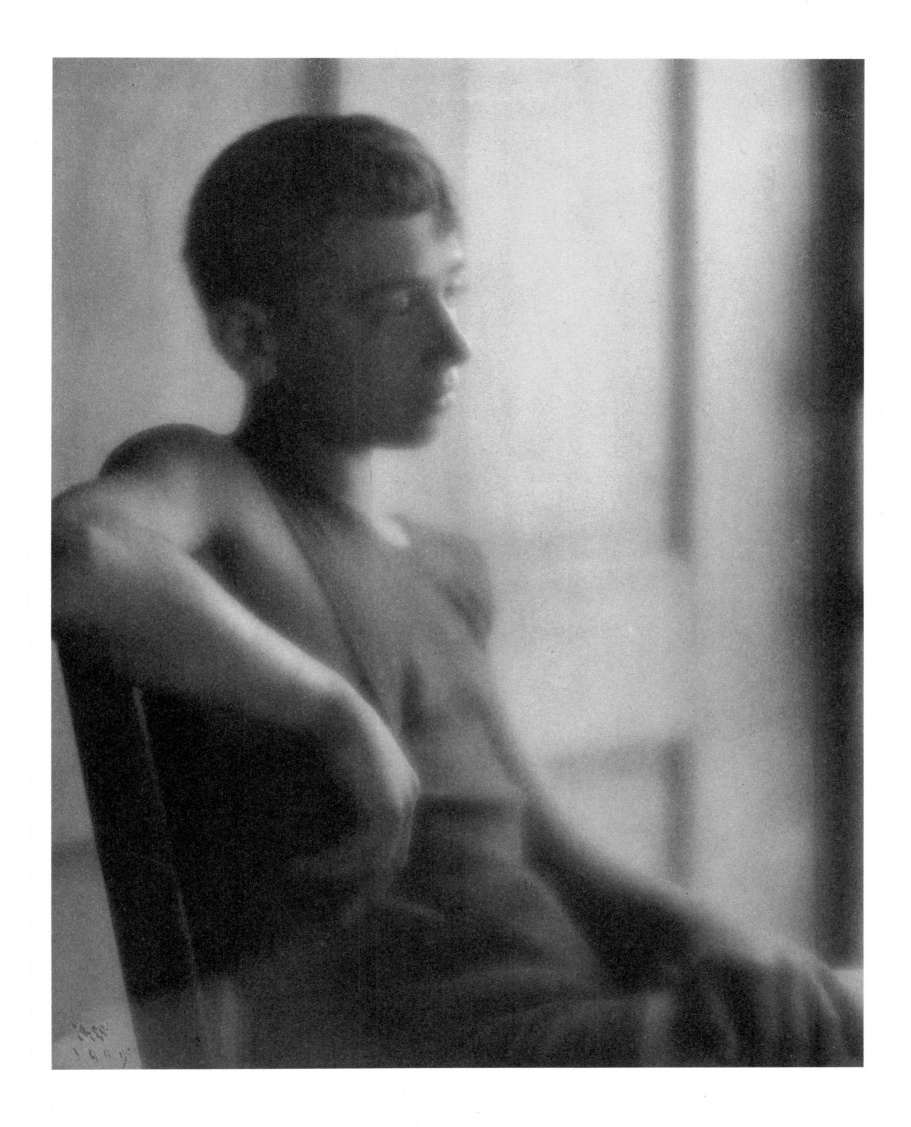

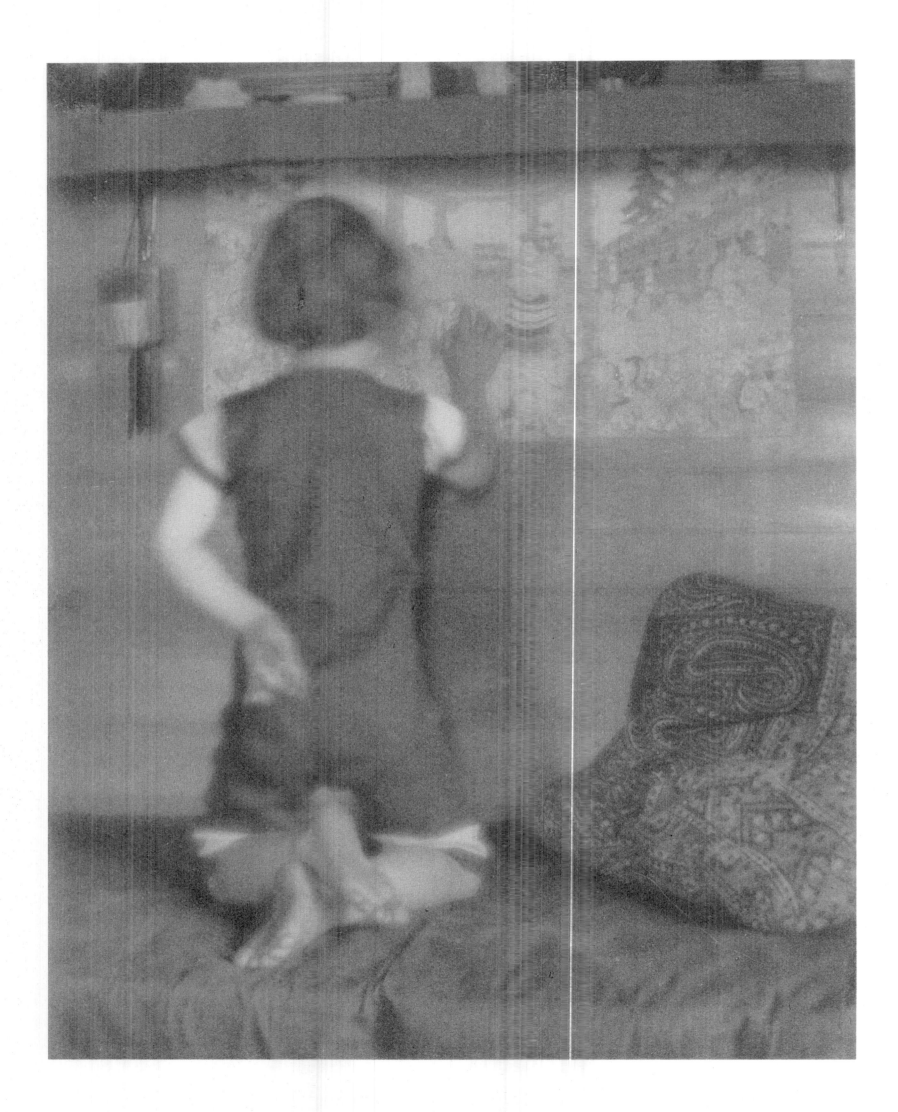

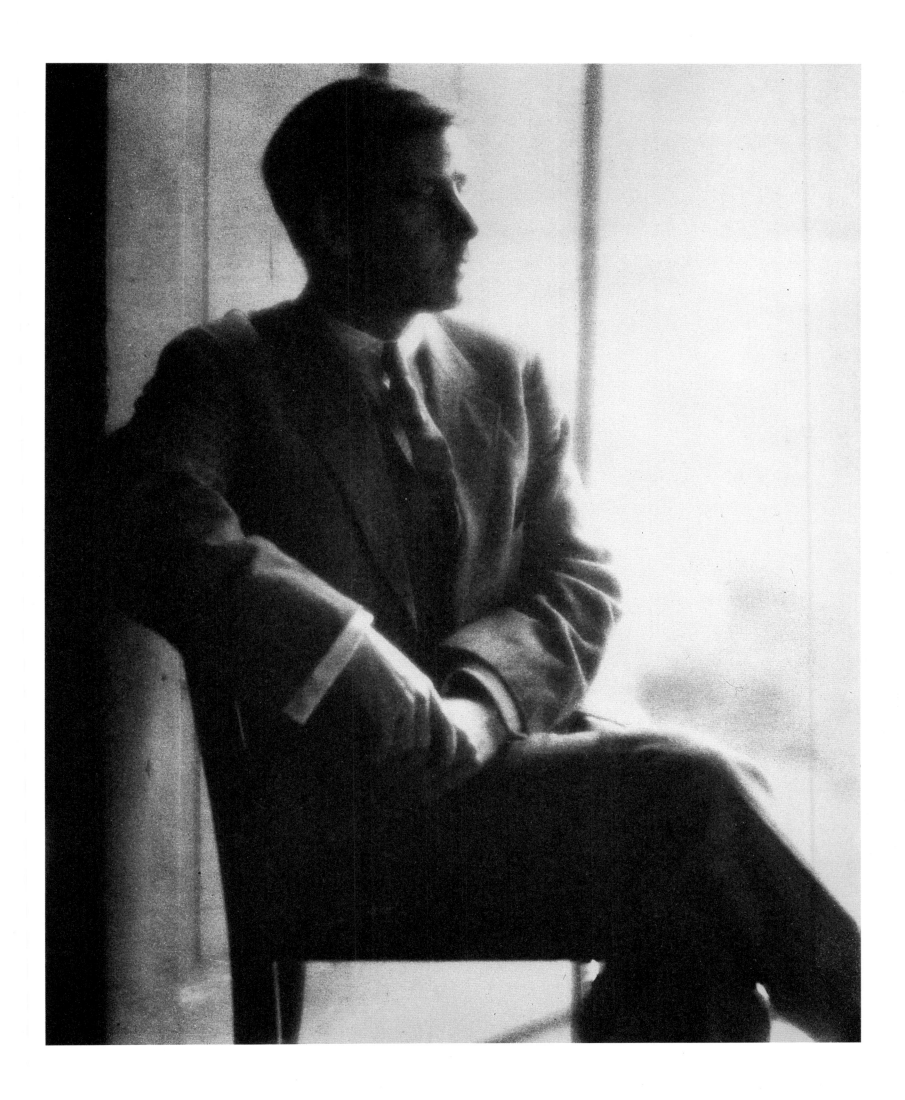

LIST OF PLATES

42. *Boy's Head, Looking Down*, 1905, platinum with gum bichromate, 9 ½ x 7 ½ in. Courtesy Library of Congress, Prints and Photographs Division, PH DAY, F., NO. 192.

43. *Young Woman and Girl in White Dress*, 1905, platinum, 6 ⅞ x 8 ⅛ in. Courtesy Library of Congress, Prints and Photographs Division, PH DAY, F., NO. 173.

44. *Black Man Wearing Hat*, c. 1897, platinum, 6 x 4 ⅜ in. Courtesy The Royal Photographic Society, Bath, RPS 3537.

45. *Girl With White Collar*, c. 1905, Fresson print, 9 ⅝ x 7 ⅜ in. Courtesy The Royal Photographic Society, Bath, RPS 350 .

46. *Nude Youth in Rocky Landscape*, c. 1905, cyanotype, 9 ½ x 7 ⅜ in. Courtesy Library of Congress, Prints and Photographs Division, PH DAY, F., NO. 266.

47. *Face of Youth with Laurel Wreath*, c. 1907, platinum with hand coloring, 9 ¼ x 7 ⅜ in. Courtesy Library of Congress, Prints and Photographs Division, PH DAY, F., NO. 356.

48. *Nude Youth in Rocky Landscape*, c. 1907, platinum with hand coloring, 9 ½ x 7 in. Courtesy Library of Congress, Prints and Photographs Division, PH DAY, F., NO. 360.

49. *Nude Youth in Shadow*, c. 1909, platinum, 9 ½ x 7 in. Courtesy Library of Congress, Prints and Photographs Division, PH DAY, F., NO. 473.

50. *The Archer*, c. 1905, platinum with hand coloring, 7 ¾ x 5 in. Courtesy Library of Congress, Prints and Photographs Division, PH DAY, F., NO. 262.

51. *Saint Sebastian*, c. 1906, platinum with hand coloring, 5 ⅞ x 3 ½ in. Courtesy Library of Congress, Prints and Photographs Division, PH DAY, F., NO. 345.

52. *Saint Sebastian with Wound*, c. 1906, platinum, 9 ⅛ x 7 ⅜ in. Courtesy Library of Congress, Prints and Photographs Division, PH DAY, F., NO. 344.

53. *Saint Sebastian*, c. 1906, platinum with hand coloring, 9 ¾ x 7 ¾ in. Courtesy Library of Congress, Prints and Photographs Division, PH DAY, F., NO. 338.

54. *Orpheus*, 1907, platinum, 7 ⅞ x 9 ⅝ in. Courtesy Library of Congress, Prints and Photographs Division, PH DAY, F., NO. 377.

55. *Nude Youth with Lyre (Orpheus)*, 1907, platinum, 8 ¾ x 6 ⅜ in. Courtesy The Royal Photographic Society, Bath, RPS 35-1.

56. *Orpheus Before His Grotto*, c. 1907, platinum, 7 ⅝ x 9 ½ in. Courtesy Library of Congress, Prints and Photographs Division, PH DAY, F., NO. 389.

57. *Orpheus*, ("The Last Chord and Then No More") 1907, platinum, 9 ¾ x 7 ¾ in. Courtesy Library of Congress, Prints and Photographs Division, PH DAY, F., NO. 403.

58. *Orpheus*, 1907, platinum, 8 x 2 ½ in. Courtesy Library of Congress, Prints and Photographs Division, PH DAY, F. NO. 385.

59. *Youth with Winged Hat*, c. 1905, platinum, 5 ½ x 6 ¾ in. Courtesy Library of Congress, Prints and Photographs Division, PH DAY, F., NO. 347.

60. *Boy with Herm of Pan*, 1905, 6 x 7 ⅜ in. Courtesy Library of Congress, Prints and Photographs Division, PH DAY, F. NO. 12A.

61. *Nude Youth With Bow in Landscape*, c. 1905 platinum, 6 ⅜ x 4 ⅝ in. Courtesy Library of Congress, Prints and Photographs Division, PH DAY, F., NO 256.

62. *Nude Youth with Laurel Wreath Standing Against Rocks*, c. 1907, platinum, 7 ⅞ x 4 ¾ in. Courtesy Library of Congress, Prints and Photographs Division, PH DAY, F., NO. 367.

63. *Pilate*, c. 1906, platinum, 9 ¼ x 7 ½ in. octagon. Courtesy Library of Congress, Prints and Photographs Division, PH DAY, F., NO. 315.

64. *Youth in North African Costume*, c. 1907, platinum, 8 ⅛ x 7 ½ in. Courtesy Library of Congress, Prints and Photographs Division, PH DAY, F., NO. 353.

65. *Face of a Young Man*, c. 1906, platinum, 4 ⅛ x 3 ¾ in. Courtesy Library of Congress, Prints and Photographs Division, PH DAY, F., NO. 329.

66. *Face of Youth with Laurel Wreath*, c. 1907, platinum with hand coloring, 4 ⅞ x 7 in. Courtesy Library of Congress, Prints and Photographs Division, PH DAY, F., NO. 358.

67. *Nude Youth in Dappled Woods*, c. 1907, platinum with hand coloring, 9 ⅜ x 7 ½ in. Courtesy Library of Congress, Prints and Photographs Division, PH DAY, F., NO. 364.

68. *The Return to Earth*, from *Orpheus* series, 1907, platinum, 9 ⅝ x 4 in. Courtesy The Royal Photographic Society, Bath, RPS 3511.

69. *The Paion*, from *Orpheus* series, 1907, platinum, 9 ⅝ x 7 ⅝ in. Courtesy The Royal Photographic Society, Bath, RPS 3510.

70. *Nude Man in Woods*, c. 1907 platinum, 5 ⅜ x 4 ¾ in. Courtesy The Royal Photographic Society, Bath, RPS 3566.

71. *The Prodigal*, 1909, platinum, 7 ⅝ x 12 ¾ in. Courtesy The Royal Photographic Society, Bath, RPS 3521.

72. *Hirota Hyakubata*, 1909, platinum, 7 ½ x 3 ⅜ in. Courtesy Library of Congress, Prints and Photographs Division, PH DAY, F., NO. 426.

73. *David Leung in Sailor Suit*, 1911, cyanotype, 9 ⅞ x 7 ⅞ in Courtesy Library of Congress, Prints and Photographs Division, PH DAY, F., NO. 541.

74. *Boys in Sailor Suits Playing Checkers*, 191 , cyanotype, 8 x 9 ⅞ in. Courtesy Library of Congress, Prints and Photographs Division, PH DAY, F., NO. 565.

75. *Tony Costanza in Sailor Suit*, 1911, cyanotype, 8 x 9 ⅞ in. Courtesy Library of Congress, Prints and Photographs Division, PH DAY, F., NO. 580.

76. *"Piggy" Costanza in Sailor Suit*, 1911, cyanotype, 9 ⅞ x 8 in. Courtesy Library of Congress, Prints and Photographs Division, PH DAY, F., NO. 571.

77. *Tony Costanza in Athletic Shirt*, 1909, platinum, 9 ½ x 7 H in. Courtesy Library of Congress, Prints and Photographs Division, PH DAY, F., NO. 450.

78. *Child on Couch*, c. 1910, platinum, 9 ⅞ x 7 ⅞ in. Courtesy Library of Congress, Prints and Photographs Division, PH DAY, F., NO. 549.

79. *Clarence Waite in Suit*, c. 1910, platinum with gum bichromate, 9 ½ x 7 ⅞ in. Courtesy Library of Congress, Prints and Photographs Division, PH DAY, F., NO. 502.

80. *Maynard White on the Seashore,* c. 1910, platinum, 1 ¾ x 6 ¼ in. Courtesy Library of Congress, Prints and Photographs Division, PH DAY, F., NO. 507.

81. *Installation View of Day's Photographs at the Philadelphia Salon,* anonymous photographer, 1899, platinum, 3 ⅜ x 6 ¼ in. Courtesy George Eastman House.

82. *Little Good Harbor Album Page,* (Herbert Copeland's Room), c. September, 1913, gelatin silver prints. Courtesy Library of Congress, Prints and Photographs Division, DLP/PP—1993: 151.

83. *Little Good Harbor Album Page,* (The Swim – Last of the Season), October 10, 1912, gelatin silver prints. Courtesy Library of Congress, Prints and Photographs Division, DLP/PP—1993: 151.

84. *Little Good Harbor Album Page,* ("The Prize Winner"), August, 1913, gelatin silver prints. Courtesy Library of Congress, Prints and Photographs Division, DLP/PP—1993: 151.

85. *Little Good Harbor Album Page,* (Tony Costanza?), September, 1913, gelatin silver prints. Courtesy Library of Congress, Prints and Photographs Division, DLP/PP—1993: 151.

86. *Portrait of F. Holland Day, by Alvin Langdon Coburn,* 1900, platinum with Gum Bichromate, 11 ¾ x 7 ¼ in. Courtesy The Royal Photographic Society, Bath, RPS 3422.

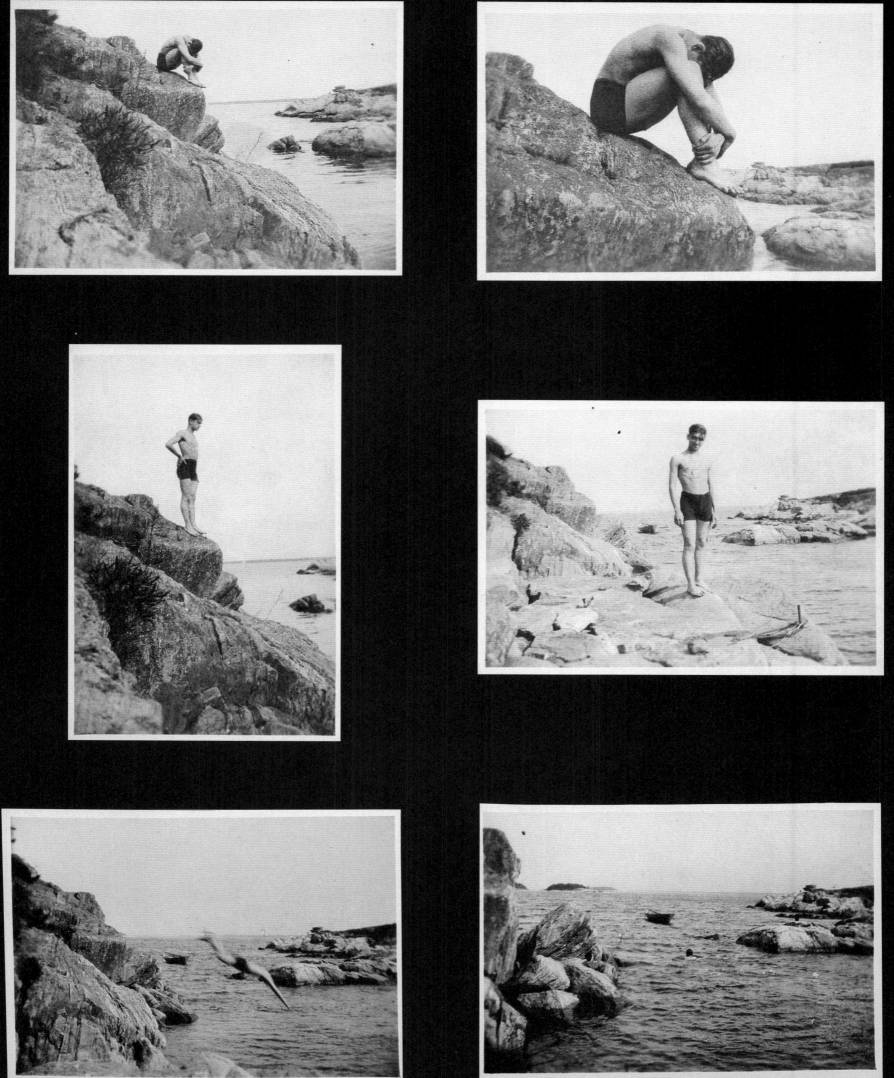

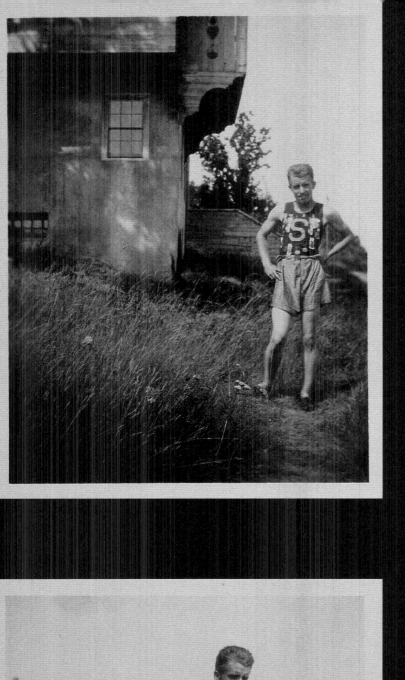
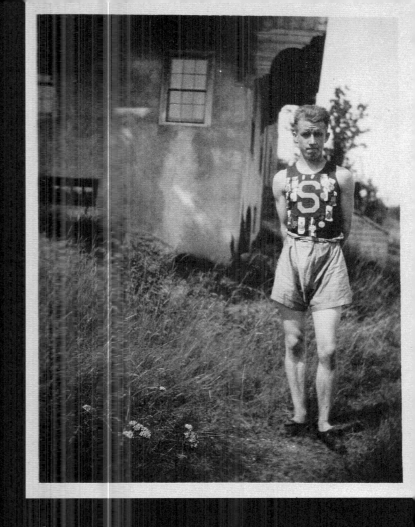
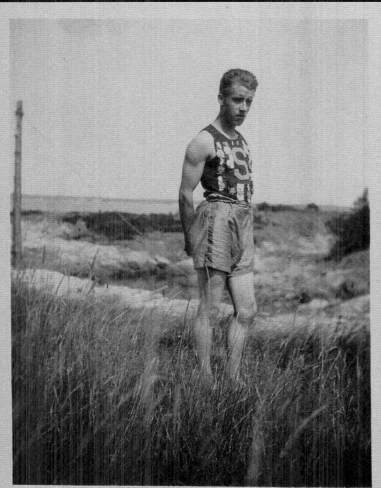
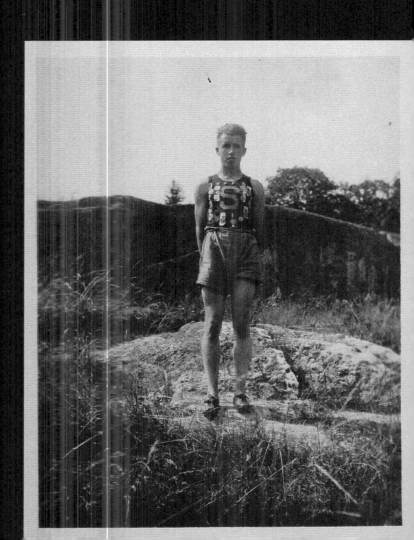

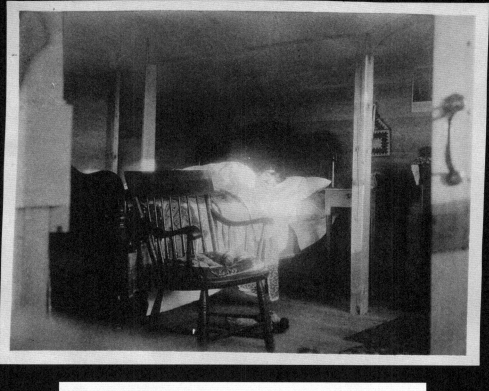

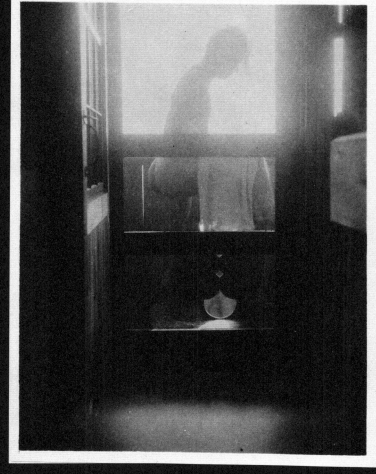

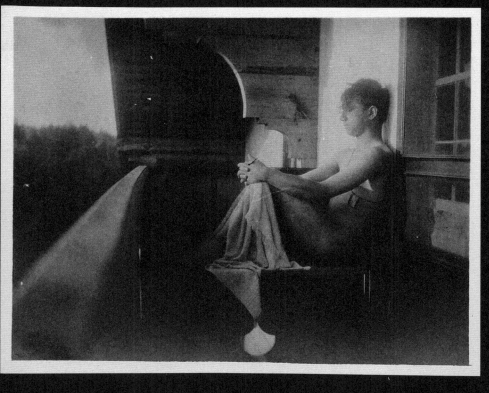

NOTES

1. As scholars of Day's photography are well aware, Estelle Jussim's biography *Slave to Beauty: The Eccentric Life and Controversial Career of F. Holland Day, Photographer, Publisher, Aesthete* (Boston: David R. Godine, 1981) is the starting point for any interpretation of Day's imagery. I am greatly indebted to this author for her groundbreaking efforts, and the encouragement she offered me on a warm summer day in Granby, Massachusetts, June 28, 1992. Of Day's European trip in 1899 (p. 40) Jussim said, "His parents, having lost patience with [Day's] long absence, were now pressuring him to come home." The correspondence that Jussim cites suggests Day's mother was quite overbearing and no less demanding of her only son. "Understandably, Mrs. Day wished to flee all the confusion, an escape that would be facilitated if Fred came home to either suffer with her or help her avoid the noisy upheaval."

2. Jussim, p. 16.

3. For the best account of Day's publishing firm, Copeland & Day, see Joe Walker Kraus, "A History of Copeland & Day (1893–1899), with a Bibliographical Checklist of Their Publications." (unpublished master's thesis, University of Illinois, Urbana, 1941), and by the same author *Messrs. Copeland and Day* (Philadelphia: George S. McManus, 1979). A more thorough study of Day and his particular literary milieu can be found in Stephen Maxfield Parrish, *Currents in the Nineties in Boston and London: Fred Holland Day, Louise Imogen Guiney and Their Circle* (doctoral dissertation, Harvard University, 1954; New York: Garland, 1987). Parrish had earlier collaborated with Edward Hyder Rollins on *Keats and the Bostonians: Amy Lowell, Louise Imogen Guiney, Louis Arthur Holman, Fred Holland Day* (Cambridge, Mass.: Harvard University Press, 1951).

4. *Book Buyer* 18 (June 1899), p. 362; cited in Kraus, *Messrs. Copeland and Day*, p. 47, n. 137.

5. In *Slave to Beauty* Jussim underestimated how Copeland & Day would later be affected by publishing Wilde's texts and the *Yellow Book*. This is a problem contiguous with Jussim's resistance to discussing homoeroticism in Day's photography, and with how the Wilde trial of 1895 ultimately affected Day's reputation. On Jussim's resistance to homoeroticism in Day's photographs see note 16; also see David Jacobs, "Ode to an Aesthete," *Afterimage* 9 (November 1981), pp. 4–5. Jussim wrote that for Day in 1889, "there still remained a choice between the martyrdom of the Crucifixion and the revels of pagan Hellenism," suggesting these two notions were mutually exclusive, when, as this text points out, they are inextricably bound together. According to Jussim, "Fred was still innocent of these extremes. He had not yet been exposed to Paris sufficiently to absorb the direct teachings of the Decadent poets, nor had he yet encountered the chic homosexuality, publicly flaunted, of so many of the English aesthetes" (p. 38). The imagery selected for the present book underscores the fact that Day was "sufficiently" informed of both British Decadence, and Hellenic neopaganism, never more so than in his sacred subjects which exploit a Christian theme for an alternative spiritual and sexual ideology. Later retreating into ambiguity and innuendo, Jussim wrote that the letters to Day from Wilde and Beardsley "confirmed what we can easily suspect" (p. 181).

6. On at least one occasion, Day used the term "queer" to connote decadence, in a letter describing Ralph Adams Cram's *The Decadent: Being the Gospel of Inaction*; see Jussim, p. 53, n. 23. As Karl Miller and other scholars have recognized, by 1900, the term queer had entered English slang as a euphemism for homosexuality; see Karl Miller, *Doubles: Studies in Literary History* (London: Oxford University Press, 1987), p. 241. " 'Odd,' 'Queer,'

'Dark,' 'Fit,' 'Nervous,' " noted Miller, "are the bricks which had built the house of the double."

7. On the pejorative use of the term decadence in the late nineteenth century see Elaine Showalter, *Sexual Anarchy: Gender and Culture at the Fin de Siècle* (New York: Penguin Books, 1990), especially pp. 169–72. According to Showalter, "Decadence is a notoriously difficult term to define. In one sense, it was the pejorative label applied by the bourgeoisie to everything that seemed unnatural, artificial and perverse, from Art Nouveau to homosexuality, a sickness with symptoms associated with cultural degeneracy and decay." In *Decadent Style* (Athens: Ohio University Press, 1985; p. 7), John Reed wrote: "I share Richard Gilman's dismay at the inaccuracy of the term *decadence*. It is a blunt tool for probing a whole culture or an artistic milieu. It is probably impossible to define decadence in the broad cultural terms . . . nonetheless, certain 'symptoms' are persistently associated with cultural decay, such as sexual irregularity, sadomasochism, diabolism, occultism, and exoticism." Richard Gilman had earlier called for the elimination of the term, arguing that it no longer had a meaningful function; see Gilman, *Decadence: The Strange Life of an Epithet* (New York: Farrar, Straus and Giroux, 1979). Perhaps most germane to our discussion here is how the term evolved into a stereotype collapsing cultural refinement into immoral, capricious, or irresponsible behavior. Most recently, Jean Clair suggested that decadence, represents modernity's "acute fear" of decline, a moment when "neophilia" is interwoven into "nostalgia"; see Clair, "Lost Paradise," in *Lost Paradise: Symbolist Europe* (Montreal: Montreal Museum of Fine Arts, 1995), p. 18.

8. Jussim saw the contradictions in Day's relationship with Guiney, even stating that Day "in many ways [resembled] the charitable, well-meaning hero of George Santayana's *The Last Puritan* — always giving, asking nothing in return, but incapable of true love or real passion for a woman" (p. 36). Nevertheless, her text gives the overall impression that Guiney was Day's love interest, when in fact the bond was merely intellectual (pp. 29–44).

9. Ralph Adams Cram, *My Life in Architecture* (Boston: Little, Brown and Co., 1937), p. 84. See also Douglass Shand-Tucci, *Life and Architecture: Ralph Adams Cram*, vol. 1, *Boston Bohemia 1881–1900* (Amherst: University of Massachusetts Press, 1994).

10. Day was a little embarrassed by Cram's manuscript, noting that author had "tried so very hard to 'do the Oscar' but failed so ignominiously that he will probably not put his name to it, but no persuasion of Herbert [Copeland's] or mine has had the least effect to leave it in M.S. It will appear most 'queer' before Christmas" (Jussim, p. 58). On the term *queer* see note 6, in the present book.

11. Cram, p. 93.

12. For discussions of Stevenson's homosocial character and personality, see William Veeder, "Children of the Night: Stevenson and Patriarchy," in *Dr. Jekyll and Mr. Hyde after One Hundred Years*, William Veeder and Gordon Hirsch, eds. (Chicago: The University of Chicago Press, 1988), pp. 159–60; Wayne Koestenbaum, *Double Talk: The Erotics of Male Literary Collaboration* (New York and London: Routledge, 1989), pp. 145–51.

13. Anonymous (Ralph Adams Cram), *The Decadent: Being the Gospel of Inaction* (Boston: Copeland & Day, 1894), p. 27. (emphasis added).

14. Jussim has stated that Aurelian was "partly a facsimile" of Day's life; see Jussim, p. 60.

15. Patricia G. Berman and Barbara L. Michaels have conducted the most insightful research to date on Day's philanthropic activities with lower-class and ethnic communities in and around Boston. I refer to both

authors' research in various segments of this essay. See Berman, "F. Holland Day and His 'Classical' Models: Summer Camp," *History of Photography*, 18:4 (Winter 1994), pp. 348–67; and Michaels, "New Light on F. Holland Day's Photographs of African Americans," *History of Photography*, 18:4 (Winter 1994), pp. 334–47.

16. The foremost and most frequently cited are Beaumont Newhall's *History of Photography from 1839 to the Present*, revised and enlarged (New York: Museum of Modern Art, 1982), and Helmut and Alison Gernsheim, *The History of Photography* (New York: McGraw-Hill, 1969). Newhall considered Day the "most curious of the photographers identified with the new pictorial movement in America," noting that Day "outraged critics by reenacting for the camera, on a hill outside Boston in the summer of 1898, the Passion of Our Lord, with himself as Jesus Christ" (p. 158). Perhaps more reproachful were the Gernsheims, who arrogantly conflated their distaste for Pictorialism with Day, and like Newhall, isolated the *Crucifixion* and *Seven Last Words*, Day's so-called sacred subjects, as if they were the total embodiment of his ambitious career. In their original German text, the Gernsheims used the phrase "ungeheuere Geschmacksverirrung" or "dreadful aberration," which implied that Day, like Pictorialism, could be typed as a malformation in photography (p. 465). These statements establish the critical terms of almost all subsequent accounts of Day's art and career up to 1975. Ironically, given the history of photography's status within art-historical circles, surveys such as Newhall's and the Gernsheims' are held up to authenticate and legitimate this relatively nascent field of study, and thus perpetuate facile or underdeveloped interpretations of Day's work. For an insightful account of this problem, see Rosalind E. Krauss, "Photography's Discursive Spaces," in *The Originality of the Avant-Garde and Other Modernist Myths.* (Cambridge, Mass., and London: MIT Press, 1985), pp. 131–50.

Day's work reemerged in the 1970s in two exhibitions. One in 1973 at the Baltimore Museum was followed by a more thorough retrospective at Wellesley College in 1975; see Ellen Fritz Clattenburg, *The Photographic Work of F. Holland Day* (Wellesley, Mass.: Wellesley College Museum, 1975). Both suggested the breadth of Day's work and offered a glimpse into the complex world he inhabited. The exhibitions made clear that the artist was unfamiliar, having been omitted from serious scholarship dealing with American photography. Nevertheless, for all the effort to present Day in grand fashion, the exhibitions fortified the clichés that had always characterized him. They showed once again that Day was "essentially a dilettante," who "lacked the serious persistence of an artist" (Clattenburg, p. 5). Notwithstanding the privileged social status that Day, and nearly every member of the pictorial and photo-secessionist movements enjoyed, his marginalization in the history of photography, as we shall see, had little to do with dilettantism, but with an array of circumstances intersecting at the turn of the century. The Wellesley exhibition catalog stated that Day, "the eccentric Boston aesthete," left behind some rather important works, the product of the photographer's "exotic sensibility" (p. 6). Quoting Stephen Maxfield Parrish's early study, *Currents in the Nineties in Boston and London: Fred Holland Day, Louise Imogen Guiney and Their Circle* (doctoral dissertation, Harvard University, 1954; New York: Garland Publishing, 1987), Clattenburg characterized Day as a flamboyant dandy, with all the stereotyped trappings of *fin de siècle* decadence (p. 10). Orientalism begins to emerge in his work, a problem explored later in this text; Clattenburg characterized Day's compositions as "always beautiful, but frequently his models are not. His idea of facial beauty was affected by his fascination with foreign or racial types" (p. 13). The catalog distinguishes Day's work from photos of Thomas Eakins, although they share some rather complex affinities, while positioning him alongside photographer Baron Wilhelm von Gloeden. The relationship of Eakins' arcadian male nudes to Eakins' own version of the displayed body of Christ pro-

vides an index to both the status of the male nude in mid- to late-Victorian America and Christ's evolving identification, two of the most consequential problems then facing Day's work. Finally, Clattenburg tells us that Day's "religious photographs were widely praised during his lifetime" (p. 17). This assertion is highly problematic, and to some extent, erroneous. The *Crucifixion* and *Seven Last Words* are pivotal to comprehending Day's complete work. They signal nothing less than a crisis in representation with both personal and public dimensions. It is a crisis related to the debates of spirituality, sexuality, and the gender relations at the end of the nineteenth century. These subjects, more than anything, account for the marginalization of Day that has occurred in the sixty years since his death. Though religious or spiritual connotations may have appealed to the contemporary viewer, Day's sacred subjects had a life of their own which sometimes deviated from, or subverted, the story they presumably illustrated.

In *Slave to Beauty* the first comprehensive biography of the artist, Jussim did correct some of the false perceptions about the photographer's life and career. She offered new analysis and a context that attempted to explain his troubled downfall as an artist. But though Jussim's careful research explored Day's significance to photography, she also felt compelled to exonerate him from perceived notions of immorality and decadence, that is from his proximity to homosexuality. Her account hermetically sealed Day's life from scandals fostered by Victorian prudery and moral propriety, to say nothing of the veiled rhetoric she used to circumscribe the work. Like Newhall and the Gernsheims before her, she disparaged Day's sacred subjects, noting: "It must be recognized that Day's sacred subjects turned out to be exceedingly bad art and worse photography" (p. 13). *Slave to Beauty* provides a more honorable lineage for Day's life by overemphasizing the influence of Keats's imagery on the photographer's aesthetic, while distancing his photographs from the less-respectable realm of Walter Pater and the scandalous reputation of Day's idol and friend Oscar Wilde. The influence of both men on Day's imagery is a crucial point for interpretation, and is integral to understanding the artist's so-called eccentricities, and the "confusion" Jussim posited about his sexuality (p. 22). Serious inquiry into the work of Pater and Wilde suggests some rather profound connections manifest in Day's imagery. Jussim also omitted any discussion of the texts of John Addington Symonds and Edward Carpenter, two intellectuals highly influential to Day's imagery. This text seeks to reintroduce Symonds's and Carpenter's writings and to provide a basis for understanding their great appeal to Day.

The urge to type Day or to continue using the narrow terms of earlier scholarship persists in even the most recent literature. And it is often the *Crucifixion* and *Seven Last Words* that serve as the centerpoint of confusion. As Melody Davis sees it in her book, *The Male Nude in Contemporary Photography* (Philadelphia: Temple University Press, 1991, p. 13), "While Day's intentions seem sincere, his effects are by now pure camp." As Susan Sontag warned in her singular essay, "Notes on 'Camp'" [1964] in *A Susan Sontag Reader* (New York: Vintage, 1983; p. 105): "To talk about Camp is therefore to betray it. If the betrayal can be defended, it will be for the edification it provides, or the dignity of the conflict it resolves." Although it would be a mistake to concede that the sacred subjects are "camp," Davis's observation does little to edify, and underscores the frequency with which these photographs are cursorily dismissed. In his book *Alfred Stieglitz's Camera Notes* (Minneapolis and New York: The Minneapolis Institute of Arts/W. W. Norton & Co., 1993, p. 28), Christian A. Peterson notes that "Day cultivated a lifestyle as a Boston aesthete." Though *aesthete* is not an unreasonable term to use, like *decadent* or *queer* it must be thoroughly qualified in order to understand its pejorative connotations. According to Naomi Rosenblum Day "was an 'improper' Bostonian of means," who

she then associates with other "misguided" photographers attempting to emulate high art for the camera; see Rosenblum, *A World History of Photography* (New York: Abbeville, 1984), p. 327. Written fifteen years subsequent to the Gernsheim's history, Rosenblum's survey suggests what little progress has been made toward reconciling Day's life with his art.

Recently, the international quarterly *History of Photography* published a special issue on Day (vol. 18, no. 4; Winter 1994) which represents the finest scholarship on the photographer to date. In this issue, provocative expansive and new essays detail Day's philanthropy, his photographs of African Americans, and the exhibition style of Day's prints; in addition it includes my own essay which repositions Day's sacred subjects. The essays by Barbara L. Michaels, Patricia G. Berman, and Jane Van Nimmen have been immensely helpful in my overall interpretation of Day's work. All three scholars understand the full extent of Day's contradictions, the overwhelming complexity of his life and photography, and how the two were inextricably interwoven. The *History of Photography* issue on Day suggests that detailed study analyzing the context of Day's life and career is crucial to yielding meaning from his photographs. These works are to be interpreted each on its own terms, but as part and parcel of his total work as an artist and of the political, social, sexual, and cultural environments in which they were created.

As Day's images gain in popularity, art critics have a difficult time resisting the sensational terms consistently used to characterize his work. In his article for the Library of Congress's quarterly publication *Civilization*, Richard A. Kaye states that Day's photographs "foreshadowed the controversies that erupted over [Robert] Mapplethorpe and [Andres] Serrano nearly a century later." Kaye's is at best a superficial, and quite false, historical equation which ultimately serves the mythology that has developed around Day, much like that grown up around other extraordinary dead photographers, Mapplethorpe, Diane Arbus, Weegee, Margaret Bourke White, and W. Eugene Smith, to name just a few; see *Civilization* July/August 1995, pp. 40–47. The irony here is that the institution sanctioning *Civilization*, the Library of Congress, houses the largest collection of Day's photographs.

17. On the famed "New School of American Photography" exhibition mounted in London in 1900, see Jussim, p. 137–52.

18. Day's rivalry with Stieglitz remains a topic for debate among scholars of Pictorialism. But the significance of his alienation from Stieglitz has only recently been considered a key factor in Day's total retreat from photography. There is no question that both men were threatened by the other's success, and their mutually stubborn resistance to overcoming difference would forever alienate them after 1900. As Edward Steichen noted in his autobiography, *A Life in Photography* (Garden City, N.Y.: Doubleday & Co., 1963), n. p., Day and Stieglitz were pioneers in a class nearly all their own. But both men refused to cede leadership of American photography. Stieglitz's criticisms of the London exhibition were as unfounded as Day's dismissal of the former's first publication, *Camera Notes*. According to Steichen, Day once referred to *Camera Notes* as a "tasteless publication," and Stieglitz had berated the New School exhibition prints as "second- and third-rate" prior even to having seen them. In fact, Stieglitz had attempted to derail the exhibition, successfully urging the British Linked Ring of photographers to cancel their plans to mount it. To this end, Day was forced to open the exhibition at the Royal Photographic Society. As Day's cousin, Alvin Langdon Coburn, noted, "Stieglitz . . . shared with Holland Day the aspiration to the leadership of the American School," both being "a little jealous of one another"; see *Alvin Langdon Coburn: Photographer — An Autobiography.* Helmut and Alison Gernsheim, eds. (1968); revised ed. (New York: Dover Publications, 1978), p. 60. Margaret Harker, the noted British historian of late-nineteenth-

century photography, wrote: "Both [Day and Stieglitz] were strongly egotistical and it seems inevitable that their personalities clashed in their bid to establish photography as an art"; see Harker, *The Linked Ring: The Secession Movement in Photography in Britain, 1892–1910* (London: RPS, 1979), p. 150.

Subsequent to the London exhibition, Stieglitz made an overture to mend the relationship. He requested Day's prints for the inaugural issue of *Camera Work,* but Day declined, presumably fed up with Stieglitz's power mongering, and the devout following Stieglitz enjoyed in the photography community. According to Jussim, "Notwithstanding the seduction of photogravure, and not surprisingly, Day refused. This decision proved to be self-destructive, almost fatally so. By excluding himself from *Camera Work,* Day inadvertently committed himself to a long and undeserved oblivion" (p. 152). Day's obscurity is partially attributable to not having been represented in *Camera Work,* but his retreat from photography, and eventually the world at large, cannot be explained by these events alone. As we shall see later in this text, the assaults to Day's reputation as an artist began during his lifetime, and were perpetuated in histories of the medium that failed to account for the other professional and personal crises that had deeply affected him.

19. Dorothy Kosinski was the first scholar to provide a basis for comparing Day's photographs with a specific Symbolist painter, Séon. Her study is significant because it underscores Jussim's resistance to admitting an influence on Day's work greater than the romantic poet John Keats. Dismissing an earlier British critic's interpretation that Day's pagan photographs were, in actuality, from a series depicting the story of Orpheus, Jussim wrote, "I favor the Apollo interpretation because of Day's lengthy involvement with Keats" (p. 102). Overemphasizing Keats's imagery in Day's photography by relying simply upon a brief passage by Keats, Jussim fails to see the legitimacy of the Orphic myth, and how relevant this myth would have been to the photographer. Day embraced Orpheus as a metaphor for artistic and sexual alienation. On the significance of the theme of homosexuality in the myth itself, see Dorothy M. Kosinski, *Orpheus in Nineteenth-Century Symbolism* (Ann Arbor: UMI Research Press, 1989), especially pp. 10–18. In *The Homoerotic Photograph: Male Images from Durieu/Delacroix to Mapplethorpe* (New York: Columbia University Press, 1992; p. 43), Allen Ellenzweig also corrected Jussim's erroneous assertions regarding the theme of Apollo in Day's work.

20. This is precisely the strategy of Ulrich Pohlmann, curator of photography for the revisionist symbolist exhibition *Lost Paradise: Symbolist Europe,* presented at the Montreal Museum of Fine Arts from June 8 to October 15, 1995. Day's photographs appear in the exhibition catalog with excessive frequency, and more often than those of any other photographer represented. While there is no question that Day's photography derived part of its transcendent spirit from European Symbolism, the catalog gives the impression that Day's influence as a Symbolist photographer was more incisive. According to Pohlmann, "It was Day who from 1901 onwards brought Coburn, Käsebier, Steichen and Seeley into closer contact with Symbolist ideas" (p. 431). All four photographers maintained strong friendships with Day, but each artist used, manipulated, and transformed symbolist imagery, and the tenets underwriting it, in their own unique terms. For instance, Pohlmann's statement would discount Coburn's slow break from Day which began after the 1900 "New School of American Photography" exhibition, and the compositional principles that Coburn learned from Arthur Wesley Dow. Pohlmann even titled his essay after one of Day's most important images, *The Genius of Greek Art,* later titled, *Beauty Is Truth, Truth Beauty.* See Pohlman, "The Dream of Beauty, or Truth Is Beauty, Beauty Is Truth: Photography and Symbolism, 1890–1914," in *Lost Paradise: Symbolist Europe* (Montreal: Montreal Museum of Fine Arts, 1995), pp. 428–447.

21. For an inclusive list of Day's writings on photography, see Patricia J. Fanning, "F. Holland Day's Writings on Photography," in *History of Photography*, 18:4 (Winter 1994), pp. 383–84.

22. F. Holland Day, "Art and the Camera," *Camera Notes* :2 (October 1897), pp. 27–28.

23. F. Holland Day, "Photography Applied to the Figure," *The Amateur Photographer* 26 (December 17, 1897), p. 504.

24. The literary figuration of Greek Love is a key theme in Day's work which will be explored in this essay. I refer often to John Addington Symonds, "A Problem in Greek Ethics," in John Lauritsen (ed.), *Male Love: A Problem in Greek Ethics and Other Writings*, foreword by Robert Peters (New York: Pagan Press, 1983). pp 1–33.

25. Sadakichi Hartmann, "F. Holland Day: A Decorative Photographer," in Harry W. Lawton and G. Knox (eds.), *The Valiant Knights of Daguerre: Selected Critical Essays on Photography and Profiles of Photographic Pioneers*, foreword by Thomas F. Barrow (Berkeley: University of California Press, 1978), pp. 186–90.

26. Hartmann "Portrait Painting and Portrait Photography," in ibid., p. 46.

27. Hartmann. "F. Holland Day: A Decorative Photographer," , pp. 188–89. Tournure d'esprit, according to Webster's New World French Dictionary, means "cast of mind." Jussim (p. 148) has also noted that Hartmann tried to ridicule Day by including in his article this description derived from a newspaper story circulating about Day. Hartmann wrote:

Once a stranger visited him and knocking at the door, heard a most cheerful 'come in,' but entering, found to great astonishment nobody present. He looked everywhere, but could find no trace of Mr. Day; then suddenly he heard a clucking sound, looked up and saw Mr. Day sitting on a shelf right under the ceiling, wrapped in an Oriental costume, smoking a water pipe.

28. Cram, *The Decadent*, p. 10.

29. R. M. Seiler (ed.), *Walter Pater: The Critical Heritage* (London and New York: Routledge & Kegan Paul, 1980), p. 5. Concerning Pater's influence on Berenson, see Sylvia Sprigge, *Berenson: A Biography* (Boston: Houghton Mifflin, 1960).

30. Richard Jenkyns has noted that the contemporary reader of Pater's text "was [being] coaxed into believing that the Greek worship of beautiful youths is acceptable, since it enveloped in a halo of quasi-religious association"; see Richard Jenkyns, *The Victorians and Ancient Greece* (Cambridge, Mass.: Harvard University Press, 1980), p. 150.

31. Seiler, p. 8.

32. This trend in medicine and the nascent field of psychological study is evidenced by contemporary publications such as Havelock Ellis's *Sexual Inversion* (1897) and Richard von Krafft-Ebbing's *Psychopathia Sexualis* (1889), which offered some of the first case studies of same-sex relations. For the best critical assessment of this literature, and the emerging discourse of sexual "deviancy" and pathology, see Michel Foucault. *The History of Sexuality*, vol. 1: *An Introduction* (New York: Vintage, 1990) p. 64.

33. Seiler, p. 8

34. Day, "Is Photography an Art?," p. 2.

35. Seiler, introduction.

36. Walter Pater, "Leonardo da Vinci: *Homo Minister et Interpres Nature*," in *The Renaissance: Studies in Art and Poetry*, introduction by Kenneth Clark (London: Collins, 1961), p. 116.

37. Ibid., p. 23.

38. Pater, "The Poetry of Michelangelo," in ibid., p. 91.

39. Pater, "Winckelmann: *Et ego in Arcadia Fui*," in *The Renaissance*, p. 192.

40. Ibid., p. 182 (emphasis added).

41. Ibid., p. 88.

42. Ibid., p. 190.

43. Jussim, p. 126. Jussim has noted that Bostonians were shocked by this image, but, as Patricia G. Berman has pointed out, there is little evidence in the critical record to support this claim. See Berman, p. 361, n. 93.

44. *Atlantic* 79 (May 1897), p. 711. Reprinted in Jonathan Freedman, *Professions of Taste: Henry James, British Aestheticism and Commodity Culture* (Palo Alto, Cal. Stanford University Press, 1990), pp. 114–15, n. 49.

45. Washington Gladden, "Christianity and Aestheticism," *Andover Review* 1 (January 1884), p. 23–24.

46. Jussim, p. 110. According to Jussim, the image made an "ideological statement straight out of Keats." The author was confused about the commingling of pagan and Christian themes, writing, "The contrast between the serious pagan figure and the dead Christ is still bewildering and uncannily hypnotic."

47. Joseph T. Keiley, "The Salons," *Camera Notes*, 3:3 (January 1900), p. 163.

48. Foucault, p. 101.

49. Having quoted Symonds in his essay on Michelangelo, Pater, in *The Renaissance* makes it clear that Day would have known Symonds's writings in some form.

50. In an effort to calm increasing anxieties about the men of decadence, several texts appeared during the 1880s and 1890s which attempted to historicize and rationalize Greek love. The civilization of ancient Greece, its culture and mythology, were most often invoked in defense of same-sex love and eroticism.

51. John Addington Symonds, "A Problem in Greek Ethics" (London: 1883), pp. 1 and 144. For Day, Symonds's appeal, like Pater's, rested on the dichotomous relationship of the pagan past and modern Christendom. Day's writings on photography sympathized with this view, believing that modern materialism, and the hollowness of traditional spiritual beliefs were wreaking havoc on society. As Symonds wrote in *Studies of the Greek Poets*:

The separation between the Greeks and us is due to something outside us rather than within . . . We are taught to think that one form of religion contains the whole truth, and that one way of feeling is right to the exclusion of the humanities and sympathies of races no less beloved of God and no less kindred to ourselves than were the Jews. Has then the modern man no method for making the Hellenic tradition vital instead of dream-like — invigorating instead of enervating? There is indeed this one way only — to be natural: we must imitate the Greeks, not by trying to reproduce their modes of life and feeling, but by approximating to their free and fearless attitude of mind.

52. Symonds, *Studies of the Greek Poets*, ibid., pp 136, 125.

53. Day, "Is Photography an Art?," pp. 5–6.

54. For examples see Gleeson White, "The Nude in Photography," *Photographic Times* 29:5 (May 1897), pp. 209–20 Carl Rau, "Notes on the Nude in Photography," *Photographic Times* 29:9 September 1897), p. 405;

and W. I. Lincoln Adams, *In Nature's Image: Chapters on Pictorial Photography* (New York: Baker and Taylor Co., 1898).

55. Day, "Is Photography an Art?," pp. 9–10.

56. F. Holland Day, "Photography Applied to the Undraped Figure," *The American Annual of Photography and Photographic Times Almanac for 1898* (New York: Scovill & Adams, 1897), p. 190. This essay is identical to "Photography Applied to the Figure," cited in note 23.

57. Day, "Photography Applied to the Figure," p. 505.

58. Jonathan Ned Katz, *Gay/Lesbian Almanac: A New Documentary* (New York: Harper & Row, 1983), p. 263.

59. B. F. Westcott, *Essays on the History of Religious Thought in the West* (London, 1891); cited in Jenkyns, p. 93, n. 40.

60. Oscar Wilde, "On the Sale by Auction of Keats' Love Letters" (1886), in H. Montgomery Hyde (ed.), *The Annotated Oscar Wilde* (New York: Clarkson N. Potter, 1982), pp. 45–50.

61. Eve Kosofsky Sedgwick, *Epistemology of the Closet* (Berkeley and Los Angeles: University of California Press, 1990), p. 148. As Richard Ellman previously noted, Wilde's "ultimate conception of himself was never put into an essay, but it is involved in . . . *De Profundis* . . . and in *The Ballad of Reading Gaol*"; see Ellman (ed.), *The Artist as Critic: Critical Writings of Oscar Wilde* (Chicago: University of Chicago Press, 1968), pp. 3–5.

62. Hyde, p. 264.

63. Guy Willoughby, *Art and Christhood: The Aesthetics of Oscar Wilde* (London and Toronto: Associated University Press, 1993), p. 57–58: "Wilde turn[ed]Christ's ministry into an individualistic revolt against authority."

64. On the typological construction of Christ as an autobiographical vehicle in nineteenth-century British literature, see George P. Landow, *Victorian Types, Victorian Shadows: Biblical Typology in Victorian Literature, Art, and Thought* (Boston and London: Routledge & Kegan Paul, 1980), pp. 11–12 and 155–60.

65. Parrish, p. 328.

66. Edward Carpenter, "The Individual Expression," in *Angels' Wings: A Series of Essays on Art and Its Relation to Life* (London: Swan Sonnenschein & Co., 1898), pp. 122–23.

67. James D. Steakley, *The Homosexual Emancipation Movement in Germany* (New York: Arno, 1975). See also David M. Halperin, *One Hundred Years of Homosexuality and Other Essays on Greek Love* (New York: Routledge, 1900).

68. Edward Carpenter, "The Intermediate Sex" (1908; selections under the title "Love's Coming of Age," 1896), in *Edward Carpenter, Selected Writings*. vol. 1: *Sex* (London: GMP Publishers Ltd., 1984), p. 188.

69. H. Montgomery Hyde, *Oscar Wilde* (New York: Farrar, Straus & Giroux, 1975), p. 185–86, n. 24.

70. Berman, p. 355.

71. F. Holland Day, "Portraiture and the Camera," *The American Annual of Photography* 13 (1899), pp. 19–25.

72. Day, "Is Photography an Art?," pp. 11–12.

73. Ibid., p. 8.

74. Hartmann, "Portrait Painting and Portrait Photography," p. 46.

75. Cited in Berman, n. 72.

76. Cited in Richard Ellmann, *Oscar Wilde* (New York: Alfred A. Knopf, 1988), p. 237.

77. Petr Wittlich, "Closed Eyes, Symbolism and the New Shapes of Suffering," in *Lost Paradise: Symbolist Europe*, p. 237.

78. Jussim, pp. 114–15.

79. Jean Gibran, *Kahlil Gibran: His Life and World* (New York: Arenel, 1981), p. 55; cited in Berman, p. 355, n. 64.

80. Thomas Mann, *Diaries, 1918–1939*, Hermann Kesten (ed.), trans. by Richard and Clara Winston (London: Routledge, 1984); cited in Robert Aldrich, *The Seduction of the Mediterranean: Writing, Art and Homosexual Fantasy* (London and New York: Routledge, 1993), p. 5.

81. Oscar Wilde, *The Picture of Dorian Gray*, in *Complete Works of Oscar Wilde* (London and Glasgow: Collins, 1975), p. 27.

82. Marmaduke Humphrey (pseudonym of Rupert Hughes) "Triumphs in Amateur Photography II – F. H. Day," *Godey's Magazine* 136:811 (July 1899), pp. 8–9.

83. On the Victorian notion of the "angel in the house," and how this relates to contemporary images in photography, see Carol Mavor, *Pleasures Taken: Performances of Sexuality and Loss in Victorian Photography* (Durham, N.C. and London: Duke University Press, 1995), pp. 52–53: "In the age of Victorian religious doubt, we find that the bride of the bourgeois Victorian male, the angel in the house, replaces Mary as a source of worship. This new secular yet angelic bride, crowned the bourgeois home and family as the new temple of purity."

84. William Innes Homer, *A Pictorial Heritage: The Photographs of Gertrude Käsebier* (Wilmington: University of Delaware and Delaware Art Museum, 1979), pp. 26–27.

85. Neither do Day's portraits of women possess the more pronounced formality of his older men (*Sir Frederick H. Evans* [1908], *James Craig Annan* [1902], *Clarence White* [1905]) and blacks. Day's portraits of women occupy a prominent position in his work. They show a liberal mind willing to acknowledge woman's autonomy and her unique character notions that were, at times, counter to the dominant image of demure femininity and motherhood.

86. Michaels, pp. 336–337. In her discussion of the photograph known as *Menelek (Menelic)*, Barbara L. Michaels correctly has noted the political rhetoric of this and other images of African Americans by Day. "In reviving the Menelek of old, Day alluded to recent events. In 1896, under its new leader, Menelek II, Ethiopia had won independence from Italy." Michaels's deft analysis of Day's Hampton Institute photographs draws out a barely known aspect of his philanthropy and his unique interest in the well-being of African Americans. Still, not once does Michaels acknowledge how fantasy or desire played into Day's images of black men. Given the contradictions we find in other photographs by Day, such as *Ebony & Ivory* (1897), *Youth in North African Costume* (1907), and the recently discovered portrait of Day by Clarence White (c. 1897); discussed later in this text, in which Day is cavalierly represented next to his semiclad black model, there are strong reasons for examining the other side of Day's fascination with racial "types." It would be facile to suggest that Day was a colonialist, set upon exploiting those he photographed. But the complexities of colonialist discourse as it appeared during the 1890s, combined with the biographical facts, such as Day's and Alvin Langdon Coburn's sojourn to Algeria in 1901, can no longer be overlooked or dismissed in a critical interpretation of these images.

87. Michaels, pp. 336–37. In addition to the Ethiopian conflicts, there is evidence to suggest Day's knowledge of the political turmoil in Algeria; Jussim, p. 156. "No sooner had Fred written Louise Guiney . . . than she pleaded with him to avoid the neighborhood of those Arab revolts."

88. Todd D. Smith, "Gay Male Pornography and the East: Re-Orienting the Orient," *History of Photography*, 18:1 (Spring 1994), pp. 3–21.

89. Richard Burton, *The Sotadic Zone* (Boston: Milford House, 1973), p. 20; cited in Smith, p. 15, n. 17.

90. Jussim, p. 10.

91. Oscar Wilde, *De Profundis*, with an introduction by Vyvyan Holland (New York: Philosophical Library, 1949), p. 94.

92. André Gide, *The Immoralist* (1902; New York: Knopf, 1970), trans. by Richard Howard, p. 60.

93. Ibid., p. 23.

94. See Lincoln Kirstein, *The Hampton Album* (New York: The Museum of Modern Art, 1966).

95. Cram, *The Decadent*, p. 10.

96. Cram, *My Life in Architecture*, pp. 92–93.

97. Charles Baudelaire, *Paradis Artificiels*; cited in Philippe Jullian, *Dreamers of Decadence: Symbolist Painters of the 1890s* (New York: Praeger, 1971), p. 31.

98. Jussim, pp. 50–51. According to Jussim, Day "openly discuss[ed] Theosophy and spiritualism" with Yeats. Day also "supplied [Yeats] with Blakeiana from his own library, and in sharing thoughts about the mystic poet, Day and Yeats argued about the propriety of experimenting with black magic."

99. Gardner Murphy, *Challenge of Psychical Research: A Primer of Parapsychology*, with the collaboration of Laura A. Dell, *World Perspectives*, vol. 26, planned and ed. by Ruth Nanda Anshen (New York: Harper & Brothers, 1950), p. 199. Dr. Richard Hodgson, an Australian scholar affiliated with the ASPR recorded Mrs. Piper's psychic sessions;. see Hodgson, "A Record of Observation of Certain Phenomena of Trance, *Proceedings of the Society for Psychical Research* 8 (1892), pp. 1–167; and by the same author, "A Further Record of Observation of Certain Phenomena of Trance," *Proceedings of the Society for Psychical Research* 13 (1897–98), pp. 285–582. William James also recorded his experiences with Mrs. Piper. See James, "Certain Phenomena of Trance," *Proceedings of the Society for Psychical Research* 2, (1890), p. 17.

100. Jussim, pp. 34, 45, and 282.

101. See Ernst Kris and Otto Kurz, *Legend, Myth and Magic in the Image of the Artist* (New Haven and London: Yale University Press, 1979). For one of the most compelling, focused studies of self-portraiture, see Joseph Leo Koerner, *The Moment of Self-Portraiture in German Renaissance Art* (Chicago: University of Chicago Press, 1994). Koerner's study examines the numerous self-portraits by Albrecht Dürer, whose transformative artistry and conceptualization of self – especially his self-portrait as Christ – must have fascinated Day.

102. On the historical usage of Christ's typology in photographic self-portraiture see Philippe Junod, "(Auto)portrait de l'artiste en Christ," in *L'autoportrait à l'âge de la photographie: Peintres et photographes en dialogue avec leur propre image* (exh. cat.; Lausanne: Musée Cantonal des Beaux-Arts, 1985). Day's self-portraits as Christ, the *Crucifixion* and *Seven Last Words* are specifically discussed later in this text.

103. Dario Gamboni, "'Of Oneself, To Oneself': Symbolism, Individualism and Communication" in *Lost Paradise: Symbolist Europe*, p. 342.

104. According to Michaels (p. 347, n. 45), the photograph was misidentified as a self-portrait by Day in Maria Morris Hambourg et al, *The Waking Dream: Photography's First Century, Selections from the Gilman Paper Company Collection* (exh. cat. New York: Metropolitan Museum of Art, 1993), p. 17 and pp. 390, 341–42. Michaels has noted that, "according to records at the Gilman Paper Company, the photograph came from the Clarence H. White Estate and is identified on the verso in an unidentified hand as 'F. H. Day by Clarence White.'"

105. Sander L. Gilman, *Sexuality: An Illustrated History Representing the Sexual in Medicine and Culture from the Middle Ages to the Age of AIDS* (New York: John Wiley & Sons, 1989), p. 278. Also of note by the same author is *Difference and Pathology: Stereotypes of Sexuality, Race, and Madness* (Ithaca, N.Y.: Cornell University Press, 1985).

106. Gilman, *Sexuality*, p. 278. According to Gilman, "the antithesis of European sexual mores and beauty is the black."

107. F. Holland Day, "Sacred Subjects in Photography," VII, original handwritten manuscript. "After giving the matter serious consideration," Day first conceptualized the sacred subjects in the summer of 1895. It is likely that the date recorded in his original manuscript is inaccurate, as two published sources give 1896 as the actual date. According to Jussim (p. 121) "some 250 negatives" were taken.

108. Cram, *The Decadent*, p. 35. In his unpublished manuscript "Is Photography an Art?" Day wrote that the "truth of science" was the "truth of detail," something that art should never aspire to. It is likely that he was quoting from Robert de la Sizeranne's article "La photographie, est-elle un art?," which appeared in *Revue des deux mondes*, 144 (1897), pp. 565–97, and was later published as a book (Paris: Hachette, 1899). Sizeranne's text expressed the very same ideas using remarkably similar terms. A popular writer in France, he was "against the truth of science, the truth of details." Day's interest to render every detail of the historical event of the Crucifixion is counter to Sizeranne's declaration against the "mania for stock-taking," suggesting there were other motivational factors at work.

109. Win Everett, "The Seven Last Words," *Norwood Messenger*, April 19, 1935.

110. Jussim, p. 126.

111. Ibid; Day's invitation stated that "some controversy has arisen regarding the legitimate use of the camera in this field."

112. Since Thomas Eakins first exhibited his painting *Crucifixion* in 1882 in New York, it had been obvious that puritan American critics would never accept a photographic depiction of Christ acted out by an artist. Neither Catholic nor a believer in Christ's divinity, Eakins also took personal and artistic risks with the subject. His *Crucifixion* provides an index to the evolving figuration and identification of Christ in America. Owing to the wrenching agony of the victim in Eakins's *Crucifixion*, and the force of its realism the painting was criticized for being too "scientific." For those actually believing in the historical event of the Crucifixion, it was thought that Eakins had failed to romanticize the drama found in European prototypes of the subject in painting. According to one critic, Eakins's *Crucifixion* neither "awaken[ed] thoughts that elevate the mind," nor stirred "any noble emotions." Like Day's sacred subjects, Eakins's *Crucifixion* was simply too "realistic." See Gordon Hendricks, *The Life and Work of Thomas Eakins* (New York: Grossman Publishers, 1974), pp. 158–60.

113. Jussim, p. 125, n. 16; she took the quote from an undated, unidentified, newspaper clipping that described a lecture by Sir Wyke Bayliss at the Society of British Artists entitled "The Likeness of Christ from the First to the Nineteenth Century."

114. "Sacred Art and the Camera," *The Photogram* (April 1899), p. 98; cited in Jussim, p. 127, n. 25.

115. Harker, p. 111.

116. Ibid., p. 150.

117. Ibid.

118. Ibid.

119. Charles H. Caffin, "Philadelphia Photographic Salon," *Harper's Weekly* (November 5, 1898), p. 1087; cited in Jussim, p. 129, n. 33.

120. Caffin, "Philadelphia Photographic Salon," *Harper's Weekly* (November 4, 1899), p. 1118; cited in Jussim, p. 129, n. 34.

121. Hartmann, p. 188.

122. Wilde, *De Profundis*, p. 98.

123. Ibid., p. 93. Critiquing Pater's *Marius the Epicurean*, Wilde wrote, "I see a far more intimate and immediate connection between the true life of Christ and the true life of the artist."

124. Wilde, *De Profundis*, p. 102.

125. Jenkyns, p. 237, n. 42.

126. Jack Stillinger, "The Hoodwinking of Madeline," in Allan Danzig (ed.), *The Eve of Saint Agnes: A Collection of Critical Essays* (Englewood Cliffs: Prentice Hall, 1971), p. 66.

127. Jussim, p. 80.

128. Landow, p. 156–57.

129. Ian Gibson, *The English Vice: Beating, Sex and Shame in Victorian England and After* (London: Duckworth, 1979), p. 309.

130. Sedgwick, p. 140.

131. Ibid., p. 147. According to Sedgwick, the binary relationship of the sentimental and antisentimental "became the body of a man, who . . . physically dramatize[d], embodie[d] for an audience that both desire[d] and cathartically identifie[d] with, a struggle of masculine identity with emotions or physical stigmata stereotyped as feminine." By the time Day executed the sacred subjects, "sentimentality" had already become a euphemistic term for homosexuality. In "The Intermediate Sex," Edward Carpenter compared the heterosexual man to the homosexual, stating that "with a good deal of experience in the matter, I think one may safely say that the defect of the male Uranian or Urning, is not sensuality — but rather sentimentality"; see Carpenter, p. 187.

132. Clair, p. 18.

133. Day, "Photography Applied to the Undraped Figure," p. 186.

134. Wilde, *The Picture of Dorian Gray* (New York: Modern Library, 1931), pp. 174–76.

135. Ibid.

136. A. Horsley Hinton, "Both Sides," *Camera Notes* 2:2 (January 1902), p. 79; cited in Peterson, pp. 41–42, n. 47.

137. In his review of the Philadelphia Salon of 1899, Joseph Keiley wrote:

"It struck me as being rather characteristic of Mr. Day's style that the pagan idea was given the first place — for I have long felt that Mr. Day approached all of his subjects, whether representations of 'Christ' or such themes as Ebony and Ivory, from a purely Greek point of view."

Keiley, a photographer himself, and one of the most revered critics of the period, had earlier praised Day's *Ebony & Ivory*, noting that "its tonal values are exquisitely harmonious." But he concluded this commendation by stating that "in its conception" *Ebony & Ivory* "is distinctly Greek." Keiley, well versed in the terminology of decadence and the controversial creed "art for art's sake," was here referring to the primacy of beauty which Day's aesthetic is grounded upon. But the critic wished to signal Day's Greek sensibility, his homoerotic predisposition.

138. The term is borrowed from Sedgwick, p. 136–41.

139. On the myth of Orpheus, see note 19 which cites the work of Dorothy Kosinski.

140. Symonds, "A Problem in Greek Ethics," p. 1.

141. Lord Alfred Douglas, "Hymn to Physical Beauty," in *Lyrics* (London: Rich and Cowan, 1935), p. 52; cited in Berman, p. 362, n. 102.

142. See Kraus, *Messrs. Copeland and Day*, p. 44.

143. Jussim, p. 205, n. 15.

144. Kraus, *Messrs. Copeland and Day*, p. 44.

145. Ibid.

SELECTED BIBLIOGRAPHY

ALDRICH, Robert. *The Seduction of the Mediterranean: Writing, Art and the Homosexual Fantasy*. New York and London: Routledge, 1993.

"An Exhibition of Prints by the New School of American Photography Supplemented by an Additional Collection of One Hundred Examples of the Work of F. Holland Day of Boston." London: Royal Photographic Society (1900), Nos. 95–100.

BERMAN, Patricia G. "F. Holland Day and His 'Classical' Models: Summer Camp," *History of Photography* 18:4 (Winter 1994), pp. 348–67.

BURTON, Sir Richard. *The Sotadic Zone* (1888). Boston: Milford House, 1973.

CARPENTER, Edward. *Edward Carpenter: Selected Writings, vol. 1: Sex*, introduction by Noël Greig. London: GMP Publishers Ltd., 1985.

CLAIR, Jean, et al. *Lost Paradise: Symbolist Europe*, Exhibition Catalog. Montreal: Montreal Museum of Fine Arts, 1995.

CLATTENBURG, Ellen Fritz. *The Photographic Work of F. Holland Day*. Exhibition Catalog. Wellesley, Mass.: Wellesley College Museum, 1975.

COBURN, Alvin Langdon. *An Autobiography*. Helmut and Alison Gernsheim (eds.). New York: Praeger, 1966.

CRAM, Ralph Adams. *My Life in Architecture*. Boston: Little, Brown and Co., 1936.

CROMPTON, Louis. *Byron and Greek Love: Homophobia in Nineteenth-Century England*. Berkeley: University of California Press, 1990.

CRUMP, James. "F. Holland Day: 'Sacred' Subjects and 'Greek Love'," *History of Photography* 18:4 (Winter 1994), pp. 322–33.

DAY, F. Holland. "Is Photography An Art?" unpublished manuscript (c. 1900). F. Holland Day Collection, Norwood Historical Society, Norwood, Mass. Available on microfilm through the Archives of American Art, Smithsonian Institution, Washington, D.C.

_____. "Art and the Camera," *Camera Notes* 1 (October 1897), p. 27.

_____. "Art and the Camera," *Camera Notes* 11 (July, 1898), pp. 3–5.

_____. "Art and the Camera," *Lippincott's Monthly Magazine* 65 (January, 1900), pp. 83–87.

_____. "Opening Address," *Photographic Journal* 25 (October 21, 1900), pp. 74–78.

_____. "Photography Applied to the Undraped Figure," *American Annual of Photography* XI (1898), pp. 186–97.

_____. "Photography As a Fine Art," *Photo Era* 4 (March 1900), p. 91.

_____. "Sacred Art and the Camera," *American Annual of Photography* 23 (1899), pp. 19–25.

_____. "William Morris," *Book Buyer* 12 (November 1895), pp. 545–49.

DEMACHY, Robert. "The American New School of Photography in Paris," *Camera Notes* 5 (1901), pp. 33–42.

ELLENZWEIG, Allen. *The Homoerotic Photograph: Male Images From Durieu/Delacroix to Mapplethorpe*. New York: Columbia University Press, 1992.

ELLMAN, Richard (ed.). *The Artist as Critic: Critical Writings of Oscar Wilde*. New York: Random House, 1968.

_____. *Oscar Wilde*. New York: Knopf, 1988.

FANNING, Patricia J. "Bibliography: F. Holland Day's Writings on Photography," *History of Photography* 18:4 (Winter 1994), pp. 383–84.

FOUCAULT, Michel. *The History of Sexuality*, vol. 1: *An Introduction*, New York: Vintage, 1990.

FRASER, Harrison (ed.) *The Yellow Book: An Illustrated Anthology*. New York: St. Martins Press, 1974.

FREEDMAN, Jonathan. *Professions of Taste: Henry James, British Aestheticism, and Commodity Culture*. Palo Alto, Cal.: Stanford University Press, 1990.

GERNSHEIM, Helmut and A. *The History of Photography*. New York: McGraw-Hill, 1969.

GILMAN, Sander L. *Sexuality: An Illustrated History Representing the Sexual in Medicine and Culture from the Middle Ages to the Age of AIDS*. New York: John Wiley & Sons, 1989.

GREEN, Jonathan (ed.). *Camera Work: A Critical Anthology*. Millerton, N.Y.: Aperture, 1973.

HARKER, Margaret. *The Linked Ring: The Secession in Photography, 1892–1910*. London: Heinemann, 1979.

HARTMANN, Sadakichi. *The Valiant Knights of Daguerre: Selected Critical Essays on Photography and Profiles of Photographic Pioneers*. Harry W. Lawton and G. Knox (eds.). Foreword by Thomas F. Barrow. Berkeley: University of California Press, 1978.

HOMER, William Innes. *Alfred Stieglitz and the American Avant-Garde*. Boston: New York Graphic Society, 1978.

HOWE, Ellic. *The Magicians of the Golden Dawn: A Documentary History of a Magical Order, 1887–1936*. London: Routledge and Kegan Paul, 1972.

JENKYNS, Richard. *The Victorians and Ancient Greece*. Cambridge, Mass.: Harvard University Press, 1980.

JULLIAN, Philippe. *Dreamers of Decadence: Symbolist Painters of the 1890s*. New York: Praeger, 1971.

_____. *Oscar Wilde*. New York: Viking, 1969.

JUNOD, Philippe. "(Auto)portrait de l'artiste en Christ," *L'autoportrait à l'âge de la photographie: Peintres et photographes en dialogue avec leur propre image*. Exhibition Catalog. Lausanne: Musée Cantonal des Beaux-Arts, 1985.

JUSSIM, Estelle. *Slave to Beauty: The Eccentric Life and Controversial Career of F. Holland Day. Photographer, Publisher, Aesthete*. Boston: David R. Godine, 1981.

_____. "F. Holland Day's 'Nubians'," *History of Photography* 7:2 (April–June 1983), pp. 136–7.

KELLER, Ulrich. "The Myth of Art Photography: A Sociological Analysis," *History of Photography* 8:4 (October–December 1984), pp. 249–75.

_____. "The Myth of Art Photography: An Iconographical Analysis," *History of Photography* 9:1 (January–March 1985), pp. 1–38.

KOSINSKI, Dorothy M. *Orpheus in Nineteenth-Century Symbolism*. Ann Arbor: UMI Research Press, 1989.

KRAUS, Joe Walker. *Messrs. Copeland & Day*. Philadelphia: George S. MacManus, 1979.

_____. "A History of Copeland & Day (1893–1899) with a Bibliographic Checklist of Their Publications"(unpublished master's thesis). Urbana: University of Illinois, 1941.

LANDOW, George P. *Victorian Types, Victorian Shadows: Biblical Typology in Victorian Literature, Art, and Thought*. Boston and London: Routledge and Kegan Paul, 1980.

MACKENZIE, John. *Orientalism: History, Theory and the Arts*. New York: St. Martin's Press, 1995.

MICHAELS, Barbara L. "New Light on F. Holland Day's Photographs of African Americans," *History of Photography* 18:4 (Winter 1994), pp. 334–47.

_____. *Gertrude Käsebier: The Photographer and Her Photographs*. New York: Abrams, 1992.

NAEF, Weston J. *The Collection of Alfred Stieglitz: Fifty Pioneers of Modern Photography*. New York: Viking and Metropolitan Museum of Art, 1978.

NEWHALL, Beaumont. *History of Photography from 1839 to the Present*, revised and enlarged. New York: Museum of Modern Art, 1982.

NIMMEN, Jane Van. "F Holland Day and the Display of a New Art: 'Behold , It is I'," *History of Photography* 18:4 (Winter 1994), pp. 368–82.

PARRISH, Stephen Maxfield. *Currents of the Nineties in Boston and London: Fred Holland Day, Louise Imogen Guiney, and Their Circle* (doctoral dissertation, Harvard University, 1954), New York: Garland, 1987.

PATER, Walter. *The Renaissance: Studies in Art and Poetry*. Introduction and Notes by Kenneth Clark. London and Glasgow: Collins, 1961.

PETERSON, Christian A. "American Arts and Crafts: 'The Beautiful Photograph' 1895–1915," *History of Photography* 16:3 (Autumn 1992), pp. 189–232.

_____*Alfred Stieglitz's Camera Notes*. New York and London: W. W. Norton, 1993.

POTTS, Alex. "Walter Pater's Winckelmann," *Zeitschrift für Kunstgeschichte*, 46 (1993), pp. 67–73.

_____. *Flesh and the Ideal: Winckelmann and the Origins of Art History*. New Haven and London: Yale University Press, 1994.

ROLLINS, Edward Hyder and S. M. Parrish. *Keats and the Bostonians: Amy Lowell, Louise Imogen Guiney, Louis Arthur Holman, Fred Holland Day*. Cambridge, Mass.: Harvard University Press, 1951.

ROSS, Marjorie Drake. *The Book of Boston: The Victorian Period, 1837–1901*. New York: Hastings House, 1964.

SAID, Edward. *Orientalism*. New York: Vintage, 1979.

SEDGWICK, Eve Kosofsky. *Epistemology of the Closet*. Berkeley: University of California Press, 1990.

_____. *Between Men: English Literature and Male Homosocial Desire*. New York: Columbia University Press, 1985.

SEILER, R. M. (ed.). *Walter Pater: The Critical Heritage*. London and New York: Routledge and Kegan Paul, 1980.

SHAND-TUCCI, Douglass. *Life and Architecture: Ralph Adams Cram*, vol. 1, *Boston Bohemia 1881–1900*. Amherst: The University of Massachusetts Press, 1994.

STEICHEN, Edward. *A Life in Photography*. Garden City, N.Y.: Doubleday and Co., 1963.

SYMONDS, John Addington. *Male Love: A Problem in Greek Ethics and Other Writings*. John Lauritsen (ed.). Foreword by Robert Peters. New York: Pagan Press, 1983.

WEIERMAIR, Peter. *The Hidden Image: Photographs of the Male Nude in the Nineteenth and Twentieth Centuries*. Trans. Claus Nielander. Cambridge, Mass.: MIT Press, 1988.

WEINTRAUB, Stanley (ed.) *The Yellow Book: Quintessence of the Nineties*. Garden City, NY: Anthology Books, 1964.

WILDE, Oscar. *Complete Works of Oscar Wilde*. London and Glasgow: Collins, 1975.

WILLOUGHBY, Guy. *Art and Christhood: The Aesthetics of Oscar Wilde*. London and Toronto: Associated University Press, 1993.

Special thanks to
Eugenia Parry Janis,
whose spirited exchange and critical input
inpired my essay in ways
too numerous to mention.

J.C.

THIS FIRST EDITION OF
F. Holland Day: Suffering the Ideal
is limited to five thousand casebound copies.
The essay "Suffering the Ideal" is copyright James Crump, 1995.
The photographs were edited by Jack Woody and James Crump,
and are printed four color with varnish on wood-free paper stock.
The artwork for the cover is adapted from a design by Aubrey Beardsley
and was originally intended for the cover of Oscar Wilde's *Salomé.*
The text is set in the digital version of monotype Centaur.
Edited by Robin Jacobson. Typography by Eleanor Caponigro.
Design by Jack Woody.
This edition is copyright Twin Palms, 1995.
Printed and bound in Hong Kong for:

TWIN PALMS

PUBLISHERS

401 PASEO DE PERALTA
SANTA FE, NEW MEXICO 87501
505 988—5717

ISBN 0—944092—33—0

1995

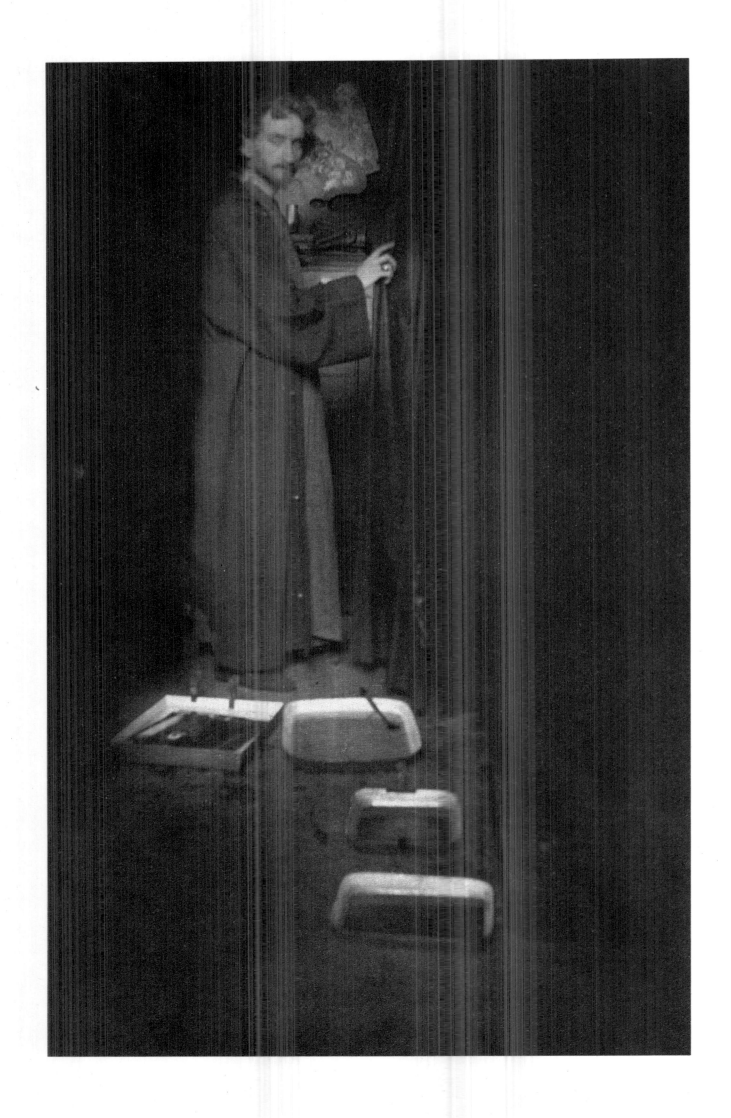